The Art of the European Goldsmith
Silver from the Schroder Collection

The Art of the European Goldsmith

Silver from the Schroder Collection

Introduction & Catalogue by Timothy B. Schroder

Essay by J. F. Hayward

The American Federation of Arts

This book has been published in conjunction with the exhibition,
THE ART OF THE EUROPEAN GOLDSMITH: SILVER FROM THE
SCHRODER COLLECTION, organized by the American Federation of Arts.

The American Federation of Arts is a national, non-profit educational
organization, founded in 1909 to broaden the knowledge and appreciation
of the arts of the past and present. Its primary activities are the organiza-
tion of exhibitions and film programs which travel throughout the United
States and abroad, and the fostering of a better understanding among
nations by the international exchange of art.

Published by The American Federation of Arts
41 East 65th Street, New York, New York 10021

LCC 83-71244

ISBN 0-917418-73-5

AFA Exhibition 82-13 / Tour: November 1983 – June 1986

Edited by Irene Gordon

Design & Typography by Howard I. Gralla

Composition in Albertus and Trump by Finn Typographic Service

Printed by The William J. Mack Company

Bound by Mueller Trade Bindery

COVER: Nef. Probably Netherlandish, ca. 1580 (Cat. no. 27). *Shown
without foot and stem.*

Contents

The American Federation of Arts

Foreword

The Schroder silver collection, which in its entirety includes approximately ninety-five objects dating from the thirteenth into the nineteenth centuries, has been cited as being one of the finest and most comprehensive private collections of the art of the European goldsmith. It was first brought to the AFA's attention by two trustees, Irwin L. Levy and Harry S. Parker, III, and we were particularly pleased when Bruno L. Schroder, the Collection's present owner, agreed to send selections from London for a two-year tour of United States museums to coincide with the sixtieth anniversary of the founding of the J. Henry Schroder banking group in New York.

There are many whom we wish to thank for their contribution to this project. First and foremost is Bruno Schroder, who, throughout, has generously guided and taken a keen and personal interest in all aspects of the project. The late Dr. J. F. Hayward, formerly Deputy Keeper of the Victoria and Albert Museum, and more recently Associate Director of Sotheby's, London, in collaboration with Timothy B. Schroder, Director of the Silver Department, Christie's, London, selected seventy-nine objects from the collection for this exhibition. Dr. Hayward also contributed the central essay for this catalogue. Regretfully, he died shortly after completing this work; thus, his contribution to this project becomes one of the last accomplishments in his long and distinguished career as an art historian. Timothy Schroder's introduction reviews the history of the Collection and sets it within the context of nineteenth-century collecting. In his notes on each object he has drawn on his extensive knowledge to provide the amateur as well as the specialist not only with technical information and stylistic analysis, but with a survey of the literature – ranging from the earliest to the most recent – on the art of the European goldsmith. The work of both of these experts is acknowledged with appreciation.

There are many others whom we wish to thank for their contributions. As Special Assistant to Bruno Schroder, Barbara Pugh coordinated many aspects of the exhibition with great diligence. Among others in London, we wish to thank Eileen Tweedy for her fine photography; Rupert Harris for his conservation treatment; and the Worshipful Company of Goldsmiths for their gracious assistance. We are additionally grateful to the British Department of Trade for allowing these objects to leave Great Britain.

In New York we have relied for invaluable advice on a variety of issues on David Revere McFadden, Curator of Decorative Arts at the Cooper-Hewitt Museum, New York, where the exhibition will be presented first. We also wish to thank Irene Gordon for the careful scholarship that characterizes her editing and Howard Gralla for his handsome design of this publication, as well as the exhibition's poster and graphics.

At the AFA the following contributions must also be acknowledged: Jane S. Tai for her overall coordination of the project; Carol O'Biso for her careful attention to the packing and transportation; Amy McEwen for scheduling the tour; Konrad G. Kuchel for acquiring the documentary photographs reproduced here and, with Fran Falkin and Mary Ann Monet, for proofreading the text; and Sandra Gilbert for organizing the publicity.

Finally, we wish to thank the museums which are presenting the exhibition and, in doing so, giving the collection the attention it so richly deserves.

Wilder Green, Director

The Art of the European Goldsmith
Silver from the Schroder Collection

Introduction

The Schroder Collection was largely formed by two individuals – Baron Sir John Henry Schröder (1825-1910) and his nephew Baron Bruno Schröder (1867-1940) – over a period of some fifty years, from the 1870s to the 1930s.

John Henry was the eldest surviving son of Johann Heinrich Schröder (1784-1883), who had founded the London banking house of J. Henry Schröder & Co. in 1818. In 1849 he was made a partner of the firm by his father and in the following year married Eveline Schlüsser (b. St. Petersburg, 1828). In 1864 he settled at The Dell, a small estate near Windsor. His main interests were gardening and collecting works of art. He also devoted much energy to various charitable causes and in particular a group of charities concerned with the German community in England. It was partly in recognition of his support of such projects as the foundation of the German Hospital and the German sailors' Mission in the East End of London that Queen Victoria conferred a Baronetcy on him in 1892.

The records of the silver collection are incomplete and leave the dates of many acquisitions uncertain. Some pieces otherwise unaccounted for have been traced in the records of Christie's, and among the earliest direct provenances is the Dasent Collection which was dispersed in 1875. Several important objects came from that sale, including the Basel beaker of circa 1540 (Cat. no. 8), the English cup of 1546 (Cat. no. 9), and the two bell salts (Cat. no. 34 and App. no. 11). Perhaps the most important items ever to have been in the Collection, the Dolgellau Chalice and Paten, were purchased after their appearance at Christie's in 1892. They were subsequently declared Treasure Trove and, after negotiations with the Treasury, it was agreed that John Henry could retain them for his lifetime, on condition that they be left to the Crown in his will. In accordance with this stipulation, they are now in the National Museum of Wales, Cardiff.

John Henry's taste in silver seems to have favored comparatively plain styles, as his purchases at the Dasent sale suggest. Although only eight pieces are known definitely to have been acquired during his lifetime, we can be fairly sure of at least another dozen or so, for these are all included in an undated inventory of the contents of The Dell which also lists the Dolgellau Chalice and was therefore probably compiled before, or at, his death in 1910. Taken together, these objects form a broadly homogeneous group within the Collection and establish an important aspect of its overall character. In addition to the pieces already mentioned, these include the ewer of circa 1610 (Cat. no. 42), the steeple cup (Cat. no. 49), and some of the more important early-eighteenth-century English pieces, all of which avoid the extremes of the Mannerist taste that characterize some of his nephew's purchases. That these reveal his taste and not simply his opportunities is supported by the fact that in 1905 he appears to have turned down the offer of a London dealer of what was described in a letter as "the finest work of Benvenuto Cellini," probably the Rospigliosi salt cellar now in the Metropolitan Museum of Art, New York.

John Henry died without an heir. A collection of Sèvres porcelain and Renaissance cameos was sold at Christie's soon after his death. He left his collection of pictures to the Kunsthalle in Hamburg, but bequeathed his property in England and his silver collection to his nephew Baron Bruno Schröder.

Bruno was the youngest son of Clara Louise, his uncle's younger sister. Since John Henry lacked a natural heir, the future of the bank had been one of his main considerations in selecting a successor. Bruno's similarity of character and approach to business became clear at an early stage and made him the obvious choice. In 1892, at the age of twenty-five, he was made a partner of the firm, and on his uncle's death he became proprietor of J. Henry Schröder & Co. Like his uncle, he was passionately interested in horticulture, especially orchids, and in collecting. Two years after becoming a partner in the bank he married Emma Deichmann (b. Cologne, 1874) and in 1900 bought a house near The Dell which, between 1912 and 1914, he had rebuilt into a large mansion in the Jacobean style.

Bruno was a rather more specialized collector than his uncle and was particularly interested in Renaissance works of art, not only silver, but German portraits, Italian majolica, bronzes, and Limoges enamels. However, the most important aspect of his collecting was goldsmiths' work. This was probably largely due to the enthusiasm of his wife. The few letters relating to the collection which have survived appear always to be addressed to her rather than her husband.

From at least 1917 Bruno Schröder bought almost exclusively through the Bond Street dealers Crichton Brothers, either buying from their stock or having them act on his behalf at auctions. It has been possible to trace only two purchases between 1910, the year of John Henry's death, and 1917 (Cat. nos. 22, 53), but those solitary pieces suggest that there were probably others as well. Although two English pieces were bought in 1917 – the Elizabethan tankard (Cat. no. 21) and the standing salt (Cat. no. 31), the bulk of the collection was assembled during the nine years between 1919 and 1927. In the first year of that period at least nine objects were acquired, including the Nef (Cat. no. 27) and four pieces from the Earl of Home's sale (Cat. nos. 12, 19, 36, 38).

The years 1924-26 undoubtedly stand as the most fruitful period, in terms both of quantity and quality of additions. It was also then that the well-established connection with Crichton Brothers was turned to real advantage, for they succeeded in acquiring certain important items and whole collections that had not appeared on the open market, from which they offered selected pieces to special clients. Among these were the four pieces Bruno secured from the Duke of Cumberland Collection, (Cat. nos. 29, 40, 43, and App. no. 4) and at least one piece from the Green Vaults in Dresden (App. no. 5). Much of the Cumberland Collection had once been part of the English Royal Collections and had been taken to Germany by George I and II for use at their Hanoverian Electoral residence. The Electorship passed out of the hands of the English monarch when Victoria succeeded to the throne and devolved upon the Duke of Cumberland, who was the eldest surviving son of George III.

The pace of expansion slackened significantly after this and the only items of real importance that he acquired during the 1930s were the castellated cup and cover (Cat. no. 4) bought in 1935 and the cup and cover purchased from the Victor de Rothschild Collection in 1937 (Cat. no. 18). Bruno Schröder died in 1940, leaving the collection to his

son Helmut. When Helmut died in 1959 he left the collection to his son, Bruno. Bruno has taken a considerable interest in the collection and certain additions have been made, the most important of which are the Aldobrandini tazza (Cat. no. 16) and the Italian ewer and basin (Cat. no. 41).

In its entirety the Schroder Collection comprises about ninety-five items, of which seventy-nine are included in the present exhibition. The first public exhibition of the Collection, held in 1979 at the Goldsmiths' Hall in London, concentrated on the Renaissance period but included the few pieces that are of an earlier date, as well as some of the more imposing seventeenth-century objects. Some of the most delicate of these items have had to be withheld from the current exhibition because of the risk involved in transit, among them a number of extremely fragile rock crystal pieces and an extraordinary mid-sixteenth-century silver and enamel salt cellar (App. no. 3). Despite these exceptions, which are listed and illustrated in the Appendix, a more rounded impression of the Collection will be gained from the inclusion of a group of early-eighteenth-century Huguenot plate not previously shown, as well as several nineteenth-century "historicising" pieces, which were certainly considered to be works of the sixteenth century when they were acquired. This requires some explanation.

One of the most interesting aspects of late-nineteenth-century collecting is the fashion that developed for Renaissance goldsmiths' work. During the early years of the century, collectors favoring this field were exceptional, but by its end a number of important collections had been formed. Particularly noteworthy is the Sir Augustus Wollaston Franks Collection, now in the British Museum. Sir Julius Wernher and Baron Ferdinand de Rothschild also formed impressive collections of early continental silver along similar lines and these are still intact, at Luton Hoo and the British Museum respectively. Likewise, in America, William Randolph Hearst and John Pierpont Morgan energetically accumulated Renaissance silver during the early years of this century. Both these magnificent collections were dispersed in sales during the 1930s and 1940s, and the last remnants of the Morgan collection were sold at auction in New York during the fall of 1982.

Historicism in silver, that is, the manufacture of pieces carefully reproducing the styles of earlier periods, was first taken seriously in England at the beginning of the nineteenth century by collectors, such as William Beckford, and certain dealers, notably Kensington Lewis, who made something of a speciality of the auricular and floral styles of the seventeenth century. Subsequently it was taken up by the architects Augustus Pugin and William Burgess, who did much to foster a scholarly attitude toward medieval metalwork. But the line between historicism and fraudulent antiquarianism was at times very fine. The high prices that were regularly paid for medieval and Renaissance pieces inevitably led to exploitation by certain parties. On the one hand, collectors were prey to the often archaeologically very exact products of workshops like that of Vasters of Aachen (Cat. no. 77) and Bosard of Lucerne. On the other, dealers such as the Parisian Frédéric Spitzer were notoriously ready to carry out "improvements" to works of art in order to make them more saleable. One of the best-known cases of this was Spitzer's treatment of some of the Aldobrandini tazzas (see Cat. no. 16).

Appalling though such frauds are, they are nonetheless interesting to the historian for they serve to crystalize the taste of the day and illuminate the prevailing understanding, or misunderstanding, of the Renaissance. Spitzer modified the tazzas in order to make them conform more closely to current taste and to make them, to his mind, more "Renaissance" than they already were. In their altered state they seemed more convincing than in their original state. For this reason, they tell us more about the knowledge and taste of collectors of the time than the models they emulate.

The guiding principle under which the Schroder Collection was formed was much the same as that of the Schatzkammer, or Treasure Chamber, assembled by princely and aristocratic wealth in the German-speaking lands during the sixteenth century and later. These accumulations usually included some objects of great age, and others of modern workmanship added by succeeding generations. Many of them express a curiously Germanic interpretation of the idea of the Renaissance Man: the combination of rare natural objects, such as rock crystals and exotic sea shells, with gold and silver mounts whose decorative programs allude to the various branches of learning (for example, Cat. nos. 17, 18). The clear purpose behind these displays was not only to exhibit the great wealth of the patron, but also to reveal his sophistication and learning.

From inventories and paintings we know that similar collections existed in England, but most of these failed to survive the vicissitudes of time and were replaced by liquid funds or objects more in keeping with modern fashions. The dispersal of these important collections has reinforced the singularity of the Schroder Collection, which is perhaps the finest of its type that still exists in private hands. During the years preceding the Second World War selected pieces from the Collection frequently appeared in important loan exhibitions. In recent years individual objects have been mentioned and reproduced in scholarly publications and have been included in special exhibitions, such as the one celebrating the intellectual and artistic achievements of Augsburg which was held in that city in 1980. It is hoped that this comprehensive exhibition will not only be of interest to students, scholars, and collectors, but will also provide the interested viewer with the delight, astonishment, and pleasure that the makers of these objects originally intended to evoke.

Timothy B. Schroder

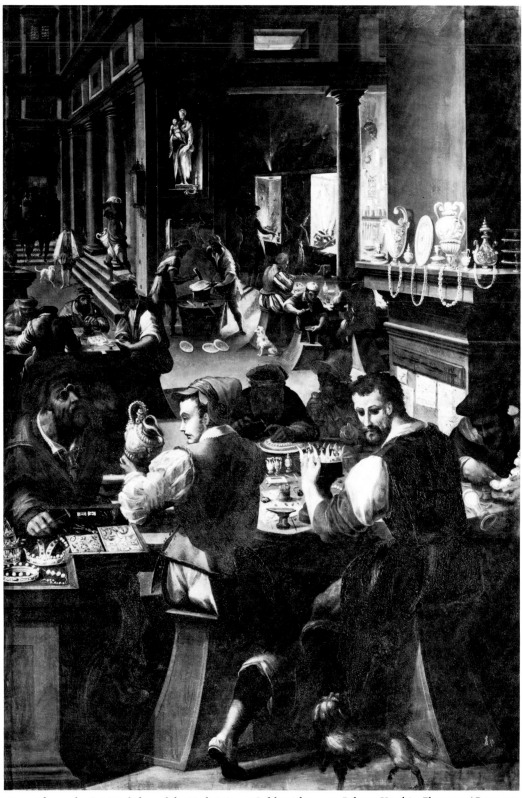

FIG. 1 Alessandro Fei. *Workshop of the Medici Court Goldsmiths.* 1572. Palazzo Vecchio, Florence (Courtesy Alinari Art Resource, Inc.) *See note p. 28.*

The Art of the European Goldsmith

The silver of the Schroder Collection covers a period of some five hundred years, from the thirteenth to the eighteenth century. Its chief strength lies in works of the sixteenth and early seventeenth centuries, corresponding to the cultural and stylistic phases known as Renaissance and Mannerism, a concentration that reflects the taste that prevailed when the Collection was assembled. The Collection consists of pieces of the highest quality, made for wealthy ecclesiastical and secular patrons who expected the goldsmith to achieve something more than a merely competent exercise of his craft. In such pieces emphasis was placed on art rather than function. The more complex the form, the more recondite the classical allusions in the decoration, and the more abstruse the philosophical program of the ornament, the more they were admired. While the design might be based on some familiar domestic article such as a vase, ewer, or basin, the functional form was often treated as a theme upon which elegant and fanciful variations were played.

The term *goldsmith* is generally used to describe an artist or craftsman who works with precious metals, that is, gold, silver, or, since the nineteenth century, platinum. Few larger objects of gold have survived. Thus, with the exception of the gold-and-enamel set of knife, fork, and spoon (Cat. no. 75), the Schroder Collection consists of objects made of silver. A high proportion of these, however, are gilded and it is customary to refer to such pieces as gold plate although they are not of solid gold. Gilded silver has a luster and brilliance lacking in gold, which does not reflect the light so effectively. At certain periods, especially during the sixteenth and early seventeenth centuries, most display plate was gilded, a practice that was revived in the Empire period, or the Regency in England. Owing to the considerable expense, it is now rare for silver to be gilded. Domestic plate, which received a great deal of use, was nearly always left in the white. The Dutch, perhaps because of their more democratic social structure, have always preferred white silver and those Dutch pieces that are now gilded have in most cases been enriched later, after export to some other country.

The title *The Art of the European Goldsmith* reflects the fact that from their beginnings most of these objects were intended for display rather than practical use. Although such pieces have usually held a strong appeal for the sophisticated collector, it would not in any case have been possible in the twentieth century to assemble a collection of routine domestic plate that dated before the eighteenth. The intrinsic value of silver has always been such that only pieces of exceptional artistic or historic importance have been retained once their style ceased to be fashionable. In fact, it was not until the early nineteenth century, when the Prince Regent of England began to collect silver, that anyone thought of preserving earlier domestic plate, and only in the present century have even the simplest pieces acquired an antique value. The regular destruction of earlier silver for conversion to more useful or more fashionable form can be followed in

the inventories of princely treasures and in the order books of working goldsmiths, where entries make allowance for the "worn" plate handed over for melting.

The inventories of precious metal in the treasuries of the ruling families of Europe show that a great part of their wealth was not kept in the form of bullion, but in wrought plate, which, owing to political or military exigencies, had to be sacrificed sooner or later. During the second half of the sixteenth century, in an atmosphere of increased awareness of the aesthetic significance of the goldsmiths' art, some European princes specified that their chief treasures be preserved in perpetuity. In 1565, for example, the Duke of Bavaria established a list of twenty-seven objects that were never to be disposed of; but, such is the uncertainty of human affairs, only nine have survived and are today in the Schatzkammer of the Residenz in Munich.

While changes of taste and rough use have led to the refashioning of all but a minute proportion of pre-eighteenth-century goldsmiths' work of northern Europe, political events, in particular the French Revolution and the Napoleonic invasions of Italy and Spain, have resulted in the destruction of nearly all the pre-nineteenth-century silver of southern Europe. The loss, with but few exceptions, of sixteenth-century Italian goldsmiths' work is particularly serious, as Italy was not only the home of the most highly skilled goldsmiths – the name of Benvenuto Cellini comes immediately to mind – but also the center from which knowledge of classical antiquity, so eagerly sought after in northern Europe, was disseminated. The dignity and exquisite sense of proportion associated with the Italian Renaissance are not evident in most of the work of their northern

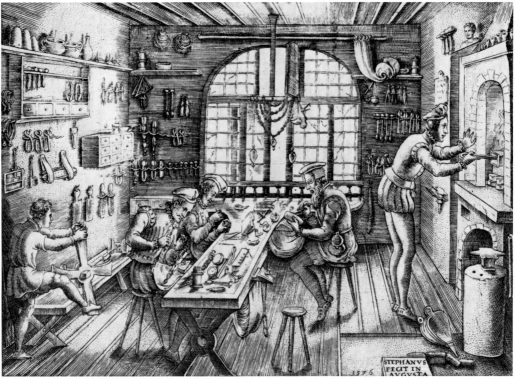

FIG. 2 Etienne Delaune. *The Goldsmiths Workshop, I.* 1576. Engraving (Courtesy the British Museum, London). *See note p. 28.*

contemporaries shown in the exhibition. The tall Swiss beaker (Cat. no. 8) that comes nearest to satisfying these standards derives its form from a Late Gothic northern prototype. Appreciation of classical antiquity was transmitted to northern Europe in the sixteenth century through the northern goldsmiths who spent their "wander" years – which were required before they could be certified masters of their craft – in Italian workshops. More important were the printed pattern books, published mostly in the Flemish city of Antwerp and the south German city of Nuremberg.

While ordinary domestic plate, used in the service of the table, was less subject to frequent change in fashion, display plate, intended to be set out on the cupboard or the sideboard to display the taste, wealth, and sometimes the ancestry of the owner, was more subject to the rigors of fashion. However, the costliness and superb workmanship of such pieces were likely to preserve them from destruction by later generations. This applies in particular to vessels mounted in precious metal with bowls or bodies made of other materials such as rock crystal, semi-precious stones, ivory, ostrich egg, nautilus shell, and coconut, for which no alternative use could be found if the mounts were removed. For this reason the number of vessels of this type that has survived is out of proportion to their prevalence at the time. The Schroder Collection is rich in these mounted vessels. Three of rock crystal and one of nautilus shell, which are not included in the traveling exhibition because of their fragility, are shown in the Appendix (nos. 2, 4, 5, 9).

A patron who commissioned an expensive piece from the goldsmith expected him to be conversant with the latest fashion in the cultural centers of Europe, and the printed

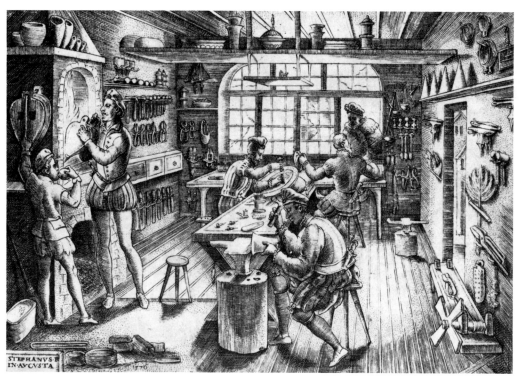

FIG. 3 Etienne Delaune. *The Goldsmiths Workshop, II.* 1576. Engraving (Courtesy the British Museum, London). *See note p. 29.*

pattern books enabled a provincial master to keep up with contemporary changes in fashion. The effectiveness of the pattern book in disseminating knowledge is demonstrated by the striking consistency in design of vessels made in any one period over the whole region of Teutonic culture from Denmark across to Poland and Rumania. A secondary influence that made for uniformity was the fact that from the sixteenth to the eighteenth century Augsburg and Nuremberg were the predominant centers of the craft; journeymen during their wander years sought employment in the workshops of these cities, whence, after completing the period of training for which they had bound themselves, they carried their style back to their home towns. A further source of conformity in German goldsmiths' work, certainly in detail of ornament, was the practice of dealers offering casting patterns of ornament for sale at the great annual fairs of Frankfurt am Main, Leipzig, and Linz, which were bought by goldsmiths from the whole Teutonic cultural area.

Study of the sixteenth-century silver in the exhibition will show that the interpretation of classical art in northern Europe was by no means faithful to the original. Although unquestioning respect was given to the remnants of Roman civilization excavated in Italy, no ancient goldsmiths' work, apart from rings, was discovered. Goldsmiths in search of protoypes had to be satisfied with vessels of bronze or marble, and even these were often incomplete, lacking either spout or handle. These missing parts were reconstructed by the Italian engravers in their pattern books with a varying degree of accuracy. The early representations of Roman vessels were published in Italy, but there were few Italian patterns books of silver designs, presumably because Italian goldsmiths preferred to work from drawings or models. Most of the sixteenth-century pattern books by Flemish or German designers of ornament were not based on direct acquaintance with classical antiquity but derived from the contingent of Italian artists who were brought by King Francis I of France to decorate his palace at Fontainebleau. Thus it was not the first phase of Renaissance design, which had conformed to the antique Roman dignity and purity of proportion, that influenced the goldsmiths of northern Europe, but a later and second phase, in which classical precedent was neglected in favor of the originality and variety purveyed through the imagination of the pattern book engravers.

The northern engravers were particularly fascinated by the grotesque decoration composed of a fanciful arrangement of figures within foliate scrollwork derived from Roman wall and ceiling paintings. Coupled with the grotesque was the moresque, a decoration of Near Eastern origin based on conventional floral designs. Introduced to Europe via Venice, first exploited by an Italian engraver, and then copied in France, the Low Countries, and Germany, an early example of its use can be seen on the English cup of 1546 (Cat. no. 9). A band of engraved moresques was also the standard decoration of the communion cup in Elizabethan England (Cat. no. 15). The ubiquity of the moresque in the decoration of northern goldsmiths' work is an indication of their readiness to assimilate ornament of diverse ancestry and to forget the discipline of classical precept. While pattern books obviously had the effect of increasing conformity, there are, in fact, very few pieces copied exactly from a published design. Indeed, exact reproduction of a pattern book design is a prima facie ground for doubting the authenticity of a piece.

The emergence of Antwerp, Augsburg, and Nuremberg as the chief centers of design led to the development of Northern Mannerism, a style that is particularly well repre-

sented in the Schroder Collection. Though the Mannerist style was given its most extreme expression in northern Europe, it would not be correct to regard the style as an exclusively northern development. So complete has the loss of Italian goldsmiths' work been, that it is no longer possible to appreciate the contribution of Benvenuto Cellini, Antonio Gentile, or Manno di Sbarri, who are now known by no more than one or two pieces, or of a host of others whose creations have completely disappeared. The Schroder Collection does, however, include magnificent though anonymous examples of Italian Mannerism in the Aldobrandini tazza and the ewer with companion basin of about 1600 (Cat. nos. 16 and 41).

The decorative style developed at Fontainebleau could be readily adapted to the needs of the goldsmith. Its characteristic features – bold cartouches composed of strapwork with rolled-over ends enclosing busy figure subjects in low relief, but supported by larger figures in high relief – spread rapidly over northern and western Europe. The style, with its all-over decoration that gave ample opportunity for the chaser to display his skill in working precious metal in relief, became more profuse in the version transmitted by Flemish and German pattern books; the convolutions of the strapwork are less controlled, while the human figures, instead of resting comfortably on an elegant volute, are trapped and held prisoner within encumbering straps. The ingenuity of the goldsmith in developing the strapwork was such that eventually the cartouches became more important than the figure subjects, which were almost submerged in their burgeoning frames.

Modern eyes tend to concentrate on form alone and to regard decoration as a secondary consideration. This was not the sixteenth-century point of view. The goldsmith was expected to offer novelty (*inventio*) and superb craftsmanship (*difficultà*) in which the whole range of his techniques – embossing, flat chasing, engraving, etching, and cast work – were engaged. His creations cannot be appreciated fully when seen from a distance. Once the form as a whole has been understood, the vessel must be held in the hand so that the whole lavish program of decoration, often minute in scale, can be appreciated. These goldsmiths were working for clients who, like the proverbial Texan millionaire, had everything. Their success depended on their ability to surprise their clients by novelty of form and virtuosity in working their material.

Some of the vessels in the Schroder Collection, such as the ewer in the form of a galley (Cat. no. 27), were intended for the collector's cabinet. During the second half of the sixteenth century the practice arose among the dynastic princes of establishing, in addition to their treasury of articles made of precious metal, a cabinet of works of art and curiosities of nature (*Kunst- und Raritätenkammer*). While the treasury was a symbol of their wealth, the Kunstkammer bore witness to their culture and taste. While the treasury was likely to be raided at any time to provide money to pay troops (such, for instance, was the fate of the treasure of the kings of England during the troubles that preceded the Civil Wars), the objects in the Kunstkammer, often of lesser or even minimal intrinsic value, have survived in greater number. Kunstkammer objects in the Schröder Collection include the owl with a body of coconut, the nautilus shell cups, and the twelfth-century-Sicilian rock crystal ewer engraved and mounted in the late seventeenth or early eighteenth century (Cat. nos. 11, 33, and App. nos. 10, 15).

Vessels as elaborate as most of the sixteenth-century examples in the Collection would have constituted only a small proportion of the output of a goldsmith; many of

them would have made demands beyond his competence. The average master would have been occupied mainly in the production of useful plate, dishes, plates, and beakers, of which he would hold a stock. Richly decorated articles were too expensive in both time and precious metal for the average goldsmith to stock and would be specially commissioned by the client. A drawing would then be submitted to the client for approval. This might be the work of the goldsmith himself, probably with the aid of his set of pattern books, from which he would select details to produce an original ensemble. In the case of a more important piece, the client himself might obtain a design from a graphic artist or painter. When Duke Federigo Gonzaga of Mantua ordered a reliquary from Benvenuto Cellini, he asked his court artist, Giulio Romano, to supply the drawing. (Giulio, perhaps recalling something of Cellini's fiery temper, tactfully declined, saying that Cellini had no need of other people's designs.) If the commission were sufficiently important, or the object unusually complex, a model might be made from the drawing. In his *Autobiography* and in his Treatise on Goldsmithing, Cellini refers frequently to such models both for ecclesiastical and for secular plate.

When a drawing was submitted it would probably be accompanied by an estimate of the cost of making it. A drawing submitted by Hans Lencker, a prominent Augsburg goldsmith of the early seventeenth century, specifies the cost per Mark (measurement of weight). The original note in the goldsmith's hand is written in German, but the design must subsequently have been offered to an Italian client for a second note, without a price, however, is written on the left-hand side in Italian. Another version of this drawing is among the papers, now in the Berlin Kunstbibliothek, of the early-seventeenth-century Hamburg dealer Jakob Mores, showing that efforts were made to find a customer in North Germany, South Germany, and Italy.

A major problem for a goldsmith who accepted an important order was that of financing it. The intrinsic cost of the silver and gold required was considerable, but the more prestigious the client, the greater was the difficulty in extracting prompt payment from him. In 1570 the unfortunate Augsburg goldsmith Hans Raiser had to agree to wait two years for payment of the immense sum of twelve thousand gulden owed him by Emperor Maximilian II. Certain goldsmiths solved this problem of economics by taking on the function of bankers. This did not happen in England until the eighteenth century, but in Augsburg there were goldsmith-bankers as early as the second half of the sixteenth century. These bankers or dealers (*Krämer*), as they were known, were goldsmiths of substantial financial resources who, instead of maintaining their own workshop, traveled from court to court soliciting orders which they then passed on to their goldsmiths in Augsburg. They thus accepted the risk of having to wait for payment, but doubtless adjusted the price accordingly. Some of the more elaborate caskets or cabinets which were sought by the collector-princes of the late sixteenth century were mounted in silver, but incorporated many other materials. It was in the provision of these that the dealers came into their own, arranging the commission with the client, distributing orders among the goldsmiths and other craftsmen involved, and, finally, overseeing the production of the whole object.

Commissions for silver vessels from local sources were relatively few in comparison with those from the ruling princes and nobility. Most of the silver vessels made in Antwerp or the south German cities were intended for export, not only within the

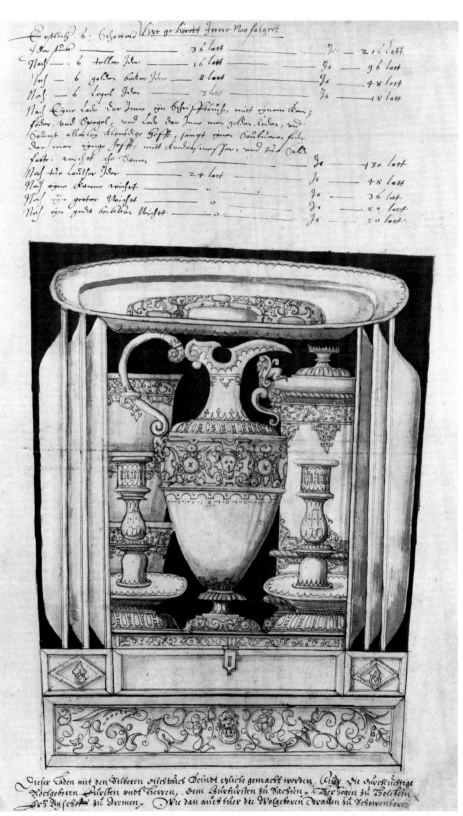

FIG. 4 Jakob Mores. *Drawing of a Traveling Service*. ca. 1600. Kunstbibliothek, Berlin, Federal Republic of Germany. *See note p. 29.*

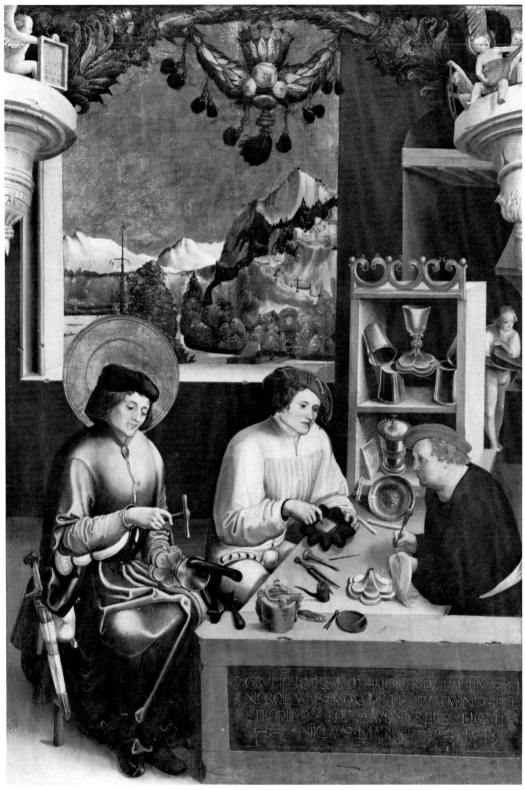

FIG. 5 Niklaus Manuel. *St. Eligius Working as a Goldsmith.* 1515. Kunstmuseum, Bern. *See note p. 29.*

territories of the Holy Roman Empire, but also to France, Spain, and England. It was in this export business that the silver dealers were most active in seeking commissions, attending not only fairs, but coronations, marriages, and births. The eldest son of Wenzel Jamnitzer, the leading Nuremberg goldsmith, actually lost his life through the misfortune of being present in Paris, while seeking commissions, during the Saint Bartholomew's Day massacre. As a result of this export trade the great centers of production such as Augsburg and Nuremberg have relatively little goldsmiths' work to show in their museums. The most extensive collections are concentrated in the cities where the rulers resided: Vienna (Holy Roman Empire), Munich (Bavaria), Dresden (Saxony), Copenhagen (Denmark), etc.

Since the Middle Ages the goldsmiths of the chief European cities were organized in craftsmen's guilds or, to use the more suggestive Italian term, *arte*. These guilds had both a religious and a secular role. Their religious function included the foundation of special chapels, attending religious ceremonies as a group, and arranging the funerals of their members. Their secular functions were manifold; they acted as a benevolent society to their members and also as a trade union, restricting the number of masters allowed to open a workshop in the city and excluding foreigners. They took responsibility for maintaining the standard of competence of their members, controlling the system by which the aspiring goldsmith passed through the grades of apprentice, journeyman, and master of his craft. They set the nature of the trial pieces that had to be submitted before an aspirant could be admitted master, judged these "masterpieces" (*Meisterstücke*), and, most important, enforced adherance to a determined standard of purity in the silver they sold.

The status of the guilds varied from city to city, but inasmuch as the goldsmiths were often the richest tradesmen, their guild was usually one of the most influential. While the guild protected the social and economic status of its members, it also exercised what now seems to be an almost tyrannical control, excluding persons of illegitimate birth from admission to their ranks, forbidding marriage before admission as master, punishing refractory members by fine or imprisonment, and limiting the number of apprentices or journeymen that a member might employ. This last regulation was intended to prevent any one master from gaining a predominant position and, hence, excessive wealth.

Members of the goldsmiths' guild were required to stamp the silver they made with their mark, which might consist of their initials, a device, or a combination of the two. This mark was registered with the guild, usually by being struck on a plate kept by the guild so that, in the case of dispute about the standard of silver used in a vessel, the goldsmith responsible could be identified. As a rule the goldsmith whose mark appears on a piece was its maker, that is, it was made in his workshop and under his supervision; but this was not necessarily so. The mark signifies the identity of the goldsmith who submitted it for assay and therefore accepted responsibility for the correctness of the standard of precious metal content. A considerable number of pieces, including many of the finest, bear no mark at all. There are two possible explanations for this. One is that the piece was made from old plate which was handed in by a client and returned to him after refashioning without ever being offered for sale; the other, that its maker worked for one of the ruling princes and had been exempted by him from control of the goldsmiths' guild of the city. This practice of appointing court goldsmiths outside the control of the guilds led

to constant trouble between the court and the city council, which represented the guild in disputes with the sovereign power. From the point of view of the court goldsmith, who was often an outstanding master, freedom from guild control meant the right to accept unlimited commissions, to take on as many assistants as the work justified, and even to evade the regulations governing admittance as master. Should the prince die, however, and the goldsmith lose his employer, the guild would not fail to make things difficult for one who had enjoyed such advantages.

The guild might sometimes be called upon to perform another service for the members. When an article was sold directly to a customer from stock, it was up to the goldsmith to fix the price and allow credit or not, as his circumstances permitted. In the case of specially commissioned pieces it was usual, should the price be disputed, to submit the finished piece to a committee of fellow members of the guild who would estimate its value. It is evident that the goldsmiths would not wish to damage one of their members by undervaluing his work, but should they decide the charge was too high, the goldsmith would have little hope of securing payment in full. Another grave risk was the brevity of life before the nineteenth century; many a goldsmith found that his client had died before delivery of an expensive commission, in which case he might have difficulty in securing more than the intrinsic value of the metal.

In the Middle Ages the church, ruling princes, and the aristocracy were the main source of commissions, but in the course of the sixteenth century the goldsmiths drew on a wider range of clients as merchants and the craftsmen's guilds grew wealthier. The treasuries of the Flemish, Dutch, and German city council guilds contained great quantities of display plate until they were dispersed first during the Napoleonic Wars and finally as a result of the dissolution of the guilds in the nineteenth century. Much of the early plate that has survived to the present day formerly belonged to a city or a guild treasury; the most spectacular cup in the Schroder Collection was once part of the treasure of the city of Lüneburg (Cat. no. 40). Only in England have the city companies of London retained a large part of their treasures which date from the fifteenth century onward.

Masters in the decorative arts were distinctly conservative when confronting new trends and there may be as much as a quarter of a century gap between the development of a new style in painting and architecture and its adoption by the goldsmith. This conservatism was rooted in German society. Even as late at the eighteenth century the Augsburg guild persisted in setting as masterpiece a standing cup of sixteenth-century design, while in Nuremberg the masterpiece was the Late Gothic columbine cup (*Akeleibecher*). Another Gothic survival in Nuremberg was the double cup embossed with lobes (*Traubenbecher*), an example of which is in the Schroder Collection (Cat. no. 5). (These cups were traditionally made in Nuremberg on the occasion of marriages between members of the ruling families, the coat of arms of the husband being engraved or enameled on one half, that of the wife on the other.) It was not until the second quarter of the seventeenth century that the basic features of the Baroque style – grandeur of scale, strength of relief, and contrast of light and shade – can be recognized in silver. This new development can be seen in the series of large German tankards and in the pair of English wall sconces of 1700 (Cat. nos. 53, 56, 62).

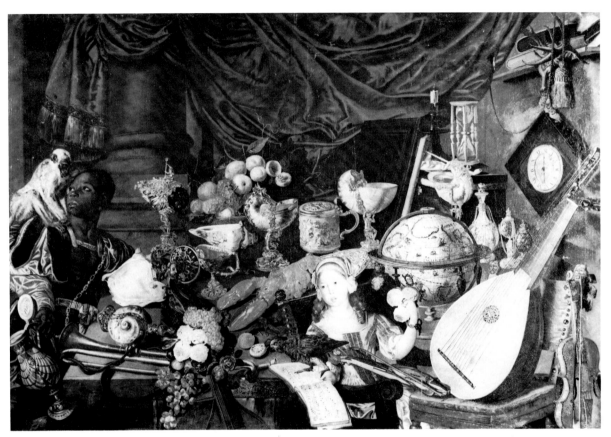

FIG. 6 Dutch School. *The Treasure of the Paston Family.* Mid 17th century. Castle Museum, Norwich, Great Britain (Courtesy the Norfolk Museums Service). *See note p. 29.*

Fashion in design and decoration of silver changed at an ever-increasing tempo once the Renaissance had ended the Gothic era. In general it can be said that a period in which profuse decoration was admired was succeeded by one in which the surface quality of unadorned silver was preferred. Such changes of fashion were not always determined by aesthetic considerations. German Baroque silver was constructed of thinner and lighter metal and was less richly decorated because the ravages of the Thirty Years' War had reduced both the number and the wealth of the clientèle. Precisely the same effect can be observed in English Baroque silver as a result of the Civil Wars, followed by the Puritan Commonwealth. It was once again a political event, the revocation by Louis XIV in the late seventeenth century of the Edict of Nantes, which had permitted French Protestants to worship in their own way, that led to a rebirth of goldsmiths' work in England. The Huguenot goldsmiths who left France and settled in England developed a dignified style that relied for effect on mass and plain surfaces only slightly enriched with engraved or applied ornament. This Anglo-French style is well represented in the collection by such imposing vessels as the punch bowls (Cat. nos. 67, 68) and ewer (Cat. no. 63).

Before forks were introduced, the ewer and basin had supplied water for rinsing the fingers between courses. By the early seventeenth century these vessels were already treated as display plate and a shallow dish replaced the basin, which had served to receive the water poured from the ewer. The Italian ewer and basin (Cat. no. 41) are of this later type. In most countries, by the end of the seventeenth century the ewer and basin had been relegated to the bedroom as part of the toilet service. Only in eighteenth-century England did the two vessels remain standard pieces of display plate for the sideboard. The Schroder Collection contains an example of an early-eighteenth-century English ewer (Cat. no. 63). In the late nineteenth century the practice of using the basin, though not the ewer, was revived at City banquets. A basin filled with rose water was passed or carried round the table after the last course, so that those dining could refresh their faces with a napkin dipped in the water.

The goldsmith always had an eminently practical approach to his craft and took as much interest in methods of increasing efficiency and economy of production as any modern factory manager. The introduction of labor-saving devices does not accord with the idealized picture of the artist-craftsman inherited from nineteenth-century writers, but, in fact, a variety of processes for producing ornament by mechanical means were in use by the second half of the sixteenth century. Widely used was a stamp which enabled the goldsmith to produce rapidly a border ornament of repeating design. The borders on the silver-gilt mounted ewer (Cat. no. 35) were provided in this way. The advantages of the division of labor were fully realized, and while the average run of domestic plate would be produced by the goldsmith in his own workshop, pieces requiring engraving or relief decoration of exceptional quality would be put out to specialists in those arts. The most obvious way of saving labor was in the use of casting patterns, which seem to have circulated among goldsmiths. For every cast element in a piece of silver, a model was required from which casting molds were made. Some, particularly those involving figure sculpture, were extremely complex and it is evident from surviving pieces that the same molds were used by goldsmiths in different workshops. It is possible that the models were retained by the carvers and rented out to goldsmiths as and when required. Once a

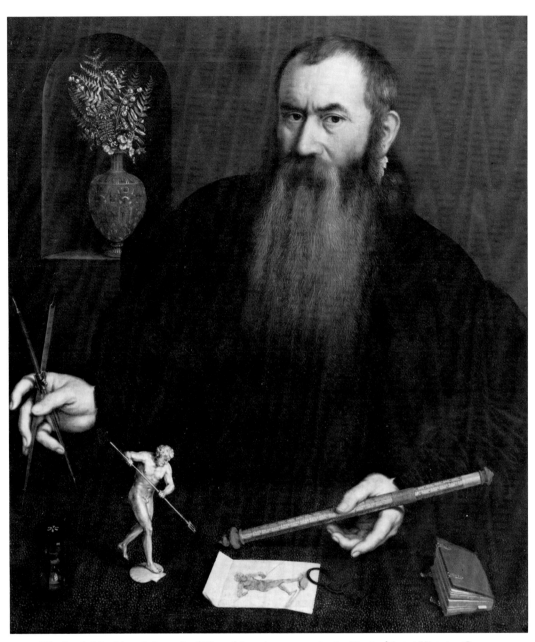

FIG. 7 Nicolas de Neufchatel. *Portrait of Wenzel Jamnitzer.* ca. 1560-65. Musée d'Art et Histoire, Geneva.
See note p. 29.

goldsmith had made a casting from his mold, he could, of course, make another model; his stock of models was indeed an essential part of his workshop equipment.

The goldsmith's production was determined by the pattern of national or local demand. The preference of the Italians, French, and Spanish for drinking wine as against the popularity of beer in northern and northwestern Europe is reflected in this exhibition by the variety of English and German beer tankards. However, wine was also drunk from tankards in northern Europe. These were of smaller size and were gilt inside, and often outside as well. Analogous differences distinguish the ecclesiastical plate of Catholic from that of Protestant countries. Both derive from earlier secular forms, but whereas the Roman Catholic chalice is based on an early medieval wine cup, the English Elizabethan communion cup is a version of a mid-sixteenth-century wine cup.

Of the virtuoso masters who created these prestigious vessels we know little. Only one, Benvenuto Cellini, has left us an account of his life and times, which, once doubted as a fiction of his own fantasy, has now gained acceptance as essentially reliable. The names of many are known, possibly their dates of birth, apprenticeship, admission as master, and death; perhaps, as in the case of the most famous of German goldsmiths, Wenzel Jamnitzer, details of offices held within the guild and the city council; but most are anonymous. The silver they made remains as testimony to their ability through five centuries to raise their difficult craft to the status of an art.

J. F. Hayward

Notes to Figure Illustrations

FIG. I

The painting, which depicts the goldsmiths shop attached to the court of the Medici, grand dukes of Tuscany, shows the activities and range of production of such a shop. Tacked to the bottom of the cupboard at the right are working drawings for objects produced in the shop. In the background a workman chases a basin, others mount jewels at a table, and two men hammer a dish at a stake. Beyond them are the furnaces for casting and annealing the metals. At the table to the left another group of workmen mount precious stones. Lying on the table in the foreground are, from the left, a papal triple tiara, a coronet, a royal crown, rings, and stones for mounting. A workman holds up an elaborate golden ewer with pinched-in spout and loop handle. On the table to his right are a pair of silver altar cruets, a perfume bottle, and a salt cellar. The master goldsmith holds the most important object, the Medici crown. To his right a workman is chasing the base of a large candlestick or altar cross. An array of finished objects stands on the shelf above the cupboard: a pair of candlesticks, a large helmet-shaped ewer, a scent flask, a basin, a large two-handled vase, a small jug, a pilgrim flask, and a table center of four dishes set one on top of the other. Gold chains looped around the vessels hang along the edge of the shelf.

FIG. 2

In this print Delaune, who was a goldsmith as well as an engraver, depicts work in a goldsmiths shop in Augsburg. The artisan in the foreground on the left side of the table chases what seems to be the link of a chain which is clamped into a mace-like vise, other examples of which hang on the rear wall to the left of the window. The workman at the far end of the table chisels the die of a seal, using a mirror propped in front of him to check the accuracy of his design. The master goldsmith, shown opening a mold on the right side of the table, may be a self-portrait of Delaune. Various scales and weights are arranged on the table before him, and at the front end of the table are chisels, pincers, and small dishes for holding jewels. The leather slings attached to the underside of the table are fastened to the belts of the artisans while they work, to catch gold dust and fragments of the precious metal. At the right a worker holds an object in the furnace with a pair of tongs, readying it for the soldering process, and at the left an apprentice is employed at the apparatus for drawing wire. Draped on a bar suspended from the ceiling is a completed chain with pendant ornaments, or perhaps glass globes used as magnifiers.

One striking characteristic of such sixteenth-century representations of various craftsmen at work

is the elegant garments worn by the workers, who are seldom shown wearing aprons or smocks. The clothing of these men serves as a status symbol, an expression of their lofty social ambitions.

FIG. 3
Here, activities related to working with silver are depicted. At the left an artisan and an apprentice use the bellows to raise the heat of the furnace, at the top of which are crucibles used in the refining process. Bars of silver lie on the floor at their feet. In the center foreground an artisan hammers a beaker on a raising stake, while at the end of the table a workman chisels the surface of an embossed basin which is propped up on a sand-filled leather saddle. Opposite him the master goldsmith speaks to a client who looks in at the window. Tools of the craft – hammers, shears, files, compasses, punches – hang on the walls; at the lower right is the apparatus for drawing wire. Overhead, on the shelf spanning the width of the room, various completed vessels are displayed.

FIG. 4
This silver traveling service, drawn by the Hamburg goldsmith who was the chief furnisher of plate to the Danish court, consists of a ewer and basin, a tankard, a pair of candlesticks, two beakers, six dishes, and plates and spoons. The note at the bottom states that he supplied similar sets to the Elector of Saxony, the Duke of Holstein, the Archbishop of Bremen, and the Count of Schanenberg.

FIG. 5
St. Eligius, the patron saint of goldsmiths, who was so honest in his profession that he made two thrones instead of one from the materials with which he had been provided for the work, is shown in his shop hammering a standing cup. Two associates work alongside him at a table covered with tools of the craft. Completed objects are displayed in a wooden cabinet, and in the background an apprentice is seen working the bellows.

FIG. 6
The survival of at least five of the pieces represented in this painting may be taken as proof that this is indeed a portrait of the collection of plate owned by a wealthy East Anglian family in the middle of the seventeenth century. Thirteen pieces of English, Dutch, Flemish, and German origin are shown. The flagon decorated with shells in the bottom left-hand corner and the large strombus shell mounted on a gilt-and-enameled brass stem lying on its side nearby both survive; the flagon, in the Metropolitan Museum of Art, New York, and the other in the Castle Museum, Norwich. The shell flask beneath the hour glass at the right is in a private collection, London. The nautilus cup in the center and the one at the right have been identified in Dutch museums. The Paston family seems to have been particularly attracted to mounted shells; of the thirteen pieces depicted, eleven are of this type and a twelfth is embossed with shells. Only the large tankard in the center has no association with the sea.

FIG. 7
This portrait of the prominent Nuremberg goldsmith shows him surrounded by various tools and objects of his profession. In his right hand he holds a pair of dividers, in his left is a type of silver rod that was used to determine the weight of various metals. A sketch of a figure of Neptune lies on the table before him and next to it is the completed figure in silver. In the niche above is a vase with flowers and grasses cast from nature, a technique for which Jamnitzer was especially famous.

Catalogue

1

Chalice

Probably South German, ca. 1180
Silver-gilt and niello
HEIGHT: 5⅞ in. (15 cm.)
MARKS: None

On spreading circular foot with hexagonal stem, large knop and shallow segmental bowl; the foot repoussé and chased with busts of six saints, and the knop with the symbols of the Evangelists; the bowl engraved with representations of Christ and the Twelve Apostles on hatched niello ground; the foot, upper part of the stem, and lip engraved with inscriptions, the last probably of the fifteenth century.

The arcade on the foot is engraved S. MARIA, S. JOHES, S. THEODO, S. ALEXRNE, S. GALLVS, and S. OTHMRRV. The first four – the Virgin Mary, St. John, St. Theodore the Martyr, and St. Alexander – are all early Church saints. The other two are St. Gall, an Irish monk, canonized in A.D. 640, who accompanied St. Columba to the Continent and settled west of Bregenz, near Lake Constance in present-day Switzerland, and St. Othmar, an eighth-century follower of St. Gall who tried to unite the various monastic cells of the latter under the Rule of St. Columba. He died in prison in A.D. 759, after struggling with the secular and ecclesiastical authorities for the independence of the order.

This chalice is part of a small group of pieces dating from around the end of the twelfth century and mainly associated with the patronage of Henry the Lion, Duke of Saxony and Bavaria. Particularly similar is a chalice belonging to the Abbey church of Ottobeuren known as the Seven Brothers Chalice (*Suevia Sacra*, no. 142, pl. 129). Chased around the foot in relief with the seven sons of St. Felicity, it is similarly decorated around the bowl and has an identical knop. It differs materially from this one only in that the stem has possibly been modified at a later date. The inventories of the Abbey of Ottobeuren, compiled in 1771 and 1786, list two chalices of closely similar type (*Suevia Sacra*, p. 161). The first is the Seven Brothers Chalice. The second was apparently removed to Wörishofen after the secularisation of the Abbey in 1802. In all probability this is the

chalice in question. The *Suevia Sacra* catalogue (p. 161) tentatively attributes the former to Schwabia, while admitting that its sculptural and painterly characteristics are not usual in South German work of the period.

The use of engraved figures on a neutral ground of niello pattern is found on two other chalices of the period – the Wilten Chalice of about 1170, now in the Kunsthistorisches Museum, Vienna (Lasko, pl. 228), and the chalice from Trzemeszno of about the same date, in the treasury of Gniezno Cathedral, Poland (Lasko, pl. 225). But these both differ from the present chalice in that they are of a slightly earlier form, and the niello is arranged in a scrolling pattern, rather than the hatching seen here. Much closer in this respect is the "Bernward" paten of about 1180, now in the Cleveland Museum of Art (Lasko, pl. 230). Lasko (p. 208) attributes the group of objects he discusses to Lower Saxony, but admits that "all these important works are woven together in a tapestry of technique, style, similarity of decoration, and sources, none of which individually convinces one of the pattern of a single workshop."

Provenance: (Probably) Abbey of Ottobeuren, Bavaria; Wörishofen, Bavaria; Stein Collection, Paris; probably acquired after 1910 to replace the Dolgellau Chalice and Paten (see Introduction, p. 10).
Exhibited: London, Goldsmiths' Hall, 1979, no. 1; London, Goldsmiths' Hall, 1983, no. 125.
Literature: C. Rohault de Fleury, *La Messe*, 1883-89, vol. 4, p. 129, pl. 315.

2

Chalice

Italian, probably Siena, mid-fifteenth century
Silver, copper-gilt, and enamel
HEIGHT: 7½ in. (9.1 cm.)
MARKS: None

On spreading hexafoil foot, with hexagonal stem, large compressed spherical knop and parcel-gilt rounded conical bowl above a foliate calyx; the knop chased with foliage, and with six applied medallions enameled with the Crucifix, the Virgin, St. John, and three other saints; the stem with panels of champlevé

Cat. no. 1, see colorplate p. 41

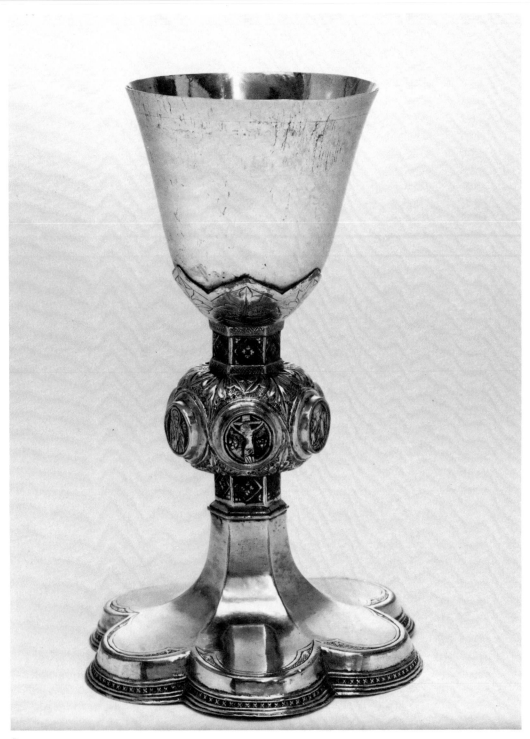

Cat. no. 2

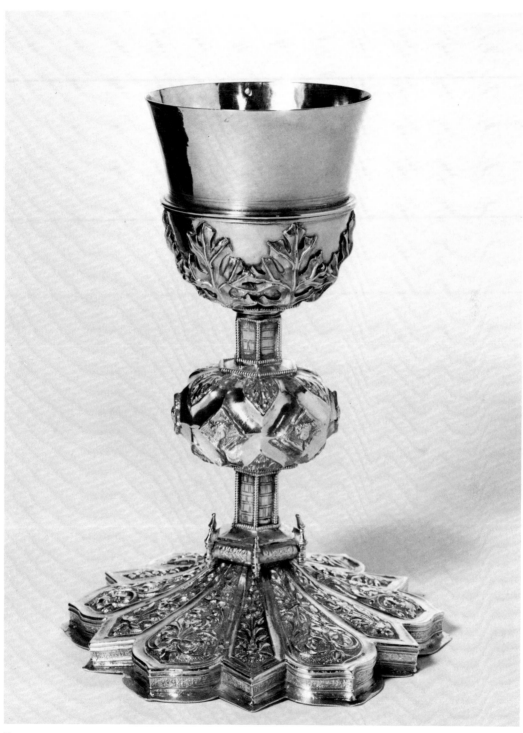

Cat. no. 3

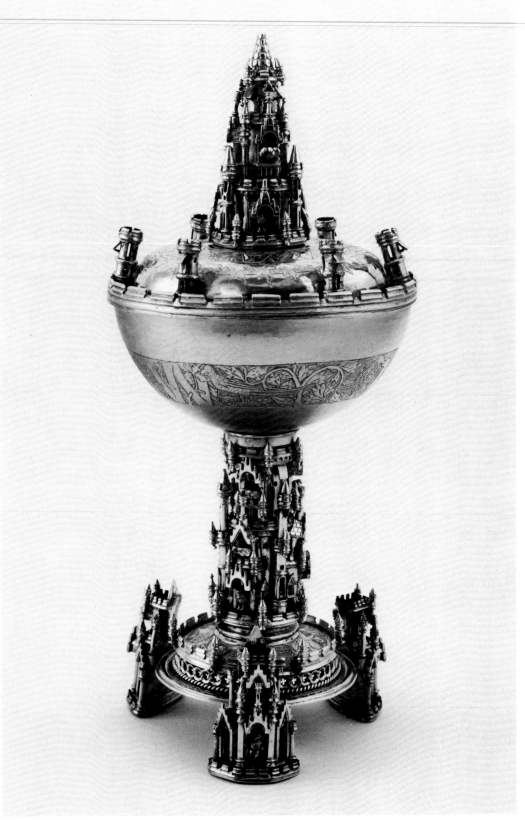

Cat. no. 4

enamel designs. The bowl is probably a later replacement.

Several features of this chalice – the large knop with its enameled medallions, the calyx beneath the bowl, and the enameled hexagonal stem – are characteristic of a type evolved and produced in large numbers in Siena during the late Middle Ages, while the plain hexafoil foot suggests a date toward the end of the period. It has been pointed out by Charles Oman (*Apollo*, 1965, p. 281) that most late Sienese chalices fall into one of three categories: those made entirely of silver and set with basse-taille enamels; those with copper-gilt stem and foot, similarly enameled; and those with enameled decoration only on the knop and stem. The present chalice falls into the third category, which was the least expensive of the three. It is however, an indication of the mass-production techniques employed in this industry that the knop and stem of this chalice are virtually identical with those of chalices falling into the second category, as, for example, one in the Art Museum, Princeton University (*Eucharistic Vessels*, no. 1).

Provenance: Unknown.
Exhibited: London, Goldsmiths' Hall, 1979, no. 3.

3

Chalice

Spanish, early sixteenth century
Silver-gilt
HEIGHT: 9⅛ in. (23.3 cm.)
MARKS: Valladolid (Castile), assay maker's mark FBO below a symbol; marked on foot

On twelve-lobed spreading foot chased with panels of foliage on matted ground; with hexagonal murally engraved stem and large compressed spherical knop chased with lozenges and foliage; the bell-shaped bowl with plain rib applied above a foliate calyx. The bowl is probably a later replacement.

The chased foliage on a ground of punched circles that decorates the foot is typical of Castilian ecclesiastical silver of the early sixteenth century and is comparable, for example, with

the foot of a monstrance bearing the Burgos mark, now in the Victoria and Albert Museum, London (Oman, 1968, fig. 106). The assay master's mark has been identified by comparison with that struck on a fragment of a processional cross by Pedro Ribadeo, also in the Victoria and Albert Museum (Oman, 1968, p. 9, no. 24).

Provenance: Unknown; included in Dell inventory, ca. 1910.
Exhibited: London, Goldsmiths' Hall, 1979, no. 4.

4

Cup and Cover

South German, early sixteenth century
Silver-gilt
HEIGHT: 14¼ in. (36.1 cm.)
MARKS: None

The plain hemispherical bowl on stem formed as a tiered Gothic architectural structure, on circular base with battlemented border and three similar architectural feet; the raised cover with similar border and tall conical castellated finial; the foot, bowl, and cover engraved with a band of ornamental foliage incorporating animals and the initial W. The top of the finial is sawn away.

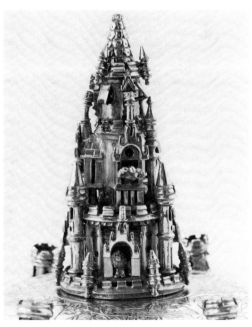

Cat. no. 4

The use of fanciful Gothic architectural structures appears on a number of pieces dating from the late fifteenth century. The most accomplished is a copper-gilt covered beaker in the Victoria and Albert Museum, London (Kohlhaussen, p. 292), attributed to Sebastian Lindenast of Nuremberg (ca. 1460-1526). Closer to this cup, however, are two other objects, a covered beaker of about 1490 in St. Paul's Cathedral, Liège (Hernmarck, fig. 35), tentatively attributed by Hernmarck to Cologne, and the Oldenborg Horn, at Rosenborg Castle, Copenhagen, which is dated ca. 1470-80 and attributed by the same writer to a German silversmith working in Denmark (Hernmarck, fig. 205). Both are engraved in a similar manner and have comparable feet and finials. The fact of the top portion of the finial having been sawn away does not necessarily indicate any serious loss; many pieces of secular plate that survive from the Middle Ages and the Renaissance do so because they were presented to the Church at an early date and thereby saved from destruction. Such presentations sometimes involved a certain "desecularisation." This would appear to be the case with the Liège beaker, whose cross finial is clearly of a later date than the rest. The missing element from the finial of this cup may also have been a later addition.

Provenance: Presented by the City of London to Sir Robert Clayton, as Lord Mayor in 1679; Sir Harold Clayton, Bart., Sale, Christie's, London, June 3, 1935, lot 156.
Exhibited: London, Burlington Fine Arts Club, 1901, Case M, no. 1, pl. 12; London, Goldsmiths' Hall, 1979, no. 5.

5

Double Cup

South German, ca. 1510, one cup a later copy
Silver-gilt
HEIGHT: 14¼ in. (36.2 cm.)
MARKS: Nuremberg (town mark only); marked on foot. The second cup unmarked.

Each cup on seven-lobed foot, repoussé, chased with lobes, and with attenuated lobes forming the stem; the waisted body similarly chased with imbricated lobes and with openwork apron of foliage applied beneath the plain lip; with various engraved inscriptions and a print engraved with two coats of arms beneath the foot of the original cup.

Double cups, or *Doppelpokale*, first appeared in South Germany at the beginning of the sixteenth century and were frequently presented in Nuremberg and elsewhere as wedding gifts; as such they became traditional objects and were less exposed to changes of fashion than other types of plate. A number survive from the late sixteenth century in a form very little changed from the late Gothic model and are in particular associated with the workshop of Hans Petzoldt, which seems to have been in the vanguard of the Gothic revival around that time. This cup is among the earliest of the genre and is an eloquent expression of the "organic" phase of the Gothic style which was more fully developed in South Germany than elsewhere. In metalwork the style was largely created by such artists as Albrecht Dürer (1471-1528) and Albrecht Altdorfer (ca. 1480-1538). It is the antithesis of the Renaissance, taking its inspiration entirely from nature, especially from plant forms, and carrying it to the logical extreme where form and decoration become inseparable.

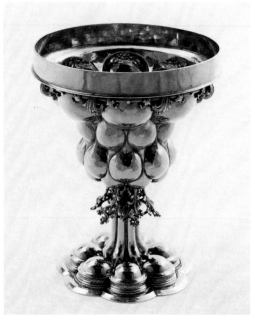

Cat. no. 5

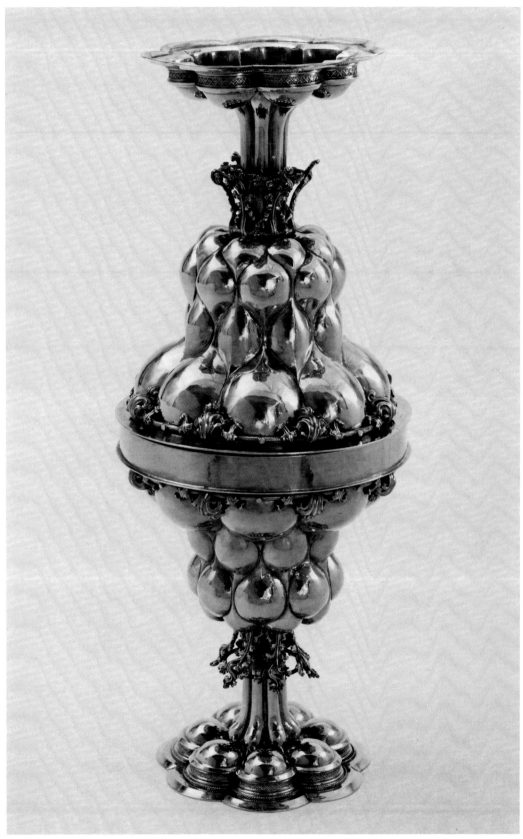

Cat. no. 5

This cup is associated with various marriages, alluded to in the inscriptions and coats of arms with which it is engraved. The first inscription reads *Lienhart *Tücher*12* and probably refers to the marriage in 1512 of Lienhart Tücher of Nuremberg with Magdalena Stromer; the coats of arms are those of Tücher and Imhoff von Spielberg of Bavaria, for Stephan IV Tücher who married Clara Helena Imhoff in 1657; and the second inscription refers to the marriage in 1704 of Hanns Paul Tücher and Maria Magdalena Imhoff. From the inscription on another cup, exhibited at the loan exhibition of 1862 at South Kensington (no. 6150), which read *Leonhart Tucher Æ. S. 81. A. 1568*, we know Lienhart to have been about 25 years of age at the time of his marriage in 1512.

Since it is fully described in the 1862 catalogue, the replacement cup was obviously made prior to that year. It is a precise replica of the other, even down to the modification under the foot which, on the original, was carried out in the seventeenth century to accommodate the engraved coat of arms and which in the case of the replica has been left blank. Most surviving double cups have a band of foliage engraved around the lip of the "outer" cup (Kohlhaussen, figs. 468, 474), from which it may be surmised that this was the "inner" one of the pair.

Provenance: G. H. Morland, Esq., Sale, Christie's, May 8, 1866, lot 80; included in Dell inventory, ca. 1910.

Exhibited: London, South Kensington Museum, 1862, no. 1060, lent by G. H. Morland, Esq.; London, Goldsmiths' Hall, 1979, no. 6; London, Goldsmiths' Hall, 1983, no. 18.

Literature: W. W. Watts, "Continental Silver in the Collection of Baron and Baroness Bruno Schröder," 1927, pp. 2 (ill.), 4, 6; H. Kohlhaussen, *Nürnberger Goldschmiedekunst*, 1968, pp. 321-22, no. 357a, fig. 472.

Albrecht Dürer. *Designs for Standing Cups.* Early 16th century. Sächsische Landesbibliothek, Dresden.

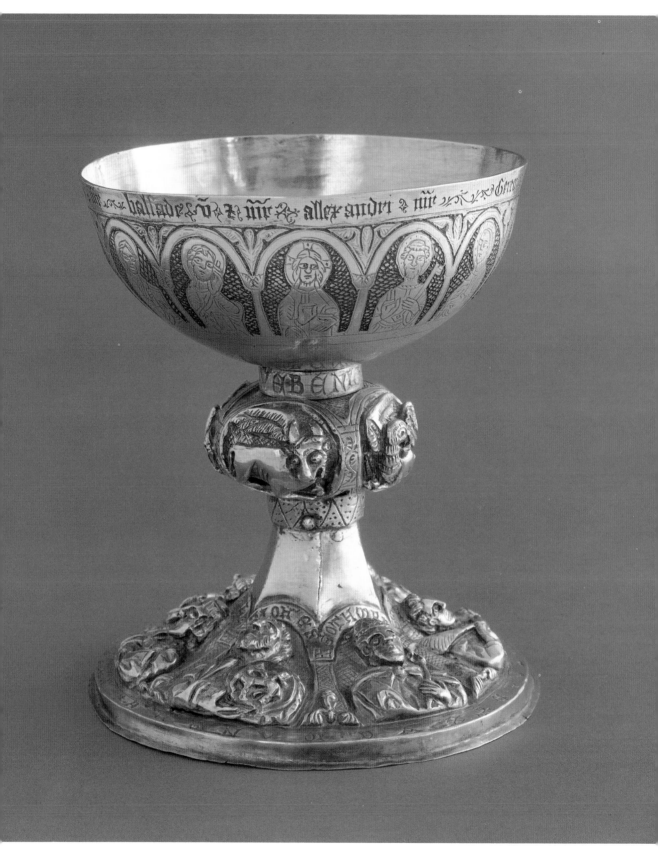

Cat. no. 1

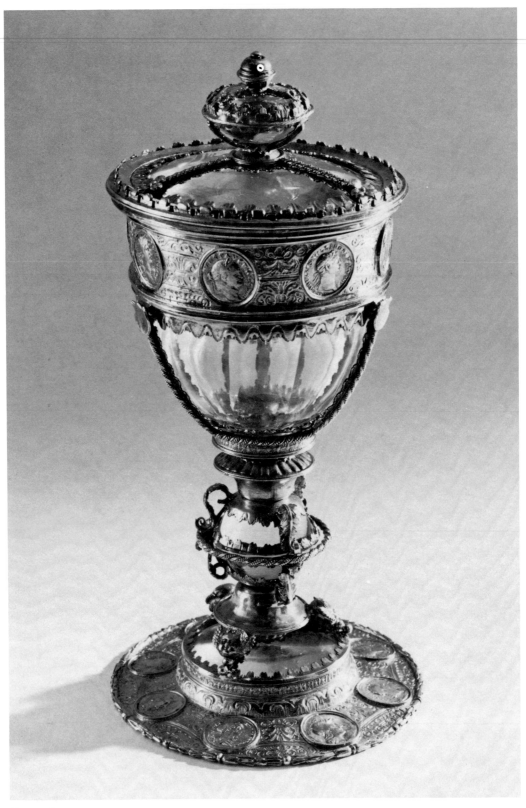

Cat. no. 6

6

Cup and Cover

Austrian, ca. 1530
Silver-gilt and rock crystal
HEIGHT: 8⅝ in. (22.1 cm.)
MARKS: Vienna (town mark only); mark
struck under base of stem

The broad circular foot inset with antique coins
and casts of coins and engraved with foliage,
with a rock crystal disk at the center; the stem
with a crystal sphere between rings; the faceted
bowl with corded vertical straps and lip-mount
similar to the foot, and with three shields
applied at the junctions of straps and lip; the
crystal cover surmounted by a hemispherical
crystal within cagework and secured to the
border by straps; a large Greek coin applied
beneath the bowl and visible through the crys-
tal; a female bust engraved inside the cover.
The finial is missing.

In a manuscript article (ca. 1925) on this cup,
Marc Rosenberg pointed out that between 1524
and 1544 the goldsmiths of Vienna were not
obliged to strike their products with a maker's
mark, which accounts for its absence on this
piece. He also suggested that the finial may
well have represented St. Bernard of Clairvaux,
who was particularly associated with Eberbach.

But even if this were the case (and there are no
particularly compelling reasons for supposing
it), it would have to have been a later addition,
since the cup was quite clearly intended origi-
nally as a secular piece.

The main center for faceted rock crystal ves-
sels during the early sixteenth century was
Freiburg im Breisgau and two other crystal ob-
jects in this Collection were also carved there
(App. nos. 2 and 5). The latter was subsequently
mounted in England, and it is possible that this
crystal, too, was ordered from Freiburg before
being mounted in Vienna.

Provenance: Kloster Eberbach, Rheingau; Sigmar-
ingen Museum; sold by the Prince Hohenzollern
Estate in Sigmaringen, 1928.
Exhibited: London, Goldsmiths' Hall, 1979, no. 8.

7

Cup and Cover

German, probably Strasbourg, ca. 1540,
attributed to Erasmus Krug
Silver-gilt
HEIGHT: 14⅝ in. (37.2 cm.)
MARKS: None.

On broad spreading foot with a band of inset
casts of antique coins between applied balus-

Cat. no. 6

Cat. no. 6

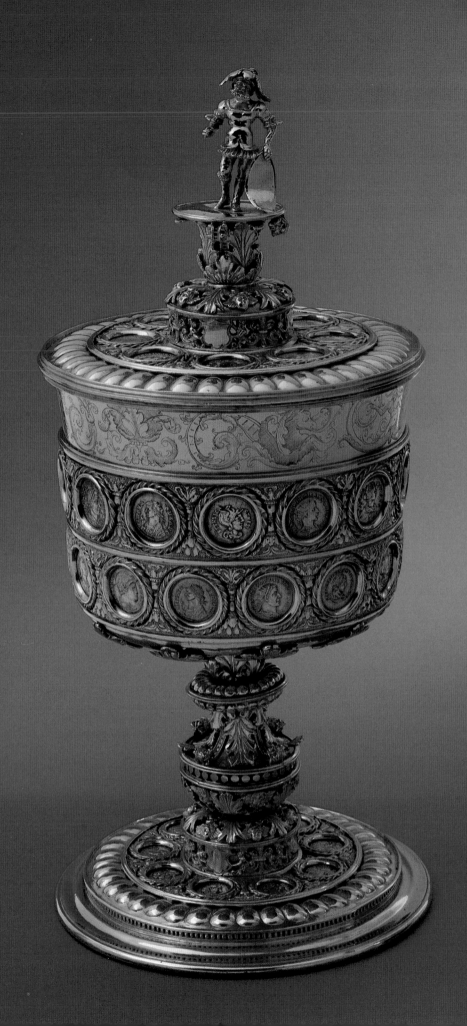

ters and foliage and within a band of embossed
gadroons; the baluster stem with applied vo-
lutes and acanthus leaves; the cylindrical body
with two similar bands of coins and with an
engraved band of foliage, figures, and horses
around the lip; the cover similar to the foot,
with finial formed as a warrior holding a shield,
standing on a plinth similar to the stem, with
an applied medallion dated 1526 under the foot
and stem. The shield held by the finial figure is
a modern replacement.

This cup is one of a pair made for Wilhelm
Honstein, Bishop of Strasbourg and Count of
Alsace (1475-1541), whose medal, struck with
his portrait and coat of arms, is set into the
cover and base. Honstein became Bishop of
Strasbourg in 1506, after studying law and
theology at the universities of Erfurt, Pavia, and
Freiburg. He became a close confidant of the
successive Emperors Maximilian I and Charles
V, undertaking a number of sensitive diplo-
matic missions on their behalf. His position
became less stable, however, during the Refor-
mation and particularly during the Peasants'
War of 1524-25, during which his residence
was sacked and burned. After his death in

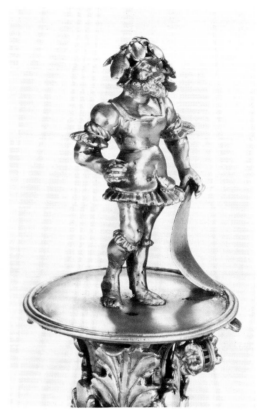

Cat. no. 7

Cat. no. 7

Cat. no. 7

1541, the two cups appear in an inventory of another Thuringian family, the princes of Schwarzburg-Rudolstadt.

The other cup of the pair was formerly in the collection of William Randolph Hearst and is identical except in two points of detail: the engraved frieze around the lip is of a different design, and the shield supported by the finial figure is engraved with Honstein's arms and would appear to be original (Kohlhaussen, no. 417, fig. 574). In an article on these cups Emil Delmár points out that the central motif on the engraved frieze around the lip of this cup, the two tritons supporting a coat of arms, is derived from a print by Wenzel Hollar after a lost design by Dürer.

Both Delmár and Kohlhaussen attribute the design of the cups to the Nuremberg goldsmith Ludwig Krug (1488/90-1532). Delmár's grounds for this attribution are twofold. He argues first from style: a number of features of the decoration are compatible with Krug's later style, for example, the band of pierced dentils around the foot, the use of acanthus foliage and volutes, and the style of the finial figure. Secondly, he considers the medal: Krug was known as a medalist (although none has been specifically attributed to him), and since there is a distinct corpus of some sixty portrait medallions, of which the Honstein medal is one, it is reasonable to associate the two. He then uses the assumed authorship of the medal to reinforce the otherwise inconclusive argument from style. This line of argument is not very satisfactory. Against the first point it might be objected that although similar decorative devices and castings are used on these cups as on other pieces attributed to Ludwig Krug, the overall character of most pieces more securely attributed to him is rather different. These, although introducing more modern elements, never fully escape the Gothic tradition, whereas the Honstein cups are a full expression of the Northern Renaissance. The failure of Delmár's first point makes the second irrelevant.

Hayward makes the alternative suggestion that the Honstein cups should be attributed to Krug's elder brother, Erasmus. The latter is known to have married a citizen of Strasbourg in 1506 and to have settled there. Although no other works have been positively identified as his, three factors make this attribution more

compelling than one to a Nuremberg workshop. First, a very closely related cup in the Schatzkammer of the Residenz at Munich (Hayward, 1976, p. 364, pl. 284) bears the Strasbourg town mark; secondly, the patron is unlikely to have taken his order elsewhere if local goldsmiths were capable of meeting his requirements (and the Munich cup certainly shows that they were); and thirdly, one would naturally expect to find certain stylistic points in common between the workshops of two brothers.

Provenance: Wilhelm Honstein, Bishop of Strasbourg; Prince Hohenlohe Schwarzburg-Rudolstadt.
Exhibited: London, Goldsmiths' Hall, 1979, no. 9.
Literature: W. W. Watts, "Continental Silver in the Collection of Baron and Baroness Bruno Schröder," 1927, pp. 88, 89 (ill.), 90; Emil Delmár, "Zwei Goldschmiedewerke von Ludwig Krug," 1950, pp. 49-67; W. Kohlhaussen, *Nürnberger Goldschmiedekunst*, 1968, pp. 400-401, no. 418, figs. 576, 577; J. F. Hayward, *Virtuoso Goldsmiths*, 1976, pp. 102-3, 364, pls. 283, 286; C. Hernmarck, *Art of the European Silversmith*, 1977, vol. 1, p. 94.

8

Beaker and Cover

Swiss, ca. 1540
Silver-gilt and enamel
HEIGHT: 13 in. (33 cm.)
MARKS: Basel, maker's mark of Johann Rudolf Fäsch-Glaser; marked under base

The plain tapering cylindrical body with flared lip and two bands of engraved scrolling foliage, on molded spreading foot with detachable bayonet fitting; the cover of ogee form, surmounted by a "wildman" with shield enameled with a coat of arms, standing on a circular base engraved WERLI VON BERENFELS and dated 1541, with a foliage calyx beneath; the inside of the cover with a circular print engraved and enameled with two coats of arms accollé, also dated 1541.

The arms on the shield of the finial are those of Bärenfels, while those inside the cover have been variously identified as those of the Upper Rhine family of von Hausen accollé with von

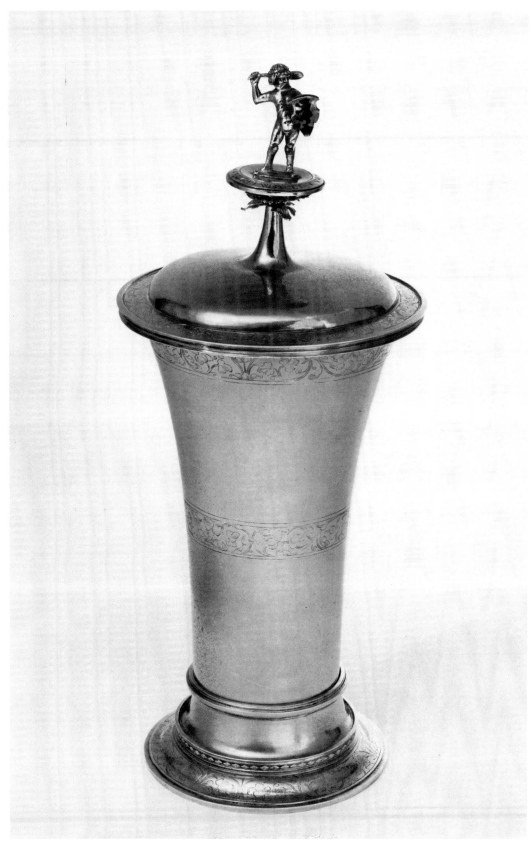

Cat. no. 8, see colorplate p. 53

Satzendorff, or, more probably, those of two families from Saint Gall, Zukenriet and Pfund.

The beaker would appear to have been made either for, or in memory of, Werher or Wernlin von Bärenfels, who died unmarried on January 9, 1541. Bärenfels was the son of Adelberg III Bärenfels-Schönau of Grenzach, near Basel, who also died in 1541. However, no connection between Bärenfels and any of the families mentioned above has been established.

The tall tapering beaker form is a relatively standard one of the period and the stamped band of lozenge ornament around the base is likewise found on a number of surviving Swiss pieces of the middle of the sixteenth century. Several similarly constructed beakers of slightly later date are in the Schweizerisches Landesmuseum, Zurich (*Weltliches Silber*, nos. 47-50). This particular example is unusual, however, for the survival of its cover. It is also quite exceptional in its subtle sense of line and the restrained balance between plain and decorated surfaces. The maker's mark was identified in 1918 by Dr. R. F. Burckhardt, then director of the Historisches Museum, Basel, according to whom this was the only known work by that maker.

The myth of the wildman was popular during the Middle Ages, especially in the southern German-speaking lands. Originally a symbol of the antithesis of civilization, by the end of the Middle Ages it had come to stand more for strength, closeness to nature, and freedom from the moral turpitude of the world (see Husband, p. 15 et seq.). The wildman is found on a number of pieces of late-fifteenth- and early-sixteenth-century silver, for example a beaker of about 1470 with Ingoldstadt marks in the Metropolitan Museum, New York (Husband, p. 178) and a pair of silver-gilt enamel ewers of about 1500 in the same museum (Husband, p. 182).

Provenance: Bernal Collection, Sale, Christie's, London, Mar. 5 seqq., 1855, lot 1421; George Webbe Dasent, D.C.L., Sale, Christie's, London, June 2, 1875, lot 124; included in Dell inventory, ca. 1910.
Exhibited: London, Goldsmiths' Hall, 1979, no. 10.
Literature: W. W. Watts, "Continental Silver in the Collection of Baron and Baroness Bruno Schröder," 1927, pp. 11 (ill.), 14; E. Alfred Jones, *Old Silver of Europe and America*, 1928, p. 332, pl. 95,2.

9

Cup

English, ca. 1546
Silver-gilt
HEIGHT: 6⅜ in. (16.3 cm.)
MARKS: London, 1546-47, maker's mark a head erased (Jackson, p. 96); marked on lip

On spreading foot with spool-shaped stem, a reeded rib and three lions' masks applied to the center of the stem; the plain bulbous bowl with a band of moresque foliage engraved around the flared lip, with a reeded rib applied to the junction of bowl and lip.

Among the extremely limited corpus of English secular plate surviving from before the reign of Elizabeth I the present cup would appear to be unique. Its form apparently unites the standing mazer of the late fifteenth century with that of the so-called font-shaped cup of the early sixteenth. It is also among the earliest surviving pieces decorated with the moresque foliage clearly derived from sources such as Holbein's

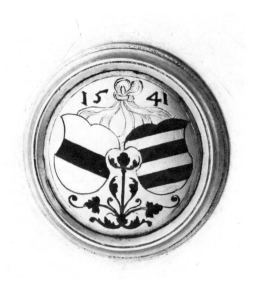

Cat. no. 8

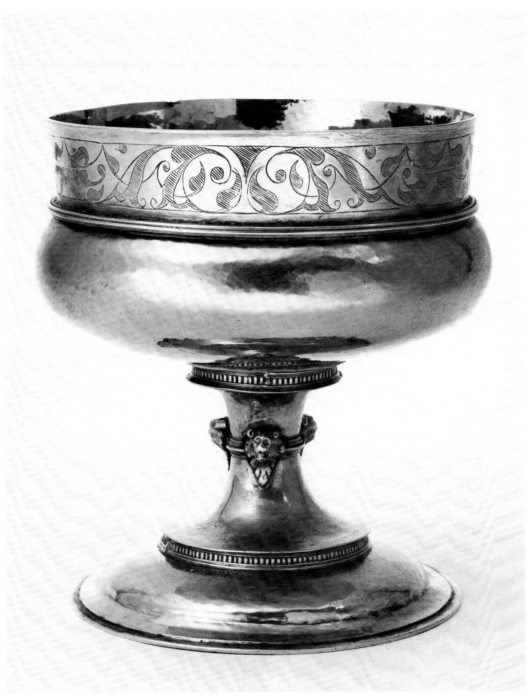

Cat. no. 9

design of 1535 for Jane Seymour's cup in the Ashmolean Museum, Oxford (Hayward, 1976, p. 341, pl. 41). A standing cup and cover presented by Archbishop Parker to Gonville and Caius College, Cambridge, in about 1570 and dated by Charles Oman to about 1540 (1978, fig. 25) has a similar band of engraved foliage around the bowl. Its maker's mark, "a Moor's head," is possibly identical with that on this cup.

From the point of view of its hallmarks, the cup is of interest in that it bears the rare mark of the lion passant guardant crowned, which was in use only from 1544 to 1550, after which the lion is shown uncrowned. According to the exhibition catalogue *Touching Gold and Silver,* "It is believed to have been [introduced] as a result of King Henry VIII's progressive debasement of the currency begun in 1542 and the need to reassure the public that the standard for plate had not been similarly lowered, and that it was struck in defiance of the King" (p. 16).

Provenance: George Webbe Dasent, D.C.L., Sale, Christie's, London, June 2, 1875, lot 130; included in Dell inventory, ca. 1910.
Exhibited: London, 25 Park Lane, 1929, no. 82; London, Goldsmiths' Hall, 1979, no. 56.
Literature: W. W. Watts, "English Silver...in the Collection of Baron and Baroness Bruno Schröder," 1927, pp. 245 (ill.), 248.

raised cover similarly chased to the foot, with snail finial above a basket and with further projecting heads.

There is a marked "family likeness" between the form and decoration of this unusual cup and a group discussed by Kohlhaussen (pp. 471-82 and passim) and attributed by him to the collaboration of Peter Flötner (ca. 1485-1546) and the goldsmiths Melchior Baier the Elder of Nuremberg and an unidentified master with initials ME. Particularly close in decorative repertoire is the so-called Lucretia Cup in the National Museum, Copenhagen (Kohlhaussen, figs. 691-696). The use on the latter of chased friezes of putti and scrolling foliage, engraved oval plaques set into the sides, and engraved foliage on the border of the cover, with further chased putti within, exactly parallels this cup. Comparable use of projecting busts within laurel wreaths appears on the stem of a tazza of 1541 by Baier, in the Residenz Museum at Munich (Kohlhaussen, figs. 663, 664). Again, the sculptural style of the Three Graces on the stem is closely related to those on the stem of a further Flötner-Baier piece, the Holzschuher Cup in the Germanisches Nationalmuseum, Nuremberg (Kohlhaussen, figs. 677-681).

10

Cup and Cover

South German, probably Nuremberg, ca. 1550
Silver-gilt
HEIGHT: 12¼ in. (31.2 cm.)
MARKS: (?) Chur (Switzerland), maker's mark a rampant animal; marked on foot

The stem formed as the Three Graces around a tree, on circular molded base with applied brackets and a band of chased foliage and masks within laurel wreaths; the bowl chased with foliage and with three projecting busts within chased wreaths on the bulbous lower part, engraved above with arabesque foliage and inset with three oval plaques, with flared lip; the

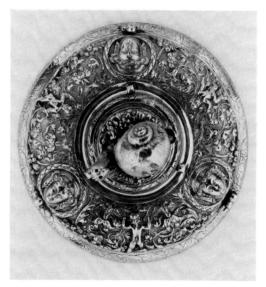

Cat. no. 10

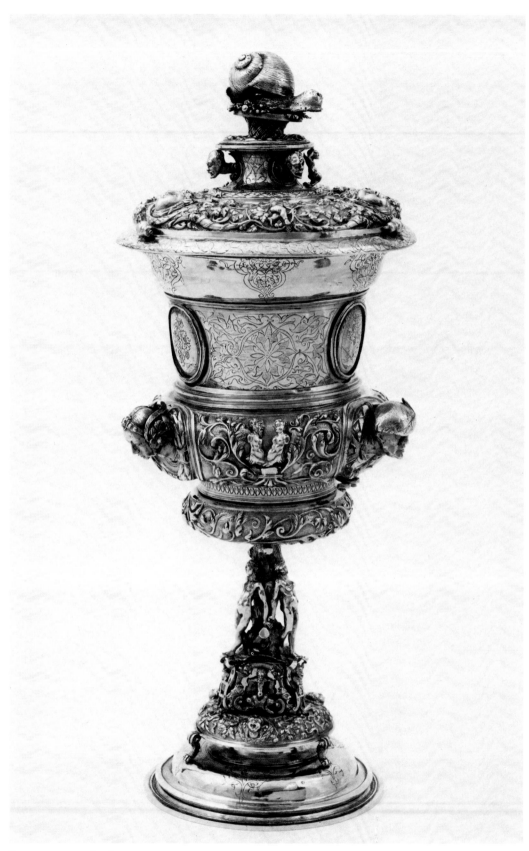

Cat. no. 10, see colorplate p. 54

Other parts of the design also associate this cup with Nuremberg. First, some details of the decoration are taken from printed ornament by the Nuremberg master Virgil Solis. In particular, the plinth of the stem is adapted from part of a design for a chased or engraved border and the chasing on the cover relates to friezes by the same master.

Allusions to the bronze shrine over the sarcophagus of St. Sebald in the Sebalduskirche in Nuremberg (Von der Osten, pl. 11) can also be recognized in the cup. This was carried out by Peter Vischer the Elder and the Younger between 1508 and 1519 and is one of the most important monuments of a period that witnessed the transition in Southern Germany from the Gothic to the Renaissance style. The shrine is characterized by an extraordinary mixture of these styles and some of the more bizarre features of the cup seem to be inspired by it, including the snail finial and the curious fauns that support it.

The identification of the hallmark is tentative but, if correct, probably indicates that the cup was marked after its arrival in Chur. It is extremely unlikely that so sophisticated an object would have been made in a provincial town. Not only the overall style and range of decoration, but also the closeness in quality of chasing and engraving that exists between these various pieces suggest that it was the product of a workshop at least associated with those mentioned above.

Provenance: Unknown.
Exhibited: London, Goldsmiths' Hall, 1979, no. 11.
Literature: W. W. Watts, "Continental Silver in the Collection of Baron and Baroness Bruno Schröder," 1927, pp. 90, 92 (ill.).

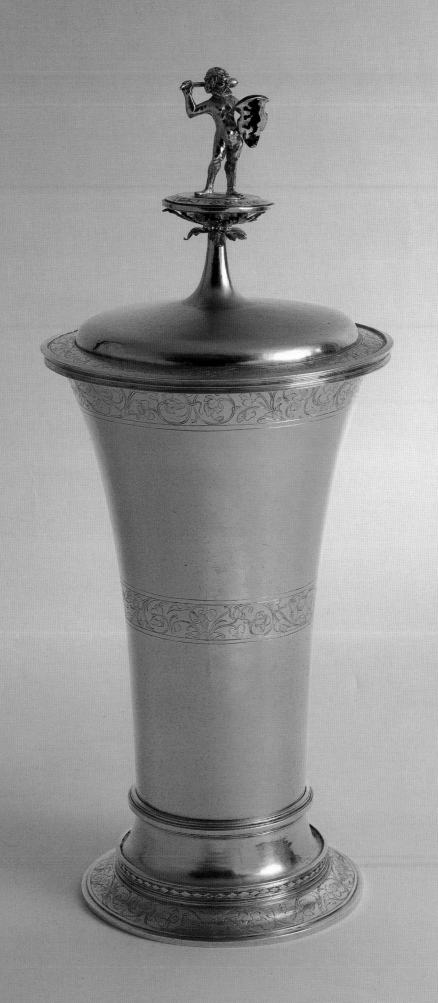

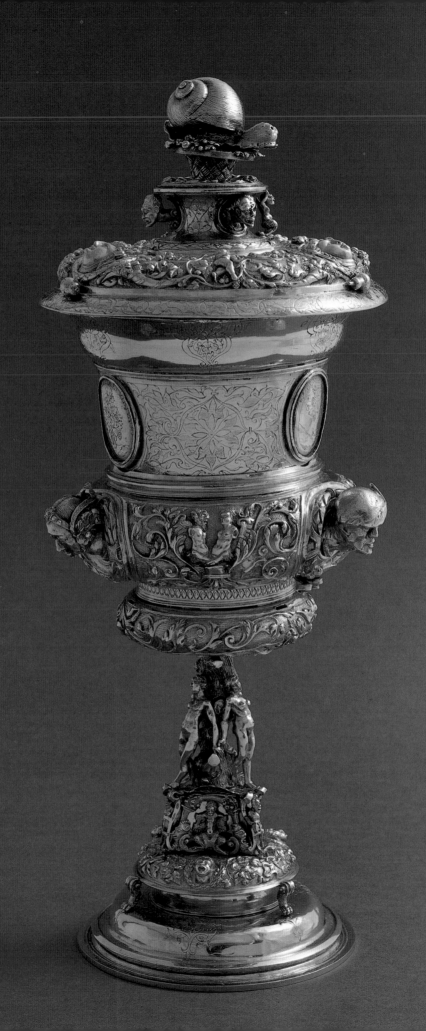

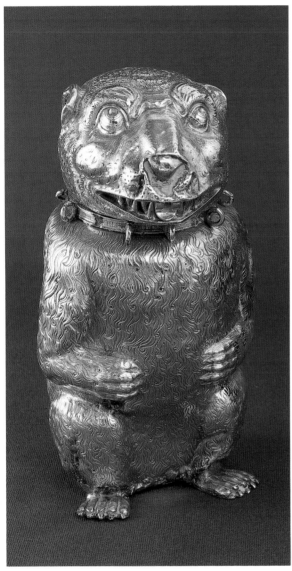

Cat. no. 28

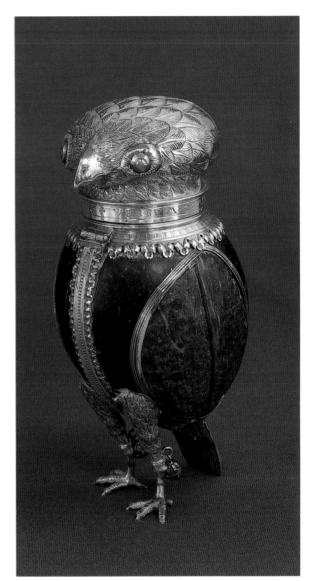

Cat. no. 11

Cat. no. 10

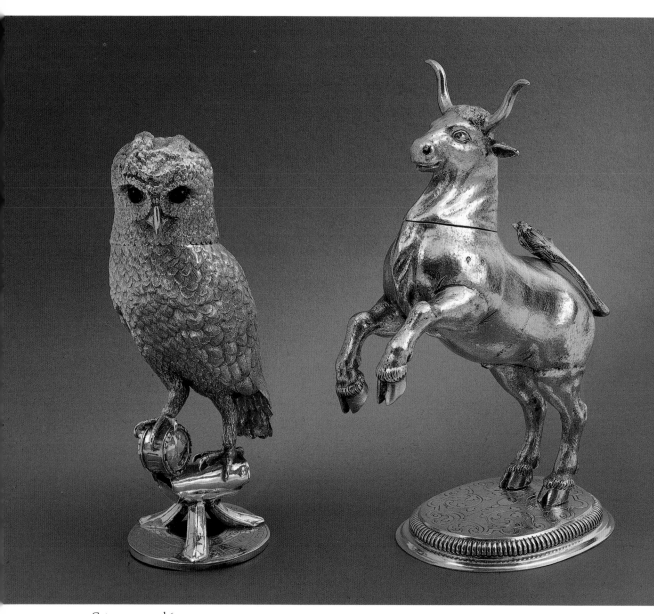

Cat. nos. 12 and 61

11

Cup in the Form of an Owl

South German or Swiss, dated 1556
Silver, parcel-gilt, and coconut shell
HEIGHT: 6½ in. (16.5 cm.)
MARKS: None

The body of polished coconut, with unpolished wings within reeded silver surrounds, resting on its feet and tail feathers, and with bells attached to the feet; the detachable head chased with plumage and engraved around the collar with an inscription; a further inscription engraved around the lip.

Among the various zoomorphic drinking vessels made in the German-speaking lands during the sixteenth and seventeenth centuries, the inscriptions frequently found on those in the form of owls distinguish them as a separate group. In an article on the subject, Karl-August Wirth argues that the form and inscriptions were connected first with a series of legends associated with the owl and secondly with the circumstances in which they were frequently presented (pp. 43-50). The owl was variously considered as a symbol of wisdom, temptation, and greed and these attributes are often alluded to in the inscriptions connected with drinking. Other legends, dating back at least to the time of Aristotle (see Cat. no. 12) and presumably associated with the nocturnal habits of owls, tell of the owl being hated and frequently attacked by other birds. By the fourteenth century it was widely regarded as a portender of evil, as, for example, in Chaucer's *Legend of Good Women*, ca. 1385, "The oule...that prophete is of wo and of myschaunce." Wirth cites a reference in a document dated 1568 to an owl cup being presented as first prize at the Emperor's shooting competition (p. 43) and suggests that, since owls are known to have had bells tied to them and to have been used as decoys to attract other birds at hunts, it is likely that such cups embellished with bells were originally used as trophies of this kind (p. 46).

This particular cup is one of a group discussed by Wirth, all of which bear the same date, 1556, and apparently the same inscriptions, VERBVM DOMINI MANET IN AETERNVM and ALS ALE FOEGELEN SIN TENIST SO IST MIN FLEGEN ANT ALER BIST. The Latin inscription is taken from Isaiah (40:8), "...the word of our God shall stand for ever." The other is rather cryptic, but by reference to a longer inscription on a similar cup in the Gemeentemuseum, Nijmegen, Wirth suggests that it should be rendered, "When all other flying creatures are in their nests, my flight is best of all." Most of the other cups in this group, including one in the Rhode Island School of Design (*Virtuoso Craftsman*, no. 89), are either unmarked or bear unidentified marks, but the example in the Focke-Museum, Bremen, is struck with a town mark similar to that of Wesel.

Provenance: Purchased from Crichton Brothers, London, 1925.
Exhibited: London, Goldsmiths' Hall, 1979, no. 14; London, Goldsmiths' Hall, 1983, no. 21.
Literature: W. W. Watts, "Continental Silver in the Collection of Baron and Baroness Bruno Schröder," 1927, pp. 3 (ill.), 6; K.-A. Wirth, "Von Silbernen und Silbermontierten Eulangefässen," 1968, pp. 50, 78 (no. K 14a), fig. 71.

12

Cup in the Form of an Owl

Probably Flemish, mid-sixteenth century
Silver
HEIGHT: 8⅛ in. (22.6 cm.)
MARKS: (?) Ghent, (?) 1557 (Rosenberg, 1922-28, no. 5273), maker's mark a geometric figure (Rosenberg, no. 5283); marked under base and on lip

Perched on a whistle and supported by a faceted tripod with ring base; chased and engraved with plumage on the body and detachable head, and with inset glass eyes; the lip engraved with Latin quotations from Aristotle and verses from Ecclesiasticus (Old Testament Apocrypha), chapter 31. The eyes are later restorations.

The Aristotelian quotations are taken from *Historia Animalium* 8. 3. 39 and may be translated, "Other birds fly around the owl and pluck at its feathers" and "Many animals hate the owl." The lines from Ecclesiasticus are a contracted version of chapter 31:27-29 and relate to

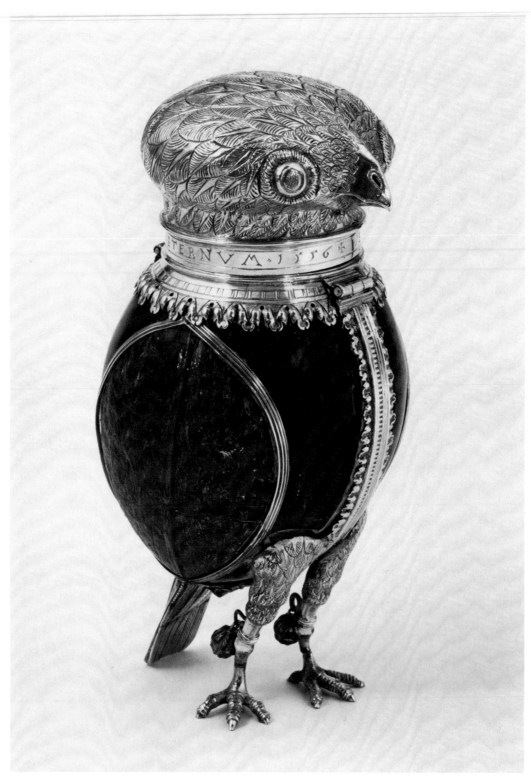

Cat. no. 11, see colorplate p. 55

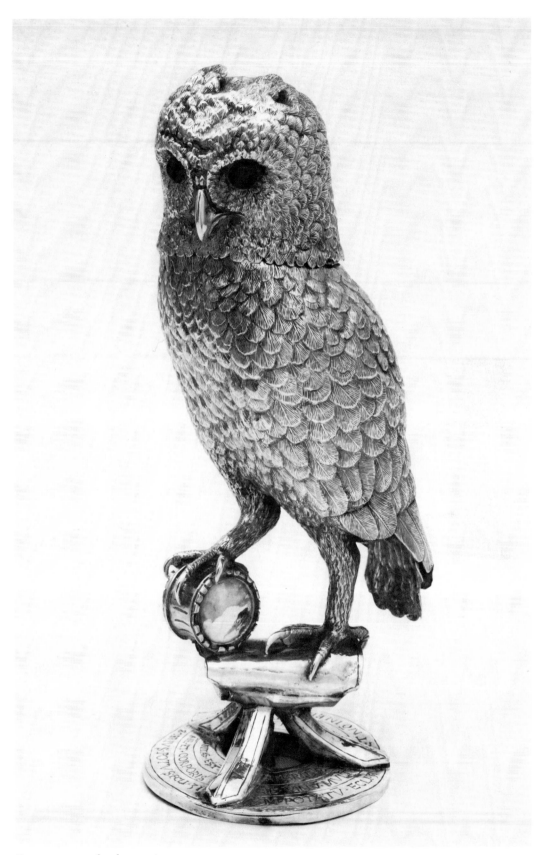

Cat. no. 12, see colorplate p. 56

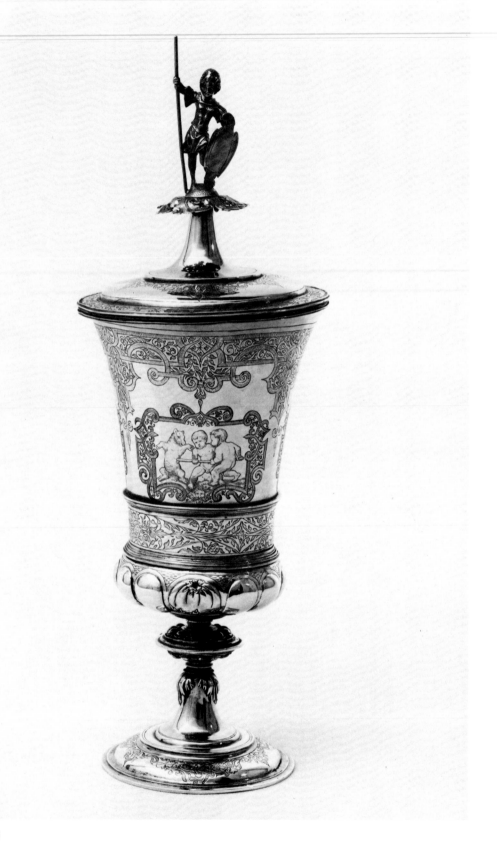

Cat. no. 13

the wisdom of drinking in moderation and the dangers of over-indulgence.

A number of other owl cups similar to this, and also with whistles, are recorded. A very similar one, although on a differing base, is in the Dortmund Museum at Cappenberg Castle (Hernmarck, fig. 191), while another was formerly in the Lamon Collection (sold at Christie's, London, Nov. 28, 1973, lot 54, cat. ill.). Karl-August Wirth lists two others bearing the same marks as this (p. 69). The identification of the date-letter was suggested by Rosenberg, who saw the cup in 1924. In a letter of 1925 to Baroness Emma Schröder, he admitted that it might also be for 1582, but the style of the lettering does seem to support the earlier date. Although he ascribed the piece to Ghent, the town mark more closely resembles that of Courtrai, which is only a few miles from Ghent.

Provenance: Earl of Home, Sale, Christie's, London, June 17, 1919, no. 58.
Exhibited: London, Goldsmiths' Hall, 1979, no. 15.
Literature: M. Rosenberg, *Der Goldschmiede Merkzeichen*, 1922-28, no. 5283; K.-A. Wirth, "Von Silbernen und Silbermontierten Eulengefässen," 1968, pp. 47-48, 69 (no. S 40), fig. 48.

13

Cup and Cover

South German, mid-sixteenth century
Silver, parcel-gilt
HEIGHT: 12 in. (30.3 cm.)
MARKS: (?) Landshutt, maker's mark a merchant's mark (Rosenberg, 1922-28, no. 2979)

The body of beaker form, embossed at the base with gadroons and engraved above with arabesques and cartouches containing putti hunting; on stepped ogee foot engraved with further arabesques, and with compressed spherical knop; the cover similar to the foot and with finial formed as a warrior holding a shield and spear. Some restorations; the cartouches were engraved on the bowl at a later date and the spear of the finial is a modern replacement.

Certain aspects of the design of this cup relate quite closely to designs published by Hans Brösamer in *Ein New Kunstbuchlein* around 1548. This is particularly true of the treatment

of the knop which is almost identical with that of the Boleyn Cup in Cirencester Church, Gloucestershire (Oman, 1978, fig. 24) and which is taken directly from one of the Brösamer designs. The latter bears London hallmarks for 1536-37.

Provenance: H. P. Mitchell (?); Wyndham Francis Cook, Esq.; Humphrey W. Cook, Esq., Sale, Christie's, London, July 9, 1925, lot 334.
Exhibited: London, Goldsmiths' Hall, 1979, no. 16.
Literature: Catalogue of the Wyndham Francis Cook Collection, vol. 1, 1904, no. 270; M. Rosenberg, *Der Goldschmiede Merkzeichen*, 1922-28, no. 2979.

14

Cup

Flemish or English, dated 1564
Silver and coconut shell
HEIGHT: 7¼ in. (18.7 cm.)
MARKS: None

On domed foot chased with masks, putti, and foliage, with partly fluted vase-shaped stem with openwork brackets applied to the upper part; the nut carved with the biblical subjects of the drunkenness of Noah, Lot and his daughters, and Judith and Holofernes; with three vertical demi-figure straps and flared lip engraved with arabesques. The silver lining to the bowl is a later addition.

Its qualities of shape, imperviousness, and capacity for taking a high polish or being carved made coconut shell a very suitable material for mounted cups. Its popularity during the sixteenth century should also be attributed in part to the general preoccupation of the period with "exotic" materials. Examples are known from the fifteenth century and its fashionableness is indicated by its frequent appearance in designs and pattern books (for example, Hans Brösamer, *Ein New Kunstbuchlein*, ca. 1548). This cup is typical, especially in the carving of the nut, of those produced in the Low Countries during the third quarter of the sixteenth century. One also carved with the same episode from the story of Noah and bearing Antwerp marks for 1560-61 is in a private collection in London (Hayward, 1976, pl. 598). But while carved nuts are less common among English coconut cups, the general proportions of

this cup and some features of the mounts, such as the straps to the bowl, are more suggestive of England than the Continent. Given the very close links between England and Flanders at the time and the considerable number of foreign goldsmiths working in London, certain attribution is very difficult in the absence of hallmarks.

Provenance: Probably purchased from S. J. Phillips, 1906; included in Dell inventory, ca. 1910.
Exhibited: London, Goldsmiths' Hall, 1979, no. 17.
Literature: W. W. Watts, "Continental Silver in the Collection of Baron and Baroness Bruno Schröder," 1927, pp. 4 (ill.), 6-7.

15

Communion Cup and Paten

English, ca. 1568
Silver
HEIGHT: 6 in. (15.3 cm.)
MARKS: London, 1568-69, maker's mark possibly a snail (Jackson, p. 103); marked on lip and inside paten

The conical bowl engraved with a band of strapwork and moresques; on raised spreading foot and with spool-shaped stem and plain knop; the raised cover reversible to form the paten, similarly engraved and with flat-topped spool-shaped finial.

This is a standard example of by far the commonest category of surviving sixteenth-century English plate apart from spoons. The form is due entirely to the Reformation in England and the liturgical consequences of it. Under the Roman practice, the chalice was restricted to the celebrant priest, communion being taken only in one kind by the congregation. In 1548, however, the cup was restored to the laity and again in 1559 at the accession of Elizabeth. This meant that in most cases the bowl of the chalice was inconveniently small, and steps were taken after both these dates (although halted during the reign of Mary when

Cat. no. 14

Cat. no. 14

Cat. no. 14

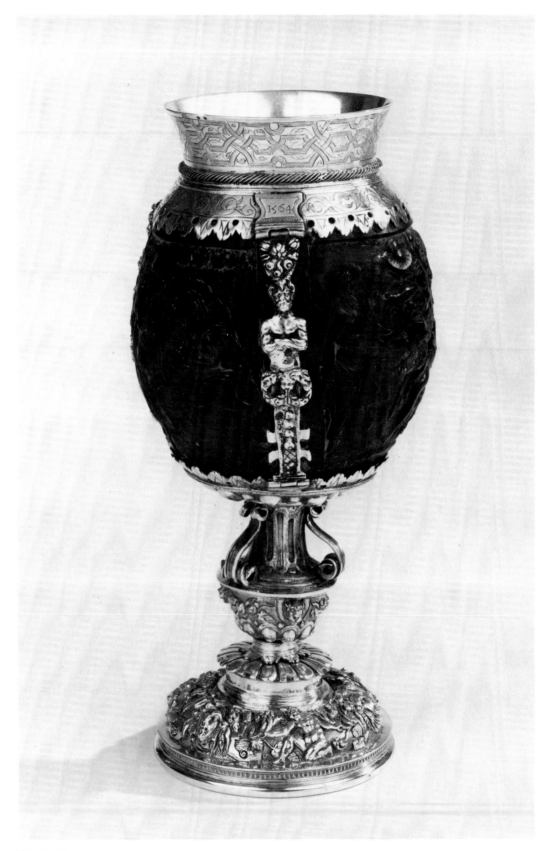

Cat. no. 14

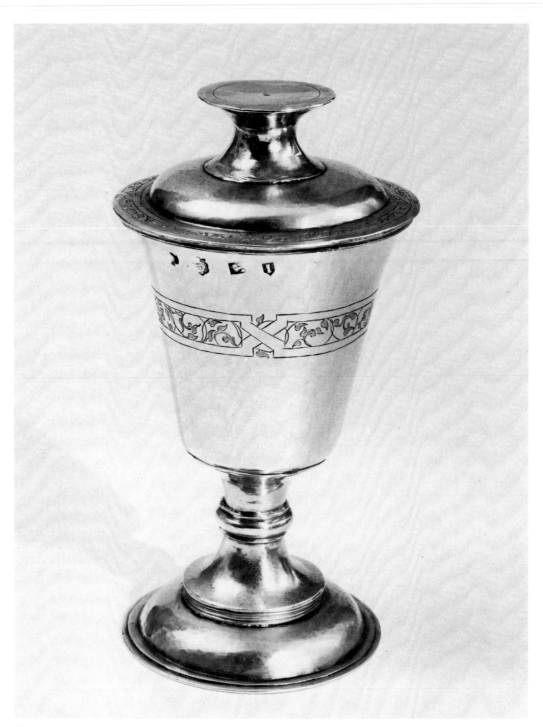

Cat. no. 15

the country returned to Catholicism) to convert the chalices into vessels of larger capacity. In both instances the intention seems to have been less theological than practical and political: to produce a cup not only better suited to the new liturgy, but also quite distinct in form from those of the old order.

Only eighteen communion cups from the reign of Edward VI (1547-52) are recorded and the conversion of the old chalices only began in earnest after Archbishop Parker and Bishop Grindal acceded to Canterbury and London in 1559. Grindal's elevation to York in 1571 inaugurated a similar, though less successful campaign in the northern province. No document relating to the compulsory conversion of chalices into communion cups is known to exist before 1565, but clearly some sort of agreed policy was operating, since the conversion program was conducted in an organized manner, dealing with groups of dioceses at a time. During the period when this cup was made, attention was concentrated on the dioceses of Chichester, Winchester, Lincoln, Ely, and Peterborough.

Some 2,000 Elizabethan communion cups survive, mostly dating from the late 1560s and 1570s. The majority were made by London goldsmiths, although the goldsmiths of Exeter were active in supplying local parishes, while the order to convert the chalices of the diocese of Norwich led directly to the establishment of the assay office there in 1564. By 1578 the campaign was over.

The earliest cups display a certain variety of design, but by the late 1560s a successful formula had been evolved and those made in London became increasingly uniform. Most were made from the metal of the old chalices and the comparative simplicity of the standard design was conditioned chiefly by the need to minimize the cost of labor while producing a bowl of maximum capacity. This militated against elaborate decoration and the use of cast parts, which were extravagant in metal.

Provenance: Unknown; included in Dell inventory, ca. 1910.
Exhibited: London, Goldsmiths' Hall, 1979, no. 58.

16

Tazza

Probably Italian, ca. 1550/60
Silver-gilt
HEIGHT: 17 in. (43.2 cm.)
DIAMETER: 15 in. (38 cm.)
MARKS: None

On spreading foot of ogee form, and with vase-shaped stem chased with broad bands of flutes; the dish repoussé and chased with four scenes from the life of the Emperor Galba divided by tapering fluted columns, with a border of imbricated disks and the figure of the Emperor Caligula in the center on a fluted plinth; the underneath of the dish pricked with a coat of arms.

The arms are those of Cardinal Ippolito Aldobrandini, born at Fano (Italy) in 1536, who took the name of Clement VIII when elected to the Papacy in 1592. He died in 1605 after an energetic pontificate, during which he edited the Vulgate and re-edited the Index.

This is one of a service of twelve tazzas which collectively have been described as "the most impressive single monument of Italian and perhaps European goldsmiths' work of the sixteenth century" (Hayward, 1976, p. 165). Each

is chased with four scenes from the life of a Roman Emperor. The scenes are taken from Suetonius' *The Twelve Caesars*; in this case they represent the following incidents from the life of Galba: (a) "One day, as Galba's grandfather was invoking sacrificial lightning, an eagle suddenly snatched the victim's intestines out of his hands and carried them off to an oak-tree laden with acorns. A bystander suggested that this sign portended great honour for the family." (b) "While living at Fundi, he was offered the governorship of Tarraconesian Spain; where, soon after his arrival, as he sacrificed in a temple, the incense-carrying acolyte

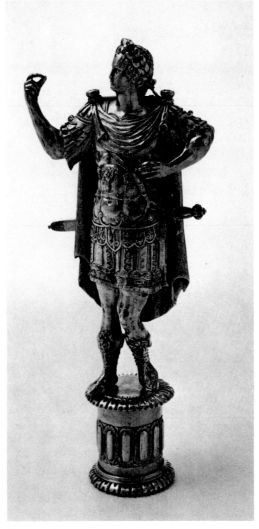

Cat. no. 16

Cat. no. 16

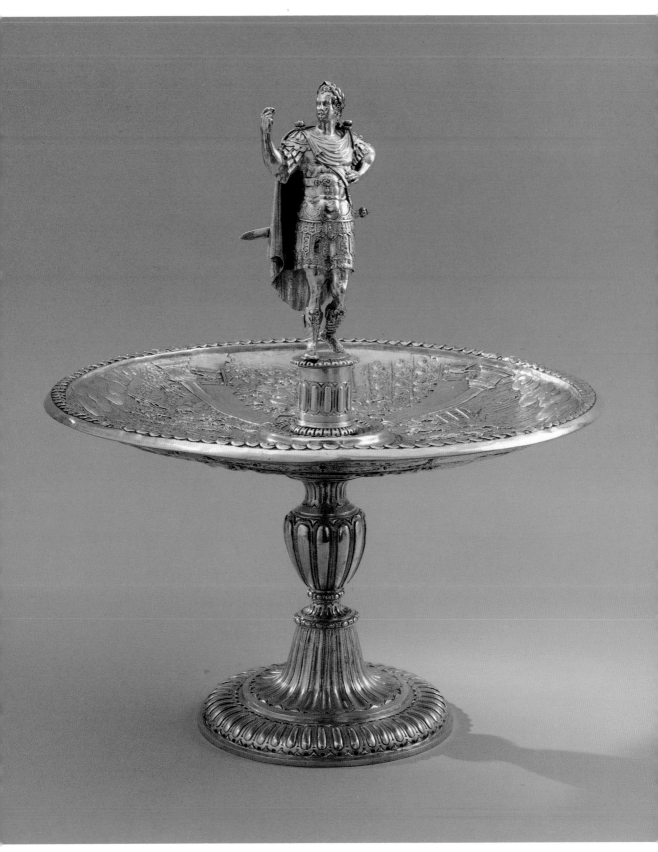

Cat. no. 16

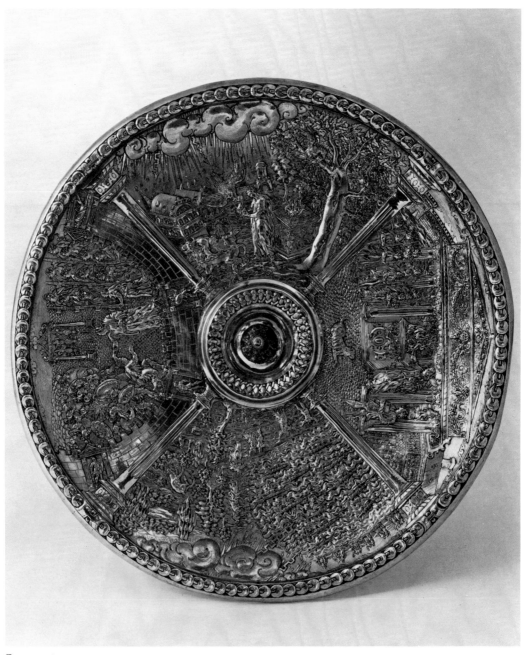

Cat. no. 16

went white-haired before his eyes.... And presently, when a thunderbolt struck a lake in Cantabria, twelve axes, unmistakable emblems of high authority, were recovered from it." (c) "Galba heard about [the discontent of the Roman troops in Germany] and, thinking he was being criticized for his childlessness rather than his senility, singled out from the crowd at one of his morning receptions a handsome and well-bred young man, Piso Frugi Lucianus, to whom he had already shown great favour, and appointed him perpetual heir to his name and property. Calling him 'my son,' he led Piso into the Guards' camp, and there formally and publicly adopted him." (d) "Galba had set aside from his treasure a pearl-mounted collar and certain other jewels, which were to decorate the Goddess Fortuna's shrine at Tusculum. But, impulsively deciding that they were too good for her, he consecrated them to Capitoline Venus instead" (Graves, pp. 249, 251, 256).

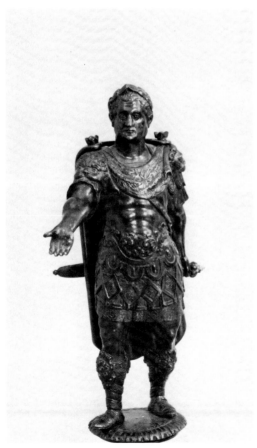

Galba. 18th-century bronze casting.

The service remained intact until its sale in 1861, some time after which it was split up. Six of the twelve tazzas were acquired by the Parisian art dealer Frédéric Spitzer. A controversy later developed around them, since it was noticed that the feet and stems were not all alike. Some had the simple fluted foot and stem of this example, while others – those which had passed through Spitzer's hands – had very much more elaborately designed feet and stems. The immediate assumption was that the latter were in their original state, while those with the simpler feet had been modified; however, it is now generally accepted that the reverse is true (Hayward, 1970). Quite apart from Spitzer's reputation for "improving" works of art, three factors put it beyond dispute that his were the altered ones. First, all those, and only those, with elaborate feet had belonged to Spitzer; the others had been dispersed. Secondly, the very full description in Christie's 1861 sale catalogue makes no reference to any discrepancy, but describes them all as having "the stems and feet fluted." Thirdly, various alterations to the junctions of the stem and dish are evident on the suspect tazzas.

Unfortunately, a further but less serious muddle has affected those not owned by Spitzer. Most of the bowls and figures have been wrongly assembled and have yet to be correctly reunited. The Caligula bowl, now in the Minneapolis Institute of Arts, to which this figure belongs, is surmounted by Augustus; the present location of the Galba figure is unknown.

The questions of the precise date and origin of the service are far from settled. The positions of the coat of arms suggest that they were an afterthought, since they are fitted into various places on the dishes where space allowed and clearly were not part of the original scheme. They cannot, therefore, in themselves be taken as grounds for supposing that Aldobrandini was the original owner of the service; if anything, they imply the reverse. Nor is it true, as has been suggested, that the manner in which the arms are depicted necessarily means that he must have owned them before 1585, when he became a cardinal. They are surmounted by an ecclesiastical hat with six tassels to each side. Normally a cardinal's hat was shown with twice this number, but there is some evidence of flexibility in heraldic convention at this date.

For example, a pair of early-sixteenth-century candle snuffers in the British Museum, which bears the arms of Cardinal Bainbridge, Archbishop of York, displays the arms with a hat similar to Aldobrandini's.

The internationalism of goldsmiths' work of the period makes a positive attribution to one center rather than another extremely difficult. Nevertheless, a number of attempts to establish the origin of the service have been made. Yvonne Hackenbroch (p. 192), suggested Augsburg, partly on the grounds of the chased pine cone in the decoration of one of the bowls which is similar to the emblem of that city. But the pine cone was widely assumed to be a symbol of Imperial Rome and had probably been adopted by Augsburg for that reason. Hayward rejects this attribution, since "they show no similarity to German tazzas of the same period.... All [the] German examples were made in Augsburg and conform to a single type...quite different in proportion and form from the Aldobrandini set" (1976, p. 165). He himself prefers an Italian attribution, while allowing the possibility of the chasing being by an itinerant German craftsman (1976, pp. 371-72).

A number of factors support this. First we know the service to have been in Italy by an early date; secondly, the restrained horizontal emphasis of the design as a whole and the relatively plain treatment of the foot and stem are quite unlike Northern work of the period. Thirdly, the costumes of the emperors are full of very carefully observed detail (although it must be admitted that this is far from archaeo-

Cat. no. 16

Cat. no. 16

70

logical). But none of these considerations is conclusive and the difficulty is increased by the fact that almost no Italian secular silver from the sixteenth century survives with which to make comparisons. Moreover, an attribution to Italy must be set against the character of the chasing itself and the relationship between the chasing and the overall design.

One of the most impressive features of the tazzas is the very marked unity of the design as a whole. To treat the tazzas and the chased scenes separately is to miss the importance of the numerous correspondences between details of the scenes, the costumes of the emperors, and the decoration of the bases, stems, and borders of the dishes. These include the capitals of the columns separating the scenes, which reflect the cylindrical plinths in the center, and, for example, the imbricated lobes on the skirts of Vespasian's costume, which echo the borders of the dishes. Once having accepted the unity of the design, it is impossible to ignore the style of the chased scenes. Both their naive perspective and the "incorrectly" drawn columns separating them suggest an unfamiliarity with the finer points of Italian theory, which would be inconsistent with such sophisticated draughtsmanship unless the designer were a foreigner. Moreover, certain architectural and decorative details point away from Italy, in particular, the two altars in the sacrificial scenes, both of which are decorated with strapwork of a distinctly Northern, non-Italian type.

Parallels for the chasing are hard to find, but perhaps the closest is a basin in the Louvre which bears Antwerp marks for 1558 (Hernmarck, figs. 605, 606). This depicts the campaign of Emperor Charles V against Tunis in 1535 and shows the same characteristics as the Aldobrandini set: fine detail expressed in low relief and a curious tendency to "project" the perspective to fit the shape of the surface available. Moreover, the border of the basin corresponds very closely to the capitals of the dividing columns and the emperor's plinth on the tazzas.

In conclusion, the unity of form and decoration suggests that the craftsmen who made the tazzas were working to a single and minutely finished design. This design is conditioned more by Northern conventions of decoration than Italian. The complete absence of Mannerist ornament and the predominant horizontality both argue for a date rather earlier than has normally been accepted and indicate a date of around 1550/60, rather than 1580. The shape of the foot and stem are untypical of northern Europe and suggest that the service was commissioned in Italy, probably under the supervision of a Flemish goldsmith and as a result of detailed discussions between patron and artist.

Provenance: Ippolito Aldobrandini (Clement VIII); Prince Giovanni Battista Pamphili, inventory of 1710; Charles Scarisbrick, Esq., Sale, Christie's, London, May 15, 1861, lot 159 (part); Anonymous, Sale, Christie's, London, June 22, 1960, lot 102.
Exhibited: London, Goldsmiths' Hall, 1979, no. 26.
Literature: Y. Hackenbroch, "The Emperor Tazzas," 1950, pp. 189-97; J. F. Hayward, "The Aldobrandini Tazzas," 1970, pp. 669-74; J. F. Hayward, *Virtuoso Goldsmiths*, 1976, pp. 46, 165, 371, pls. 363, 365; C. Hernmarck, *Art of the European Silversmith*, 1977, pp. 126-27, fig. 234; David R. McFadden, "An Aldobrandini Tazza: A Preliminary Study," 1976-77, pp. 44, 51.

17

Cup and Cover

Probably Flemish, ca. 1570
Silver-gilt, bone, and enamel
HEIGHT: 17⅞ in. (45.5 cm.)
MARKS: None

On circular foot repoussé and chased with marine subjects, with gadrooned vase-shaped stem with applied brackets; the bowl chased with floral sprays, and with applied lions' masks, six panels of bone inset above with demi-figure straps between, and with flared lip; the domed cover chased with various figures and with lions' masks and strapwork, and the finial formed as a unicorn holding a shield engraved with a coat of arms dated 1597, the underneath of the foot engraved with a bust.

The arms are probably those of Wierman of Franconia.

Unicorn horn, which the panels of bone were believed to be, was a much valued material owing to the various properties attributed to it. According to a bestiary published by Konrad Gesner in 1563, the "genuine unicorn is good

against all poison.... This horn is useful and beneficial against epilepsy, pestilent fever, rabies, proliferation and infection of other animals and vermin, and against the worms inside the body from which children faint" (Beer, pp. 115-16). It was also held to be an aphrodisiac. But in addition to the supposed medicinal properties of the horn, a number of myths, not all of which are mutually compatible, developed around the beast during the Middle Ages and it is to these that the problematic decorative program on the cover relates.

Beer (pp. 98-104 and passim) describes a number of these traditions. One associates the unicorn with the Five Senses and is the key to a series of tapestries of about 1500 in the Musée Cluny in Paris (Beer, pls. 91-96). Another was the myth of the Celestial Hunt of the Unicorn, through which the beast became symbolic of the Annunciation and Salvation; and a third, which took a rather different view of the Celestial Hunt and treated the unicorn as a symbol of eroticism and lust.

At least two of the figures on the cover hold attributes – the horn and the apple – that are frequently associated with two of the senses, namely hearing and taste. It may be, therefore, that the five figures are intended on one level as personifications of the senses, especially since their iconography was not standardized in the sixteenth century. But there also seem to be

Cat. no. 17

Cat. no. 17

references to the other traditions. According to the story of the Celestial Hunt, the unicorn could only be approached by means of a virgin "decoy," whose purity he sensed and was attracted to. In some accounts, the object of the Hunt is not so much to capture the unicorn as to drive him to the virgin. The connection of this theme with the Annunciation and Conception is illustrated in another fifteenth-century tapestry, in which the angel of the Annunciation is shown kneeling before the Virgin Mary and blowing a horn, while the unicorn leaps toward her breast and the Christ Child and

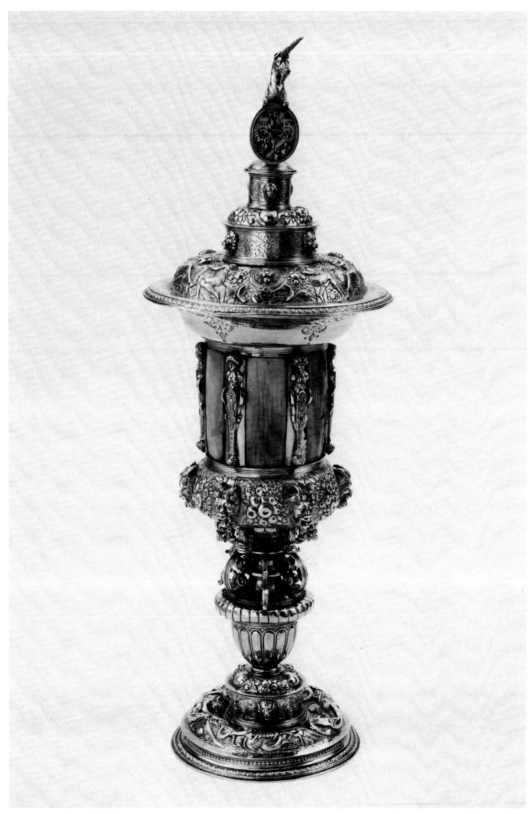

Cat. no. 17, see colorplate p. 78

Holy Spirit descend simultaneously from heaven (Beer, pl. 72). Two of the figures on the cover, with a vase of lilies between them, probably also represent the Annunciation. The erotic associations referred to above are alluded to in the fauns' masks applied to the cup.

The cup entered the collection without a cover, but is described with one in the catalogue of the 1862 exhibition at South Kensington. The cover was evidently wrongly associated with another cup while still in the Gustave de Rothschild Collection. It now belongs to the Victoria and Albert Museum, London, to which it came as part of the Hildburgh bequest during the 1950s. We are grateful to the Museum for enabling the cup and cover to be re-united for this exhibition.

Provenance: F. Davis, Esq.; Baron Gustave de Rothschild; Sir Phillip Sassoon, Bart. and the Countess of Rocksavage, Sale, Christie's, London, Nov. 26, 1919, lot 88.
Exhibited: London, South Kensington Museum, 1862, no. 6309, lent by F. Davis, Esq.; London, Goldsmiths' Hall, 1979, no. 19; London, Goldsmiths' Hall, 1983, no. 35.
Literature: W. W. Watts, "Continental Silver in the Collection of Baron and Baroness Bruno Schröder," 1927, pp. 10, 13 (ill.).

Cat. no. 17

18

Cup and Cover

South German, ca. 1575
Silver-gilt and enamel
HEIGHT: 17½ in. (44.6 cm.)
MARKS: Augsburg, maker's mark of Hierony-
mous Rayser (Seling, no. 736); marked under
foot

The bowl with a cylindrical sleeve with applied
personifications of Virtues within a chased ar-
chitectural framework and with applied oval
medallions of floral sprays in translucent
enamel, with a bulbous section below, repoussé
and chased with busts and foliage, and with
similar enameled plaques; the flared lip etched
with arabesques; on spreading foot and with
brackets applied to the baluster stem; the raised
cover similar to the lower part of the bowl and
with finial formed as David with the head of
Goliath.

In terms of range of techniques and standards of
craftsmanship, this is one of the most virtuoso
pieces in the collection. Almost the entire
technical repertoire is represented: casting,
chasing, engraving, etching, and enameling.
The Mannerist decorative principle of horror
vacui – a concern to fill all available surfaces
with ornament – has in this case been applied
with great discipline, with the bands of orna-
ment rigidly zoned within the horizontal di-
visions of the cup, so that the outline and
coherence of the design are not impaired.

Cat. no. 18

Cat. no. 18

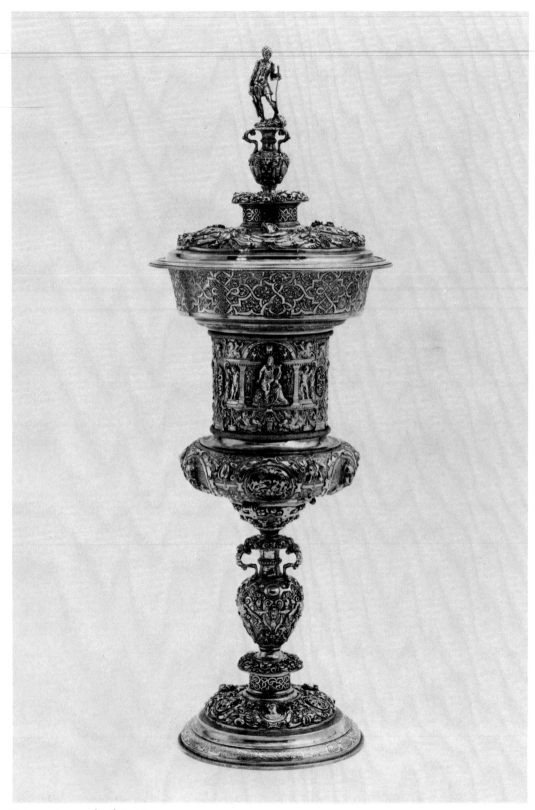

Cat. no. 18, see colorplate p. 79

The design makes full use of the various pattern books current at the time, especially the closely packed inhabited strapwork popularized by Virgil Solis. Likewise, the enamel plaques are either from, or in imitation of those produced in the workshop of David Altenstetter (see Cat. no. 37). As with many of the most imposing Mannerist cups of the period, the decorative "program" is didactic. The group of Virtues on the bowl (Faith, Hope, and Fortitude) is rather odd, two being Theological and one Cardinal. But taken together they may be seen as a commentary upon the charac-ter of the boy David of the finial. The cast figures are unlikely to have been made specifi-cally for this cup, however, and would probably have been made from models already available in the stock of the workshop.

Provenance: Baron Carl von Rothschild, Frankfurt; Victor Rothschild, Esq., Sale, Sotheby's, London, Apr. 27, 1937, lot 190.
Exhibited: London, Goldsmiths' Hall, 1979, no. 24; Augsburg, Rathaus, *Welt im Umbruch*, 1980, no. 704.
Literature: F. Luthmer, *Schatz Rothschild*, vol. 1, 1883, pl. 8; F. Luthmer, *Gold und Silber*, 1888, p. 122, fig. 120.

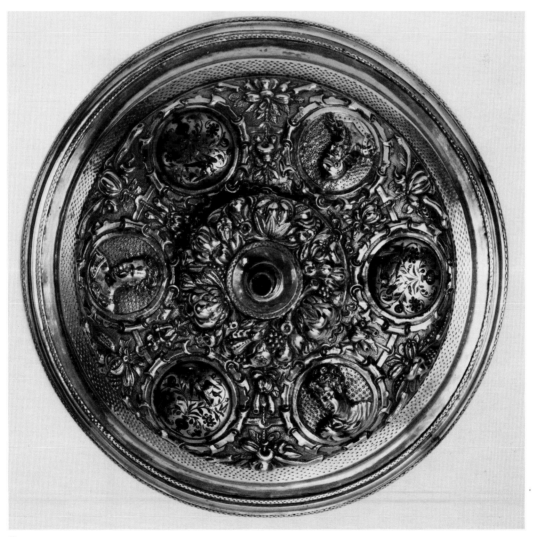

Cat. no. 18

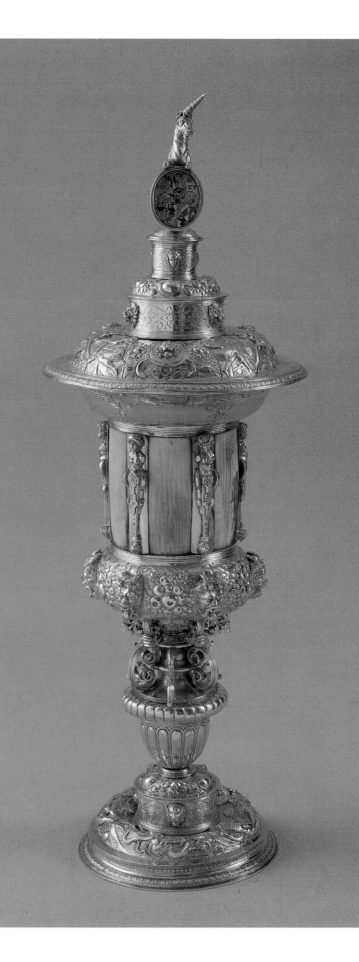

Cat. no. 17

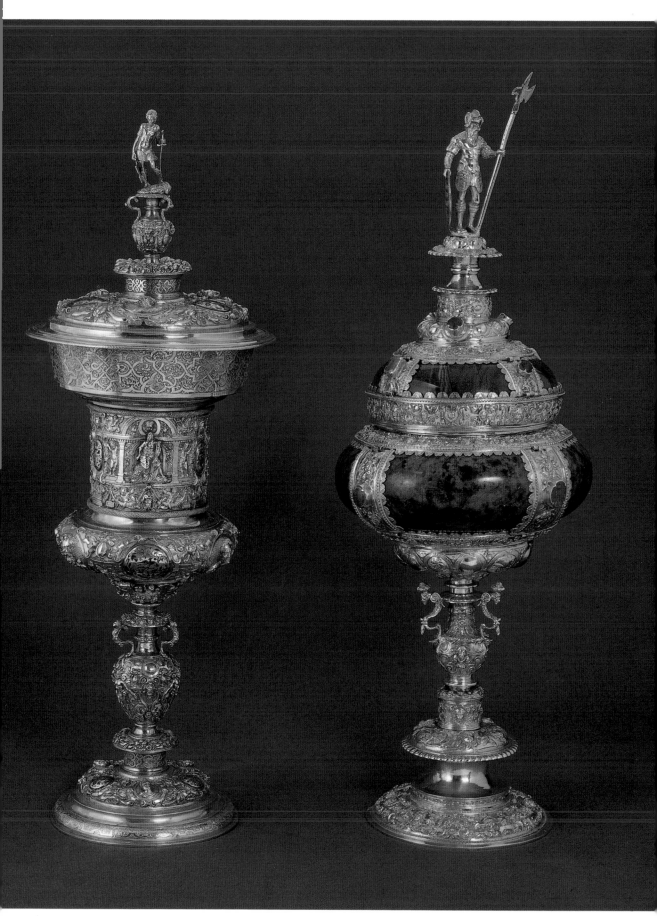

Cat. nos. 18 and 29

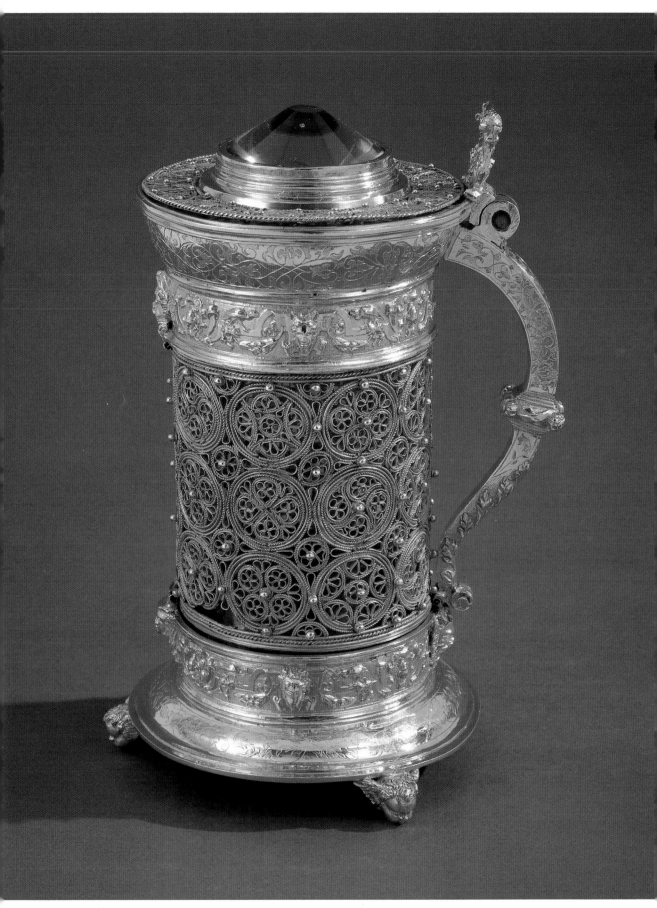

Cat. no. 20

Tankard

German, ca. 1570
Silver-gilt
HEIGHT: 5⅛ in. (13.1 cm.)
MARKS: Augsburg, maker's mark of Ulrich
Meringer (Seling, no. 670); marked under
the base

On molded foot, the tapering body etched with
moresques and with three applied oval car-
touches, cast and chased with putto masks
within scrolls; a medallion of St. George and
the Dragon applied to the center of the cover,
within a chased surround of strapwork, scrolls,
and masks; with scroll handle formed as a
caryatid figure springing at the lower junction
from a ball-and-claw and with infant Bacchus
thumbpiece.

Ulrich Meringer (or Möringer) was a Roman
Catholic goldsmith who received commissions
from Archduke Albrecht V of Bavaria and the
Augsburg banker Hans Fugger. His work makes
full use of the most up-to-date pattern books of
the day and in particular shows awareness of
the moresque designs of Virgil Solis published
in Nuremberg during the mid-sixteenth cen-
tury (O'Dell-Franke, pls. 138-146). A closely
similar object by the same maker is a water jug
in the Kunsthistorisches Museum, Vienna (Sel-
ing, vol. 2, fig. 262). This incorporates the same
ornament and an identical band of decoration
around the foot. A drawing by Hans Mielich
(1516-1573) in the Bayerisches National-
museum, Munich, of a tankard formerly in the
Schatzkammer of Albrecht V again shows a
remarkably close correspondence of design. Al-
though the ornament there is enameled rather
than etched, both the composition and the form

Hans Mielich. *Design for a Tankard.* Bayerisches Nationalmuseum, Munich.

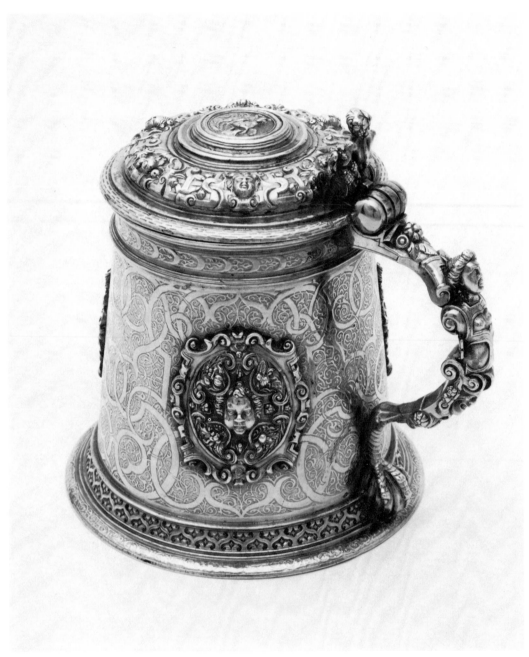

Cat. no. 19

of the tankard suggest that it may have been the work of the same goldsmith as the present tankard.

Provenance: Earl of Home, Sale, Christie's, London, June 17, 1919, lot 70.
Exhibited: London, South Kensington Museum, 1862, no. 6202, lent by the Earl of Home; London, Goldsmiths' Hall, 1979, no. 18.
Literature: W. W. Watts, "Continental Silver in the Collection of Baron and Baroness Bruno Schröder," 1927, pp. 8 (ill.), 10; E. Alfred Jones, *Old Silver of Europe and America*, 1928, p. 186.

Cat. no. 19

20

Tankard

South German, third quarter of sixteenth century
Silver-gilt, filigree, and glass
HEIGHT: 7⅜ in. (18.8 cm.)
MARKS: None

The cylindrical glass body with a sleeve of filigree between two chased rings of masks, strapwork and swags, with flared lip, on spreading base engraved with arabesques and with three cherub-feet; the cover inset with a truncated glass cone within similar filigree surround; with engraved scroll handle and pierced cherub thumbpiece. The glass cone is a later replacement.

This is one of a group of silver-gilt, filigree, and glass tankards made in South Germany during the late sixteenth century and usually attributed to Augsburg. The best known of the group and the closest to this is one in the possession of Clare College, Cambridge, bequeathed by Dr. William Butler in 1617 (Jones, 1910, pl. IX, 1). While this, too, is unmarked, most bear the Augsburg town mark. A third tankard with identical feet, handle, and filigree pattern to this, but with a finely modeled frieze of putti above and below the filigree and with a figure finial, has the Augsburg town mark and the maker's mark of (?) Hans Ment (Hernmarck, fig. 208). A second group of tankards of similar type but more slender proportions is associated with various Augsburg goldsmiths, such as Abraham Lotter I (Seling, vol. 2, fig. 133) and Ulrich Schönmacher (Hayward, 1976, pl. 494). The former evidently experimented with the application of this filigree work, since a basin by him dated 1561 and with a border of this kind is in the Zähringer Museum in Baden-Baden (Seling, vol. 2, fig. 62). However, the exclusive association of these groups with Augsburg workshops should be countered by a further tankard in the Schatzkammer des Deutschen Ordens in Vienna. This is closer to the first group in ornament and proportions, but bears the town mark of Ulm and the maker's mark of Wolfgang Schutzbar.

Provenance: Lionel de Rothschild, London; Alfred de Rothschild, London.
Exhibited: London, South Kensington Museum, 1862, no. 6121, lent by Baron Lionel de Rothschild; London, Goldsmiths' Hall, 1979, no. 20.
Literature: W. W. Watts, "Continental Silver in the Collection of Baron and Baroness Bruno Schröder," 1927, pp. 10, 14 (ill.); C. Hernmarck, *Art of the European Silversmith*, 1977, p. 121.

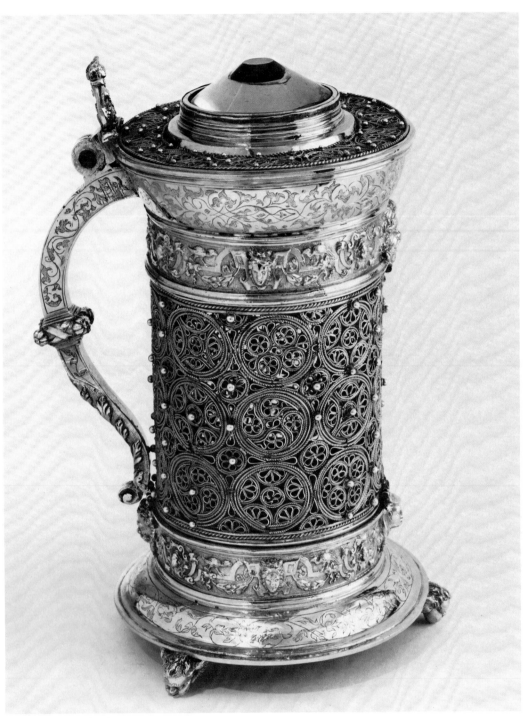

Cat. no. 20, see colorplate p. 80

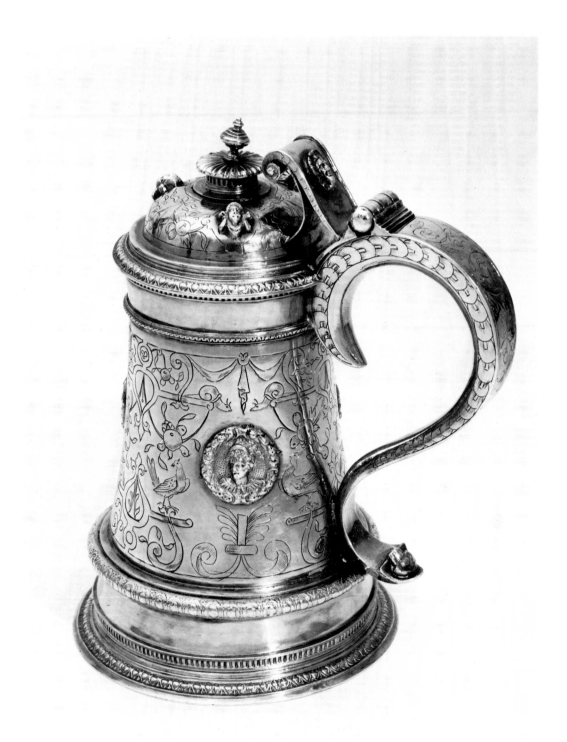

Cat. no. 21

21

Tankard

English, ca. 1575
Silver-gilt
HEIGHT: 7⅜ in. (18.8 cm.)
MARKS: London, 1599-1600, maker's mark IA
(Jackson, p. 109), for John Acton; marked under
base and on cover

Of tapered form and on spreading foot, with a
molded rib applied above; engraved on the body
with birds, snails, and foliage amid strapwork,
and with three applied medallions; the domed
cover similarly engraved, with applied female
masks and with baluster finial; the scroll
handle with openwork thumbpiece.

The earliest surviving English tankards made
entirely of silver date from the mid-sixteenth
century and relate in form to the pottery jugs
similar to those in this collection (Cat. nos. 22,
23). Michael Clayton (p. 292) suggests that the
tapered cylindrical form, which first appears
around 1570, is derived from silver-mounted
horn vessels.

This tankard is very similar to one in Corpus
Christi College, Cambridge (Clayton, fig. 596),
differing only in the engraved decoration on the
body and cover and the style of the cast medal-
lions. The latter was given to the college by
Archbishop Parker and bears London hallmarks
for 1571-72. Moreover, the engraving on the
Cambridge tankard uses a design of strapwork
identical to this one and seems to be by the
same hand as the Magdalene Cup in the Man-
chester City Art Gallery (Hayward, 1976, pl.
674) which bears marks for 1573-74. Charles
Oman (1978, p. 48) attributes the engraving of
the latter to Nicaise Roussel, an immigrant
Flemish engraver from Bruges who is believed
to have settled in England around 1573. But his
style of engraving had changed markedly by the
date of the hallmarks on this tankard, as indi-
cated by a tankard of 1597 belonging to Christ's
College, Cambridge (Oman, 1978, fig. 48), and
the mounts on the Chinese vase in this collec-
tion (Cat. no. 35). Such close affinities with two
other pieces of apparently thirty years earlier
strongly suggest that this tankard was made
during the 1570s and only submitted for assay

some time after its manufacture, probably on
changing ownership.

The attribution of the maker's mark on this
object, as well as those of Cat. nos. 34, 42, and
48, is based on the researches of Gerald Taylor
of the Ashmolean Museum, Oxford, partly con-
tained in a paper delivered to the Silver Society
(*Proceedings,* forthcoming).

Provenance: Purchased from Crichton Brothers,
London, 1917.
Exhibited: London, Goldsmiths' Hall, 1979, no. 65.
Literature: W. W. Watts, "English Silver...in the Col-
lection of Baron and Baroness Bruno Schröder," 1927,
pp. 254 (ill.), 255; Charles Jackson, *History of English
Plate,* 1911, vol. 2, pp. 754-55, fig. 983; T. Schroder,
"Sixteenth-Century English Silver: Some Problems
of Attribution," 1979-81, p. 45.

22

Jug

English, ca. 1570
Silver-gilt and tin-glazed earthenware
HEIGHT: 7⅞ in. (20.1 cm.)
MARKS: London, 1572-73, maker's mark HW in
a lobed punch (Jackson, p. 99); marked on foot
and inside cover, the leopard's head on the foot
overstriking another mark

The pear-shaped jug with cylindrical neck,
molded with spiral flutes and with marbled,

Cat. no. 22

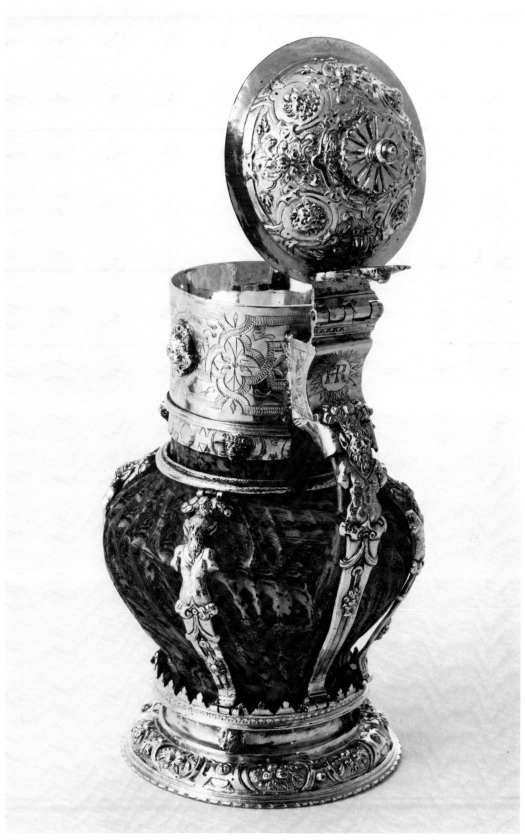

Cat. no. 22, see colorplate p. 97

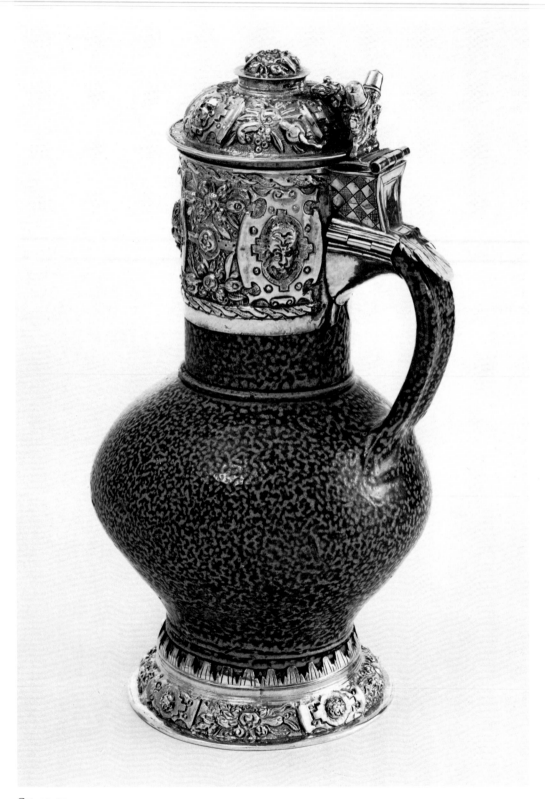

Cat. no. 23

brown tin glaze; on domed foot repoussé and chased with foliage and strapwork, with four vertical terminal figure straps to the body and another to the handle; the neck-mount engraved with moresques within strapwork and with applied cherubs and lions' masks; the domed cover similarly chased to the foot, with baluster finial and cherub thumbpiece; the handle engraved with a monogram HR and the underneath of the foot with a bust of Mars. The border of the neck-mount has been cut back.

The pottery is very unusual but is probably English, in spite of being close in form to the much-imported German stoneware jugs (see Cat. no. 23). Although apparently contemporary with the mounts, the slightly imperfect fit of the latter suggests that the jug may be a later substitute. The original may have been of the same kind, or possibly of a more valued material, such as the Venetian *vetro a fili* glass jug in the British Museum, which has silver-gilt mounts hallmarked for 1548-49 (Tait, pl. 11).

Provenance: H. Magniac, Esq., Sale, Christie's, London, July 8, 1892, lot 650; Anonymous, Sale, Christie's, London, May 1, 1913, lot 39.
Exhibited: London, Burlington Fine Arts Club, 1926, Case I, no. 16, plate XXXI; London, Seaford House, 1929, no. 65; London, Goldsmiths' Hall, 1979, no. 60.
Literature: W. W. Watts, "English Silver...in the Collection of Baron and Baroness Bruno Schröder," 1927, pp. 251 (ill.), 254-55.

23

Jug

German, the mounts English, ca. 1575
Silver and stoneware
HEIGHT: 9¾ in. (24.6 cm.)
MARKS: London, 1575-76, maker's mark WC, a grasshopper below (Jackson, p. 103); marked on foot, neck, and cover

The pear-shaped jug with cylindrical neck and mottled brown glaze; with broad silver mount to the neck, embossed with masks, fruit, and strapwork, and with similarly embossed domed foot-mount and cover, the cover surmounted by a small plinth and domed finial and with

addorsed acorns thumbpiece; with traces of gilding to the mounts.

Stoneware with a mottled brown glaze was imported into England from the Rhenish potteries, particularly Cologne, in very large quantities during the sixteenth and early seventeenth centuries and was frequently embellished with silver mounts. The earliest date from the late 1540s and are generally of rather squatter form and with a shorter neck than this model, which appeared during the third quarter of the century. As a rule, the quality of the mounts found on the earlier ones is rather finer than was usually achieved toward the 1570s, by which time an element of mass production had set in. Among the finest of all is one of 1557, with maker's mark a bird, in the Rothermere Gift at the Middle Temple, London (W. R. Hearst sale, Christie's, London, Dec. 14, 1938, lot 115, cat. ill.), and an unmarked example of similar date and probably by the same maker in the Victoria and Albert Museum, London (Oman, 1965, pl. 15). The combination of their relatively low bullion content and the toughness of the stoneware accounts for their survival in comparatively large numbers.

The term by which this stoneware is generally known in England – "tigerware" – is not at first sight particularly appropriate, since the glaze is generally mottled rather than striped. However, during the sixteenth century tigers were apparently thought to be spotted: William Caxton's *Mirrour of the World* (1481) states that "in ynde ben there other bestes grete and fyrs whiche ben of blew colowr, and haue clere spottes on the body...and ben named Tygris."

Provenance: Unknown; included in Dell inventory, ca. 1910.
Exhibited: London, Seaford House, 1929, no. 63; London, Goldsmiths' Hall, 1979, no. 61.
Literature: W. W. Watts, "English Silver...in the Collection of Baron and Baroness Bruno Schröder," 1927, pp. 251 (ill.), 254.

24

Four Monatsbecher

South German, ca. 1570
Silver, parcel-gilt
HEIGHT: 3½ in. (8.8 cm.)
MARKS: Augsburg, maker's mark of Theophil
Glaubich (Seling, no. 643); marked under
base of each

Each of tapering cylindrical form, the lower
part of the body plain and engraved around the
lip IANVARIVS, FEBRVARIVS, APRILVS, or
MAIVS, with the appropriate astrological sym-
bol and scenes of seasonal activities; on spread-
ing foot, cast and chased with marine subjects,
and with a shallow ring stamped with lozenges
forming the stem; two with an enameled coat
of arms applied within the bowl.

Cat. no. 24

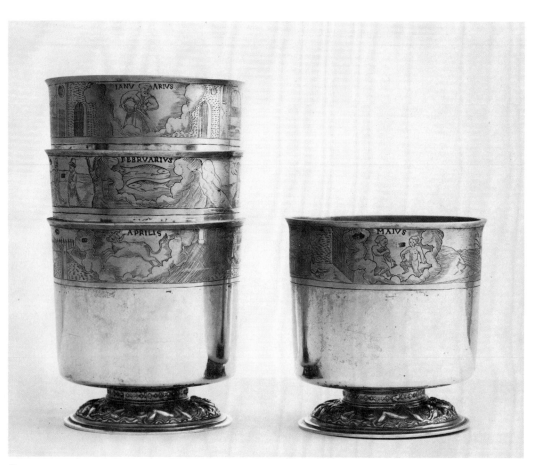

Cat. no. 24

90

The arms are probably those of Colyn of Cologne.

These beakers and those following (Cat. no. 25) represent a class of objects apparently restricted to the German-speaking countries and which was popular there during the second half of the sixteenth century. Known as *Satzbecher*, they could be stacked together to form a single object suitable for display and were frequently surmounted by a cover. These sets have seldom survived intact, however, and it is to be presumed that there were originally twelve in this set.

Provenance: A. B. H. Goldschmidt, Esq., Sale, Christie's, London, May 24 and 25, 1922, lot 115.
Exhibited: London, Goldsmiths' Hall, 1979, no. 22; London, Goldsmiths' Hall, 1983, no. 23.
Literature: M. Rosenberg, *Der Goldschmiede*

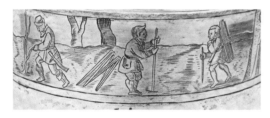

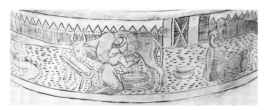

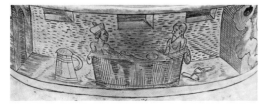

Cat. no. 24

Merkzeichen, 1922-28, no. 354; W. W. Watts, "Continental Silver in the Collection of Baron and Baroness Bruno Schröder," 1927, pp. 7 (ill.), 8.

25

Six Satzbecher

South German, ca. 1580
Silver, parcel-gilt
HEIGHT: 3 in. (7.6 cm.)
MARKS: Ulm, maker's mark probably that of Mathäus Hofherr (Rosenberg, no. 4762); marked under base of each

Of similar form to the preceding, each engraved around the lip with biblical or proverbial quotations, a coat of arms, and animals, and beneath an applied reeded rib with foliage and strapwork; on spreading foot engraved with fleurs-de-lis and with a ring stamped with formal foliage forming the shallow stem.

The arms are probably those of Gundelfinger of Zittau (Saxony) and of Nördlingen (Bavaria).

Contrary to the *Monatsbecher* (Cat. no. 24), there is no reason to suppose that this set of beakers is incomplete, although it may originally have been surmounted by a cover.

Provenance: Duke of Hamilton, K. T., Sale, Christie's, London, July 1, 1931, lot 105.
Exhibited: London, Goldsmiths' Hall, 1979, no. 23.

26

Tazza

Swiss, dated 1571
Silver, parcel-gilt
HEIGHT: 5 in. (12.6 cm.)
DIAMETER OF BOWL: 5½ in. (14 cm.)
MARKS: Uri (Switzerland), maker's mark HS in monogram; marked on the outside of bowl

The shallow bowl chased with tear-duct ornament on matted ground; engraved on the outside with a coat of arms and with a print engraved with two coats of arms accollé applied in

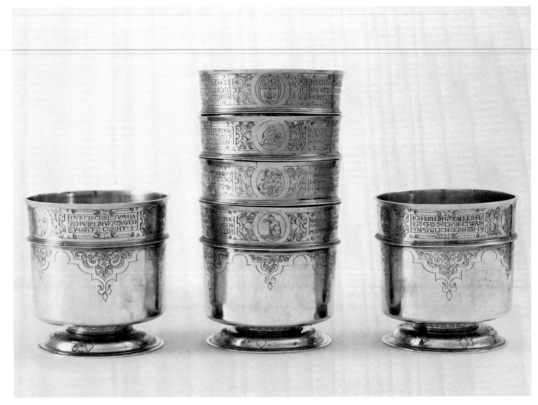

Cat. no. 25

the center; on similarly chased ogee foot and with vase-shaped stem, chased with gadroons beneath a spool-shaped section.

The coat of arms on the outside of the bowl is for Strauss, originally from Hanover; those on the print within are unidentified.

The maker's mark closely resembles that of the famous Zurich goldsmith Hans Jakob Stampfer (see Cat. no. 39). This should probably be discounted, however, both on the grounds that Stampfer is not known to have worked in Uri and that the quality of this object is considerably less fine than any of his known works in silver, for example, a covered cup of 1545 in the city museum of Strasbourg (Hayward, 1976, pl. 287).

Provenance: Duke of Hamilton, Sale, Christie's, London, Nov. 4, 1919, lot 128.
Exhibited: London, Goldsmiths' Hall, 1979, no. 21.

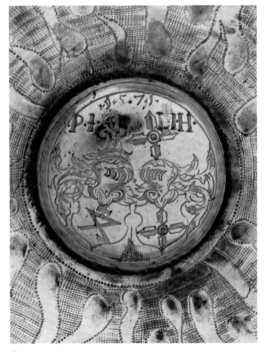

Cat. no. 26

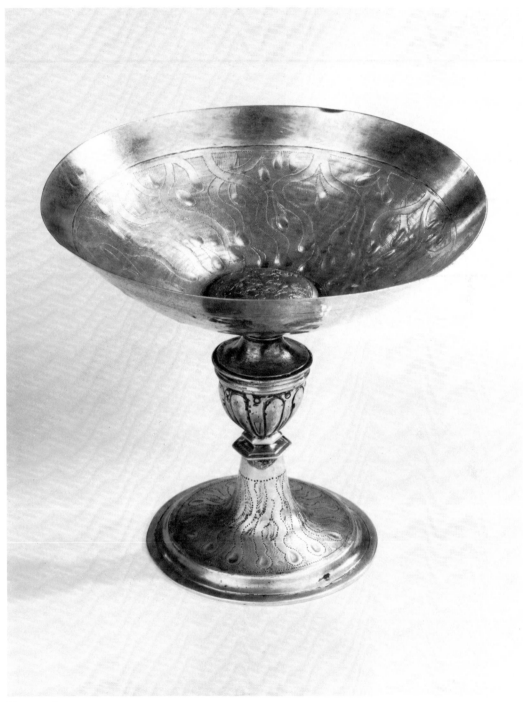

Cat. no. 26

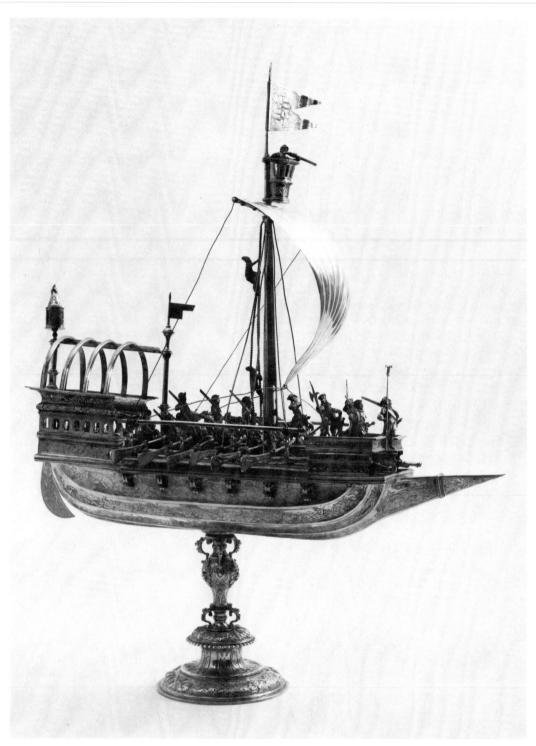

Cat. no. 27

27

Nef

Probably Netherlandish, ca. 1580; the foot
German, early seventeenth century
Silver, parcel-gilt, and cold enamel
HEIGHT: 19¾ in. (51.1 cm.)
LENGTH: 16 in. (40.6 cm.)
MARKS: Strasbourg or Ansbach, maker's mark
D in a shaped shield; marked on the foot, the
nef unmarked

In the form of a twelve-oared single-masted gal-
ley in full sail; the clinker-built hull engraved
with marine subjects, with numerous cold-
enameled oarsmen and soldiers on deck and a
banquet in the poop beneath an awning; a mus-
keteer in the crow's nest and a flag engraved
with a coat of arms flying from the mast; on
circular spool-shaped base and with baluster
stem, chased with strapwork and scrolls, and
with applied lions' masks and openwork
brackets. The foot and stem are not original
to the nef.

The arms have been tentatively identified by
Charles Oman as a possible rendering of those
of the short-lived Luis Mendes de Vasconellos,
Grand Master of Malta, 1622-23. This is com-
patible with the traditional provenance (see
below).

The word "nef" is taken from the old French *la
nef,* meaning ship, and refers to a particular type
of object developed in France during the late
Middle Ages and whose use was primarily
ceremonial. According to R. W. Lightbown (p.
3), one of the earliest references to the nef is in a
document of 1239, and during the succeeding
period it took on a variety of functions. The
chief of these was analogous to the great salt in
England (see Cat. no. 31), to mark the place of
the king, great lord, or ecclesiastic at table.
However, documents and pictorial sources also
suggest that they were used for containing the
personal eating utensils of the king at table,
while in other cases, such as the Burghley Nef
(Paris, 1527-28?) now in the Victoria and Albert
Museum, London (Hayward, 1976, pl. 252),
they were used as salt cellars.

Although fine nefs of later periods are
known, such as the gold nef of Louis XIV (no
longer extant) and Napoleon's nef of 1804 by

Henry Auguste now in the Musée Malmaison
(Hernmarck, fig. 395), its period as a gold-
smith's tour de force seems to have come to an
end quite early in the sixteenth century. Exam-
ples such as the Burghley Nef and the Schlüs-
selfelder Nef of (?) 1503, in the Germanisches
Nationalmuseum, Nuremberg (Kohlhaussen,
figs. 406-411), represent the last flowering of
the form. They continued to be made in Ger-
many in considerable numbers during the late
sixteenth and seventeenth centuries, but they
became standardized and their quality declined
accordingly. This example, therefore, is an un-
usually late representative of an earlier tradi-
tion, although its form and decoration are com-
pletely up to date. Its ostensible function, how-
ever, is different from those described above; by
unscrewing the spur and filling the hull
through the opening in the deck, it can be made
to serve as a ewer. But the difficulties of han-
dling and using it in this way must have made it

Cat. no. 27

totally impractical. Like so much elaborate Mannerist plate, the function is purely notional and it would in practice have been intended only for display.

It is not known where this nef was made, although so sophisticated an object can only have been produced in one of the leading workshops of Flanders or Germany. Previous writers have usually assumed it to have been made in Strasbourg, on the basis of the marks on the foot. But since the foot and stem appear not to have belonged originally with the nef, the evidence of the marks struck on it must be discounted. The former are close to designs of about 1600 attributed to the school of Paul Flindt of Nuremberg (Hayward, 1976, pl. 162). But the marine subjects engraved on the hull are comparable with designs produced by Erasmus Hornick, Vredeman de Vries, and Adriaen Collaert, all of whom were working in Antwerp during the second half of the sixteenth century. The evidence of the modeling of the galley and the costumes of the figures on board also point to a Flemish workshop as the likely source. Both are very carefully observed and conform closely to Spanish fashions of the time, and the official allegiance of Flanders until 1581 was to Spain.

In his catalogue of the Londesborough collection of plate, published in 1860, F. W. Fairholt recounts the traditional history of the nef as follows: "It...is stated to have been a present from the King of France to the Knights of Malta; in whose treasury it was preserved, until the island was captured by the French under Napoleon, and this among other things carried off in a French vessel; the vessel in its turn was captured by an English man-of-war, whose captain preserved this nef as a mark of his prowess. His family, at his death, parted with it to Messrs. Garrard, the silversmiths, from whom Lord Londesborough obtained it" (pp. v-vi).

Provenance: Albert, Lord Londesborough; Captain Leyland; John Malcolm of Portalloch; Colonel E. D. Malcolm, C. B., Sale, Christie's, London, July 23, 1919, lot 57.
Exhibited: London, South Kensington Museum, 1862, no. 6336, lent by Captain Leyland; London, Burlington Fine Arts Club, 1901, Case P, no. 4, lent by Colonel Malcolm; London, Goldsmiths' Hall, 1979, no. 27.
Literature: F. W. Fairholt, *Catalogue of the Collection of... Albert, Lord Londesborough*, 1860, pp. v-vii, frontispiece; E. Alfred Jones, *Old Silver of Europe and America*, 1928, p. 216, pl. 58, 3; J. F. Hayward, *Virtuoso Goldsmiths*, 1976, pl. 548.

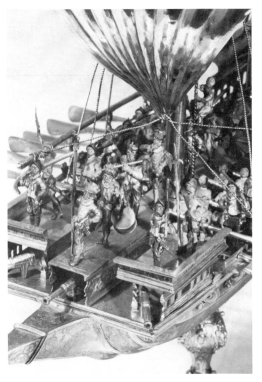

Cat. no. 27

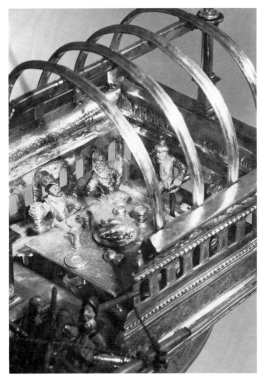

Cat. no. 27

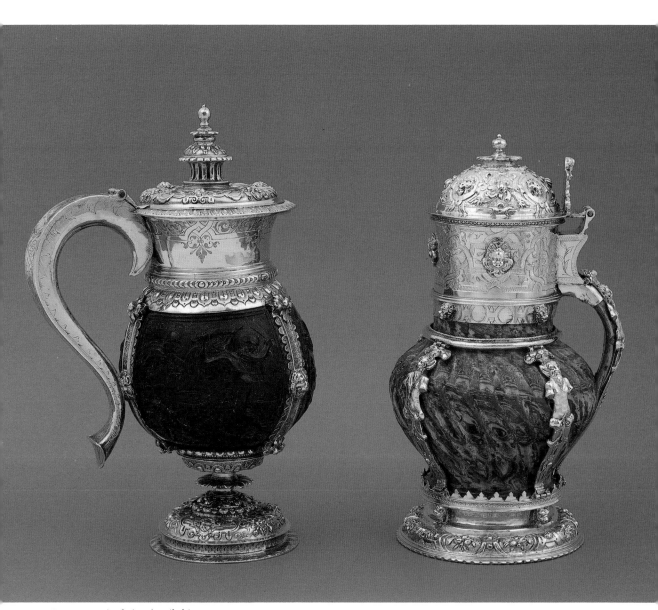

Cat. nos. 22 (right) and 30 (left)

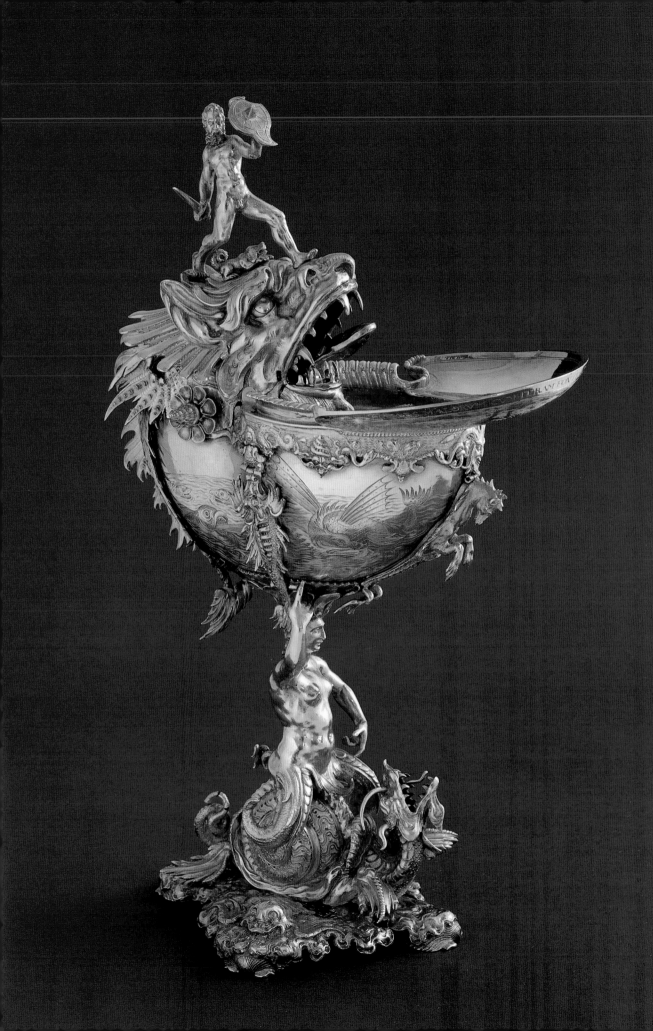

Cup in the Form of a Bear

Probably South German, late sixteenth century
Silver, parcel-gilt
HEIGHT: 6⅞ in. (17.4 cm.)
MARKS: Indistinct

Modeled squatting on its haunches with front paws to its stomach, flat-chased with fur pattern, a collar with applied rings around its neck; the head detachable, with bared teeth and protruding tongue; the rim engraved with an inscription.

The inscription reads: TVE ICH FURN VBER EILST MICH SEIWEIN WVRST SPVRN BER SCHAF AFENWEIN. This is extremely obscure but seems to be a doggerel verse relating to the manner in which the contents of the cup should be drunk. The suspension rings on the collar presumably had bells attached originally and allude to the sport of bear-baiting, the situation in which the animal would have been familiar to most German people of the time. It is a reflection of the popularity of this sport that the bear was one of the more common forms of zoomorphic cups, and most of those surviving show the animal in this fair-ground capacity. Two by Leonhard Umbach of Augsburg shown in the *Welt im Umbruch* exhibition in 1980 (nos. 759, 760), and a pair by the same maker formerly in the Lamon Collection (sold at Christie's, London, November 28, 1973, lot 60, cat. ill.) show the bear holding a pistol in one case and the two others with bagpipes. A gold-and-silver mounted example in the Kunsthistorisches Museum, Vienna (Scheicher, p. 74), shows the bear in jeweled costume and firing a wheel-lock pistol.

Provenance: The Marchioness of Graham, Sale, Christie's, London, June 2, 1919, lot 65.
Exhibited: London, Goldsmiths' Hall, 1979, no. 29; London, Goldsmiths' Hall, 1983, no. 29.

Cup and Cover

German, ca. 1580
Silver-gilt and serpentine, with applied semi-precious stones
HEIGHT: 18½ in. (47.1 cm.)
MARKS: Possibly Aachen or Frankfurt am Main, maker's mark KH in monogram (Rosenberg, 1922-28, nos. 32, 2030); marked on lip and foot

The bowl and cover of polished serpentine, with applied vertical straps, chased with foliage and set with hardstones, with similarly chased borders; the foot with two chased bands of strapwork, drapery, and masks and the baluster stem with applied brackets and a gadrooned circular boss beneath the bowl; a similar boss applied to the cover and surmounted by a plinth and a soldier with halberd and shield engraved with an inscription; a further inscription engraved around the lip.

The inscription around the lip refers to the supposed capacity of serpentine to neutralize the

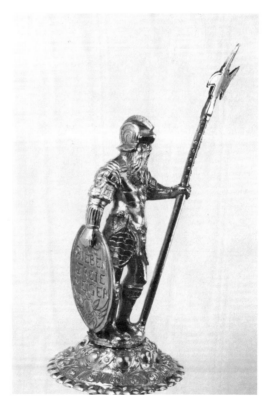

Cat. no. 29

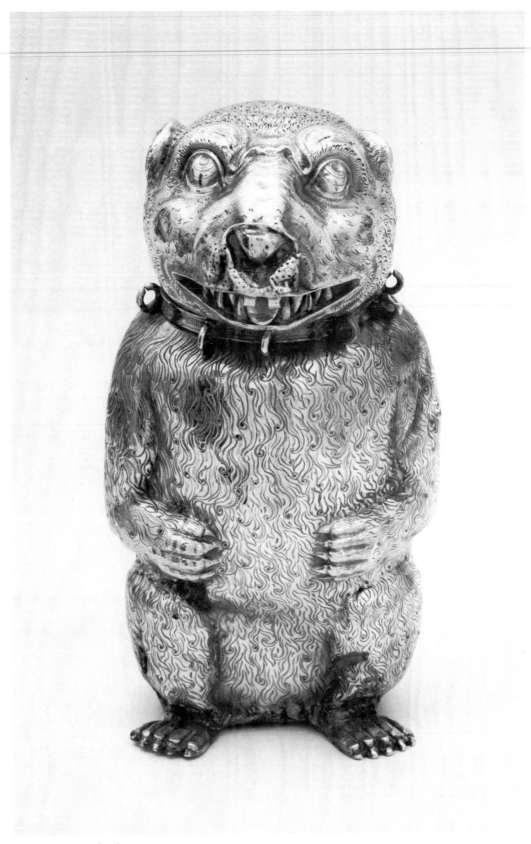

Cat. no. 28, see colorplate p. 55

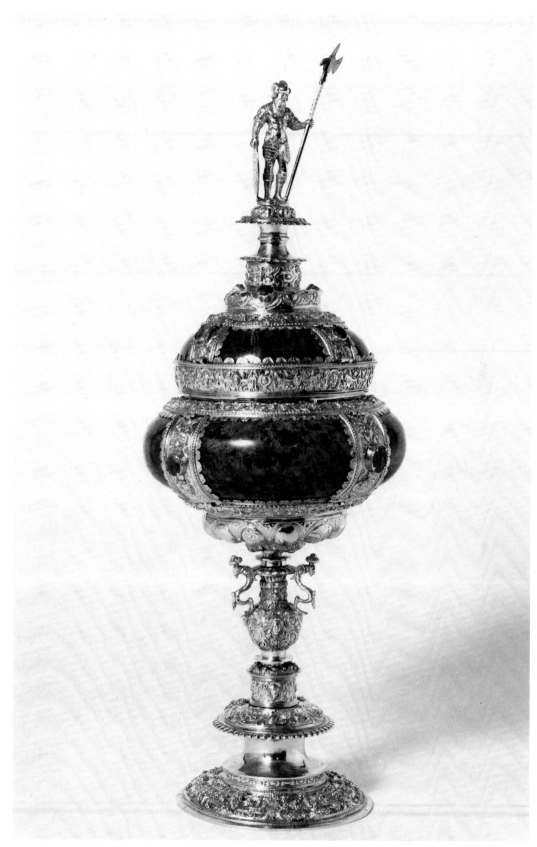

Cat. no. 29, see colorplate p. 79

effects of poison (*Serpentin heis ich alle Gift vertreib...*). The significance of the inscription on the shield of the finial (*Sieben freie Meiger*) is not clear, but is presumably commemorative.

The shape of the bowl and cover suggest that the stone was possibly carved in the fifteenth century and originally mounted as a covered bowl, such as one now preserved in the Green Vaults at Dresden (Menzhausen, pl. 71). It would then have been remounted in the sixteenth century to make a more fashionable vessel. The remounting of precious materials or heirlooms was a common practice over a long period and is true of at least two rock crystal vessels in this collection, the Tudor-mounted Roman amphora (App. no. 9) and the medieval jug with early-eighteenth-century mounts (App. no. 15), and the drinking horn as well (Cat. no. 43), if the inscription is to be believed.

The stem of the cup is an example of the trade in moldings among goldsmiths during this period (see p. 18); exactly the same stem molding is incorporated into at least three other cups made in different cities over a period of some twenty years. These are the Glynne Cup, London, 1579 (Hayward, 1976, pl. 654), the Goodriche Cup, London, 1563 (Read and Tonnochy, pls. 23, 24), and a covered cup made in Strasbourg circa 1560 (Hayward, 1976, pl. 542).

Rosenberg shows this maker's mark under both Aachen and Frankfurt and admits some uncertainty as to its attribution. Sheffler (1973) does not show it under either town.

Provenance: Duke of Cumberland Collection; purchased from Crichton Brothers, 1925.

Exhibited: Vienna, *Goldschmiedekunst-Ausstellung*, 1889, no 473 (electrotype reproduction); London, Goldsmiths' Hall, 1979, no. 30.
Literature: M. Rosenberg, *Der Goldschmiede Merkzeichen*, 1922-28, no. 32. W. W. Watts, "Continental Silver in the Collection of Baron and Baroness Bruno Schröder," 1927, pp. 5 (ill.), 7-8; T. Schroder, "Sixteenth-Century English Silver: Some Problems of Attribution," 1979-81, p. 43.

30

Jug and Cover

Dutch, late sixteenth century
Silver-gilt and coconut shell
HEIGHT: 8½ in. (21.5 cm.)
MARKS: Breda or Bergen op Zoom, date-letter (V), maker's mark a star (Rosenberg, 1922-28, no. 7602), possibly for Elias Popta; marked on lip

The nut carved with three scenes from ancient history; on domed foot chased with masks, strapwork, and foliage, and with short stem; the broad lip-mount engraved with arabesques, chased below with gadroons and connected to the stem by vertical straps; the cover similarly chased to the foot and with baluster finial; with engraved scroll handle.

The scenes carved on the coconut are inscribed HANIBAL MERVS, ANGILAS, and HECTOR TROIAS.

Cat. no. 30

Cat. no. 30

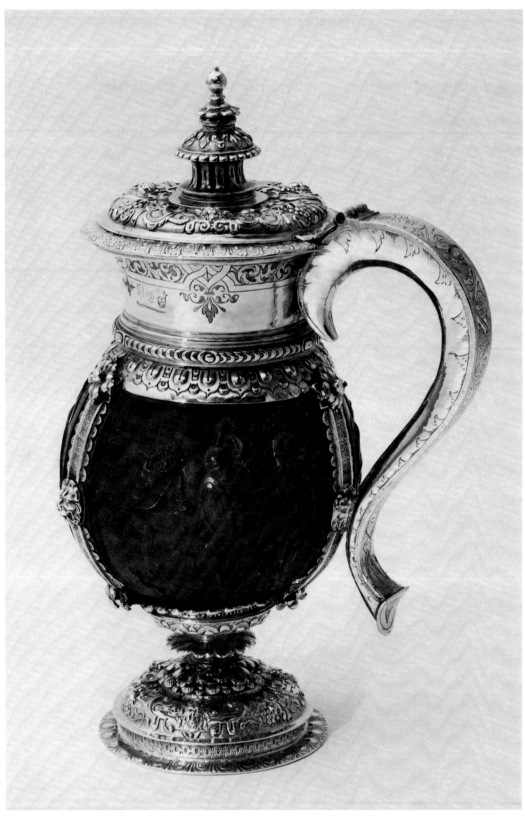

Cat. no. 30, see colorplate p. 97

J. W. Frederiks illustrates two pieces with maker's mark a star: a tazza in the Rijksmuseum, Amsterdam (vol. 1, pls. 28, 29), which bears Breda marks for about 1600, and a standing cup and cover in the Middelburg museum (vol. 3, pl. 78), with Bergen op Zoom marks. Given the proximity of these two towns (both are in North Brabant, about fifteen miles apart) and the consistently high quality and stylistic similarity of these pieces, it is likely that the same master was responsible for both and worked, or had plate assayed, in both towns. (I am grateful to Mr. Karel Citroen for the attribution of the maker's mark.)

Provenance: Unknown.
Exhibited: London, Royal Academy of Arts, 1929, no. 824; London, Goldsmiths' Hall, 1979, no. 31.

Cat. no. 30

31

Standing Salt

English, ca. 1583
Silver-gilt
HEIGHT: 9¾ in. (24.7 cm.)
MARKS: London, 1583-84, maker's mark a bull's head (Jackson, p. 105); marked in bowl, on foot, and on border of cover

On three ball-and-claw feet, the cylindrical body with domed base and similar inverted domed section above, repoussé and chased with lions' masks, strapwork, and sprays of fruit,

with plain shallow receptacle for the salt; with similarly chased domed cover, the finial formed as a warrior with shield and spear, above a vase-shaped plinth with applied openwork brackets; the shield pricked with initials, probably SBL.

Like the nef on the Continent (see Cat. no. 27), the salt in England performed a social as well as a practical function. Michael Clayton describes its early history as follows: "The comparative rarity and absolute need for salt during the Middle Ages assured a place for it on the table, and the receptacle soon attained a social importance, giving it a size far larger than required in comparison to the quantity of salt it contained" (p. 220). This particular type seems to have developed around the middle of the sixteenth century and was for most domestic purposes superseded at the end of the century by the rather less imposing bell salt (see Cat. no. 34). The ceremonial function of the standing salt, however, ensured that it continued to be made occasionally until well into the following century. The present example is of comparatively small size. The largest "great salts" surviving, such as the Mostyn Salt of 1586-87, in the Victoria and Albert Museum, London

Cat. no. 31

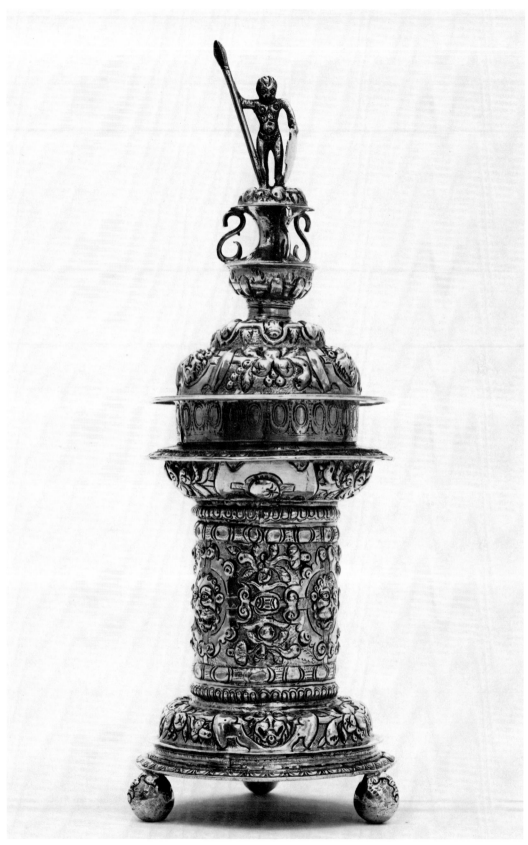

Cat. no. 31

(Oman, 1965, pl. 27), or the Reade Salt of 1574 in the Norwich Castle Museum (Clayton, colorplate 36), are some sixteen and fifteen inches high respectively. The inventory of the contents of Hardwick Hall, compiled in 1601, lists thirteen salts of silver ranging in weight from four ounces to as much as eighty-six, with the majority weighing about fifteen ounces, or slightly larger than this.

An almost identical example by the same maker, dating from 1581, which lacks only the applied brackets beneath the finial, is in the Untermyer Collection in the Metropolitan Museum of Art, New York (Hackenbroch, 1969, no. 14).

Provenance: A. Marsden Smedley, Esq.; purchased from Crichton Brothers, 1917.
Exhibited: London, Goldsmiths' Hall, 1979, no. 63.
Literature: C. J. Jackson, *History of English Plate*, 1911, vol. 2, p. 553, fig. 764; W. W. Watts, "English Silver... in the Collection of Baron and Baroness Bruno Schröder," 1927, pp. 253 (ill.), 255.

32

Pair of Glass Holders

German, ca. 1590
Silver-gilt
HEIGHT (excluding surmounting brackets):
7 in. (17.8 cm.)
MARKS: Frankenthal (town mark only);
marked under base

Each of baluster form, on waisted foot with chased bands of strapwork, fruit, and masks, and with partly gadrooned vase-shaped stem with applied openwork brackets; the extendable brackets to hold the glass in the form of winged demi-horses issuing from a compressed spherical body, similarly chased to the foot, and with three rings pendant from applied lions' masks; the center engraved with a coat of arms.

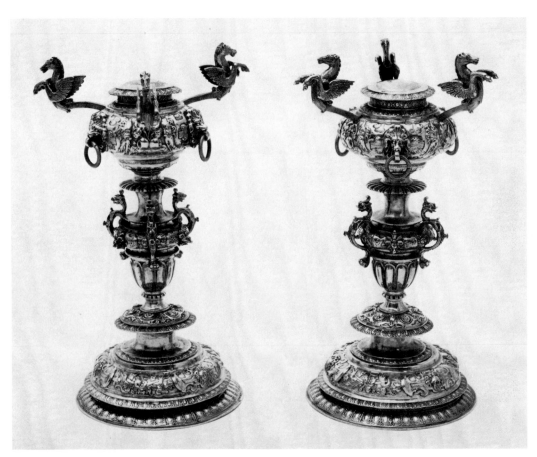

Cat. no. 32

Glass holders, or *Bekerschroeven,* appear to have been devised chiefly for ceremonial use, as a means of presenting the glass to the drinker. The surmounting brackets are linked to a rod passing through the stem and can be adjusted by means of a knob beneath the foot. They frequently figure in still-life paintings of the period and two may be cited which depict holders particularly close to these: one by Nicolaes Gillis, signed and dated 1611, in the National Gallery, London (*Art in Seventeenth Century Holland,* no. 44), and another by Jan Brueghel the Elder (London, Brod Gallery, no. 25). The one shown in the Gillis painting differs only slightly in the chasing of the foot, while that in the Brueghel is indistinguishable from these.

The roemer-holder is a peculiarly Dutch form and the presence of the German mark in this case is explained by the fact that Frankenthal was the resort of many Netherlandish Protestant refugees during the late sixteenth century. The present pair should probably be attributed to a Rotterdam master working in Frankenthal, on the grounds of the close similarity of the foot and stem to two nautilus cups bearing Rotterdam marks for 1589 and 1590, which are in the Boymans-van Beuningen Museum, Rotter-

dam (Frederiks, vol. 4, no. 28, pl. 36) and the Kunsthistorisches Museum, Vienna (Frederiks, vol. 4, no. 29, pl. 37) respectively. According to the exhibition catalogue *Dutch Silver 1580-1830* "the number of surviving examples in silver is certainly less than ten" (p. 371).

Provenance: Albert, Lord Londesborough; Lady Sophia des Voeux; Sir Henry des Voeux, Sale, Christie's, London, June 15, 1888, lot 222.
Exhibited: London, South Kensington Museum, 1862, nos. 6194, 6195, lent by Lady Sophia des Voeux; London, Royal Academy of Arts, 1929, no. 818, pl. cxv; London, Goldsmiths' Hall, 1979, no. 32.
Literature: W. W. Watts, "Continental Silver in the Collection of Baron and Baroness Bruno Schröder," 1927, pp. 6 (ill.), 8; E. Alfred Jones, *Old Silver of Europe and America,* 1928, p. 236.

33

Nautilus Cup

Dutch, ca. 1595
Silver-gilt and silver
HEIGHT: 11¼ in. (28.6 cm.)
MARKS: Delft, 1595, maker's mark a five-petaled flower head

The silver bowl in the form of a nautilus shell, engraved with sea monsters and flying fish; on shaped square foot cast and chased with marine subjects and with stem in the form of a mermaid astride a molluscan monster; with four vertical straps cast with crayfish and sea monsters applied to the bowl, and with broad lip-mount engraved with further marine subjects and an inscription; the mount to the back of the bowl modeled as a monster's head surmounted by a warrior and a hound. The silver bowl is a replacement of the original shell.

The Latin inscription reads HOSPES MALORVM CVM FERAM FONTES, TIBI COMMENDO SEDVLO MODVM 1595. This clearly refers to the deceptively large capacity of the cup and may be loosely rendered, "Since I am a bearer of evils when I contain large drafts, I commend moderation to you."

A number of Dutch nautilus cups of this type are recorded, the closest of which is probably that formerly in the Lamon Collection (sold at

Jan Brueghel the Elder. Detail of *The Marriage of Bacchus and Ariadne.* ca. 1610. Courtesy Noortman & Brod, Ltd., London.

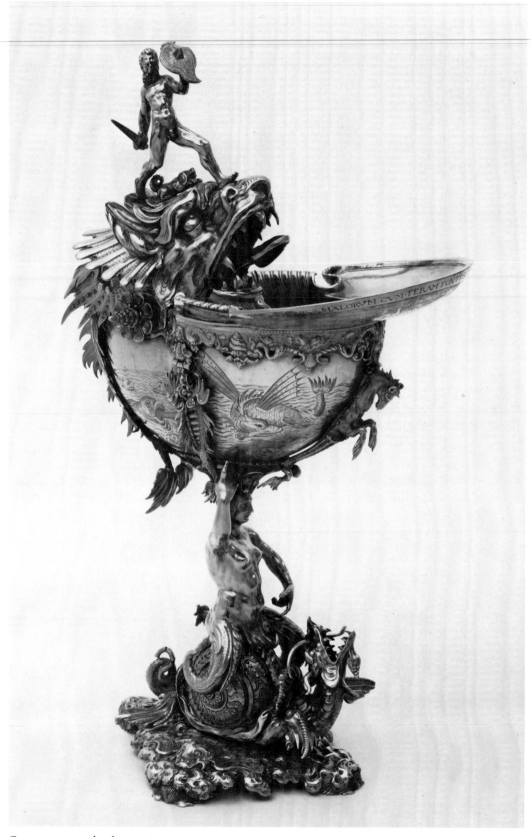

Cat. no. 33, see colorplate p. 98

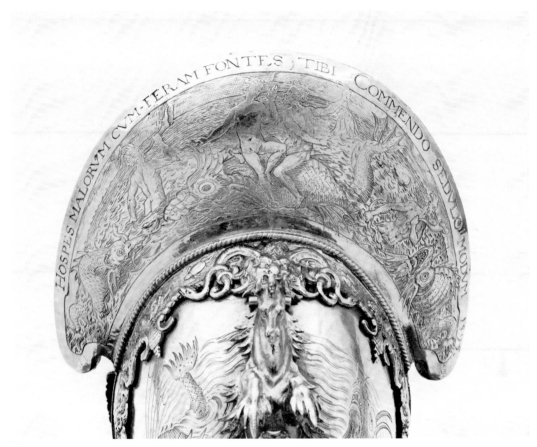

Cat. no. 33

Christie's, London, November 23, 1973, lot 62, cat. ill.) and now in the Toledo Museum of Art, Ohio. This is by Jan Jacobsz. van Royesteyn and bears Utrecht marks for 1596. Another, with Delft marks for 1592, in the Prinsenhof Museum, Delft (Gans, pl. 8), is clearly recognizable in the seventeenth-century painting of the Paston Treasure in Norwich Castle Museum, England (see p. 25). Two further examples (Frederiks, vol. 4, pls. 28, 29) have stems comparable to this and bear Delft marks for 1607 and the maker's mark of Adriaen de Grebber. None of these, however, seems to achieve quite the same sense of sculptural balance evident in this example.

Provenance: (?) Featherstonhaugh Family; purchased from Crichton Brothers, 1925.
Exhibited: London, Royal Academy of Arts, 1929, no. 819.
Literature: W. W. Watts, "Continental Silver in the Collection of Baron and Baroness Bruno Schröder," 1927, pp. 92, 93 (ill.).

34

Bell Salt

English, ca. 1600
Silver-gilt
HEIGHT: 9 in. (22.8 cm.)
MARKS: London, 1599-1600, maker's mark ER (Jackson, p. 108), probably for Edward Rowland; marked on the body of the two lower sections, the top section unmarked.

On three ball-feet and in three sections, each of tapering waisted form; the lower two sections flat-chased with strapwork, foliage, and vacant escutcheons on matted ground, and with plain shallow receptacle for the salt; the domed cover flat-chased with an acanthus calyx and with pierced spherical finial.

The so-called bell salt can be dismantled to serve as one or two salt cellars, and in some cases the perforated finial can function as a

Cat. no. 34

caster. One bearing hall marks for 1591-92 is thought to be the earliest complete surviving example of this form, and bell salts evidently remained reasonably popular until about 1620, when the "trencher-salt," which resembles one section of the bell salt, began to become standard.

The origins of the form are not clearly established. It has often been supposed that it was introduced to replace the standing salt (see Cat. no. 31). But several salts described as "belle fation with a Cover" appear in the inventory of Royal plate as early as 1574. Furthermore, Collins (pp. 466-67) points out that two appear in an inventory of the plate of Edward, Duke of Somerset, which was compiled after his execution in 1552, and that they were not unknown to the officers of the Jewel House even before the death of Henry VIII in 1549. How closely these earlier ones resembled the form of those surviving is not clear from the brief descriptions in these inventories. But a number of factors suggest that they were simpler than the familiar two-stage salt. First, in its fully assembled form the shape of the salt hardly warrants the term "bell." Secondly, the inventory of the plate of Hardwick Hall, compiled in 1601, refers in one instance to "a *double* bell salt with a Cover & a pepper boxe gilt" (p. 35, italic added), thereby suggesting a distinction between it and a "standard," or single, bell salt. A salt of 1586-87, which resembles the upper two sections of this salt (Clayton, fig. 443), has generally been supposed to be incomplete, but it more probably represents the original form of the bell salt.

For the attribution of the maker's mark, see Cat. no. 21.

Provenance: George Webbe Dasent, D.C.L., Sale, Christie's, London, June 2, 1875, lot 108.
Exhibited: London, Burlington Fine Arts Club, 1926, Case I, no. 17, pl. XXXI; London, Goldsmiths' Hall, 1979, no. 66.
Literature: W. W. Watts, "English Silver... in the Collection of Baron and Baroness Bruno Schröder," 1927, pp. 253 (ill.), 255.

Cat. no. 34

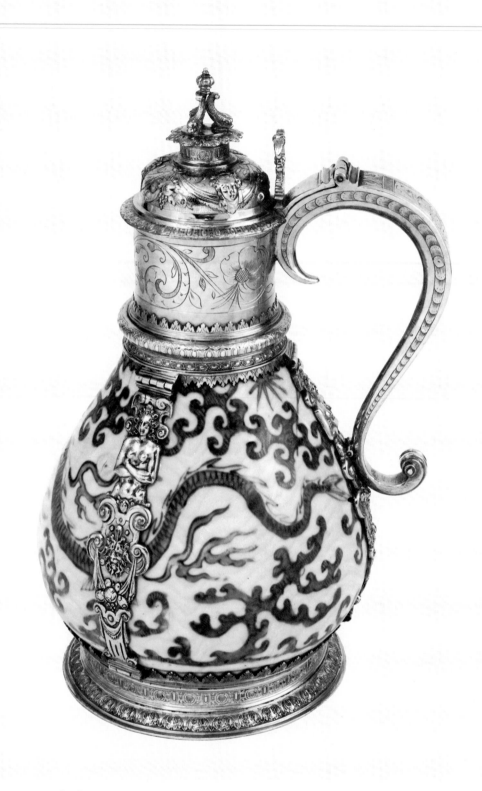

Cat. no. 35, see colorplate p. 115

35

Ewer

Chinese, Wan Li period (1573-1620), the
mounts English, ca. 1600
Silver-gilt and porcelain
HEIGHT: 11¼ in. (28.5 cm.)
MARKS: None

The blue-and-white vase painted with foliage
and a dragon, and the silver-gilt foot-mount
stamped with ovals, buds, and rose heads; with
four vertical terminal figure straps; the neck-
mount with an applied rib at its base and en-
graved above with scrolling foliage; the domed
cover repoussé and chased with masks, drapery,
and fruit and with finial formed as three ad-
dorsed dolphins; the S-scroll handle engraved
with a terminal figure and with winged mer-
maid thumbpiece.

This and another item in the collection (App.
no. 12) should be associated with a group of
mounted pieces bearing one of a series of re-
lated makers' marks, all characterized by a tre-
foil or trefoils in various configurations (Jack-
son, pp. 103, 104, 112). With the exception of a
single piece exhibited at South Kensington in
1862, for which the probably misread date-
letter was given as 1558, the group seems to
span the period 1576-ca. 1620. It includes a
group of silver-mounted vessels of Chinese
porcelain (among others, in the British Mu-
seum, the Victoria and Albert Museum, and the
Metropolitan Museum), the Gibbon Salt of
1576-77 in the Goldsmiths' Company Collec-
tion (Hayward, 1976, pl. 671), a silver-gilt
mounted agate ewer and basin of 1579-80 in the
Duke of Rutland's collection (Hayward, 1976,
pls. 683, 684), and a similarly mounted alabas-
ter casket and serpentine tankard of about
1620, both in the Victoria and Albert Museum
(Oman, 1965, pls. 43, 44). Apart from the shared
propensity for mounted exotic materials, and
taking into account a modification of style and
degeneration of quality over the period, a dis-
tinct homogeneity is evident in the repertoire
of ornament. For example, the stamped ovals at
the base of the neck of this piece also appear
quite profusely on the Gibbon Salt. The scroll
handles on the bowl in this collection (App. no.
11) are found in a different capacity on the Rut-

land agate ewer, and the same repeated band of
stamped rose heads between ovals is used on
both the alabaster casket and the serpentine
tankard referred to above.

The engraved foliage around the neck is at-
tributed to the Flemish engraver Nicaise Rous-
sel (see Cat. no. 21) and is comparable with a
cup of 1587-88 in the collection of the Gold-
smiths' Company (Carrington, pl. 10). A larger
Chinese vase with almost identical mounts,
also unmarked, was formerly in the collection
of the Marquess of Exeter (sold at Christie's,
London, June 7, 1888, lot 256, cat. ill.).

Provenance: Purchased from Crichton Brothers,
1924.
Exhibited: London, Burlington Fine Arts Club, 1926,
Case I, no. 4, plate XXX; London, Seaford House,
1929, no. 71; London, Goldsmiths' Hall, 1979, no. 68.
Literature: W. W. Watts, "English Silver...in the Col-
lection of Baron and Baroness Bruno Schröder," 1927,
pp. 249 (ill.), 252-54; E. Alfred Jones, Old Silver of
Europe and America, 1928, p. 107.

36

Playing Cards in a Box

The box Flemish, late sixteenth century; the
cards Flemish or South German, late sixteenth
century
Silver-gilt
LENGTH OF BOX: 3 in. (7.8 cm.)
WIDTH: 2 in. (5.1 cm.)
MARKS: Brussels, maker's mark indistinct, the
cards unmarked

The rectangular box with reeded molding to the
base and hinged cover, secured by a small piv-
oted clasp at the front; the front and back en-
graved with sprays of fruit and drapery swags
and the sides with abstract symmetrical de-
signs; the cover engraved with a wreath enclos-
ing an erased lozenge of arms and with a rose at
each angle, and the cards engraved with various
designs.

The first recorded reference to playing cards in
Europe is in a document of 1377 and most sur-
viving examples from that period are of Italian
origin. Toward the end of the Middle Ages the
center of production shifted to Germany, where

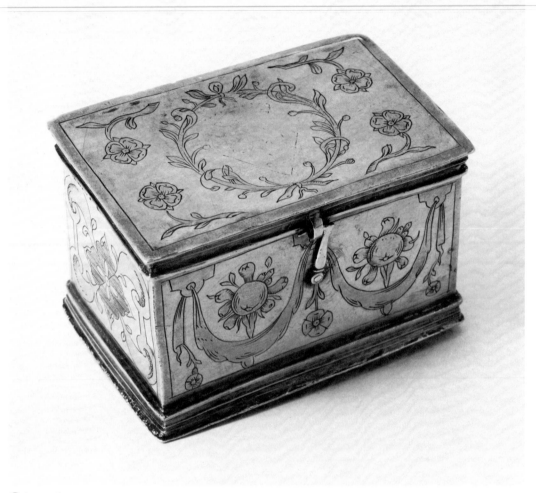

Cat. no. 36

newly developed printing techniques enabled production on a far larger scale than before. The four suits of this pack are Hearts, Bells, Leaves, and Acorns. These were quite widely adopted in Germany during the fifteenth century, although by no means became standard (Osborne, pp. 625-26). The figures represented for each suit are from different levels of society. On Hearts are members of the courtly class; on Bells, turbaned Turks or Persians; on Leaves, the gentry; and on Acorns, the well-to-do peasantry. All are depicted engaged in typical activities. Only twenty-nine cards survive in this pack, but since the total number of cards in a pack varied, it is impossible to know exactly how many are missing. It is curious to note, however, that there are apparently two aces of

Bells here, suggesting that parts from more than one matching pack may have been mingled at some stage.

A number of packs of playing cards were produced from designs by leading Nuremberg artists during the sixteenth century. Among these were those of Hans Sebald Beham (ca. 1540), Virgil Solis (1544), Peter Flötner (1540/45), and Jost Amman (1588). The present set does not correspond exactly to any of these, but is close in style to that of Solis and uses the same suits as Flötner's.

Silver playing cards are rare but not unique. Toward the end of the sixteenth century they became fashionable objects for contemporary princely "cabinets of curiosities." On his journey to Munich in 1612, the Augsburg art dealer

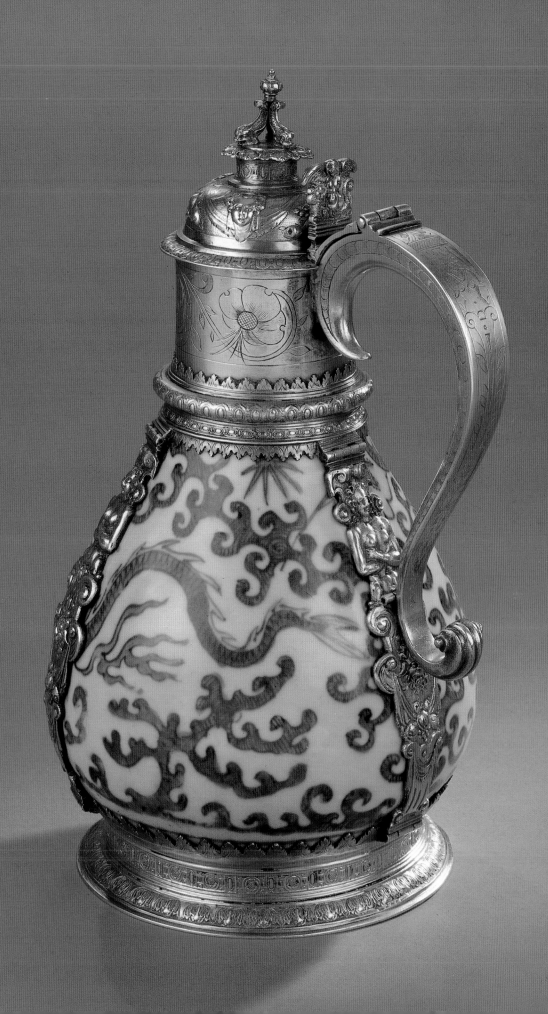

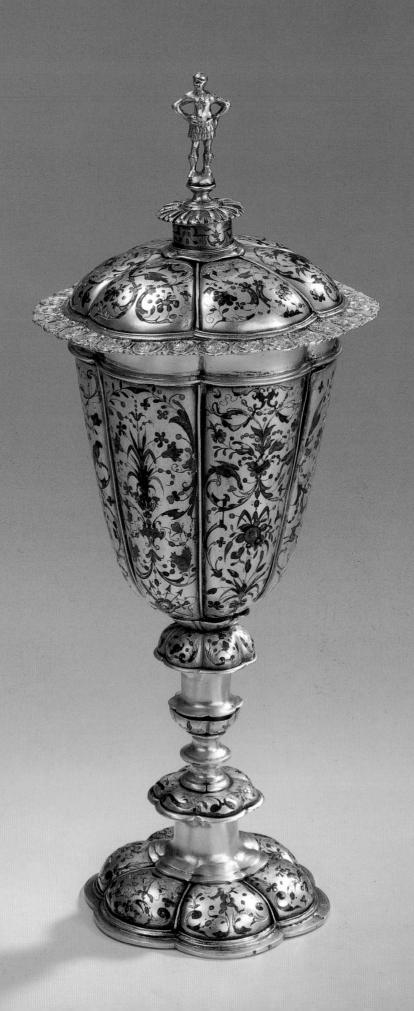

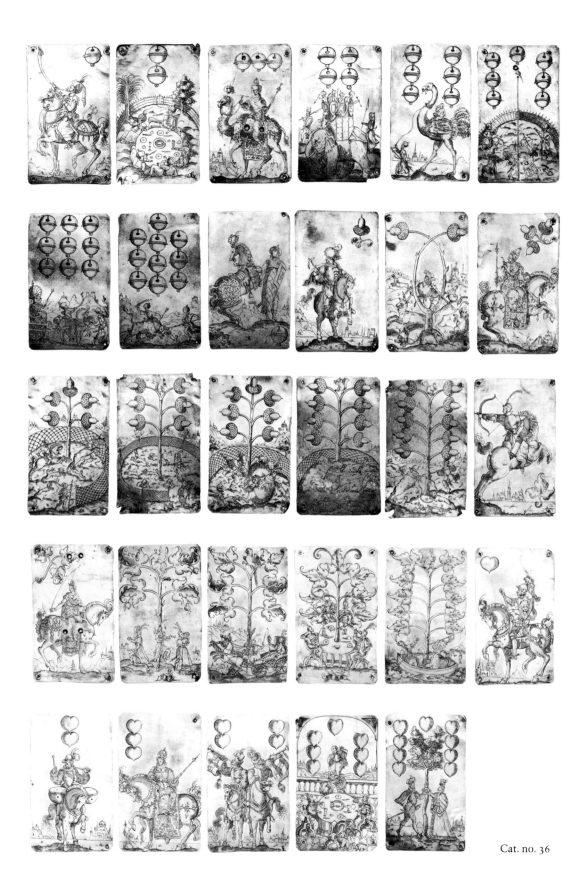

Cat. no. 36

Cat. no. 37

Philipp Hainhofer showed Prince Ferdinand and the Archdukes Albrecht and Maximilian three playing cards of silver, for each of which he was paid 100 thaler (*Welt im Umbruch*, no. 740). A set of twelve, engraved by Alexander Mair and dated 1594, is in the Royal Museum of Art and History at Brussels (*Welt im Umbruch*, no. 740).

Provenance: Earl of Home, Sale, Christie's, London, June 17, 1919, lot 90.
Exhibited: London, Goldsmiths' Hall, 1979, no. 35.

37

Cup and Cover

German, ca. 1610
Silver, parcel-gilt and enamel
HEIGHT: 11⅝ in. (29.6 cm.)
MARKS: Augsburg, maker's mark of Jeremias Mich[a]el (Seling, no. 1221); marked on foot and lip

The tapering bowl of hexafoil section, with applied panels decorated in translucent enamel with sprays of foliage, exotic birds, monkeys, and other animals; the spool-shaped foot and baluster stem with similar plaques and the raised cover with a border of shells, scrolls, and foliage and with further plaques within; with finial in the form of a standing boy, on cylindrical plinth. The finial is a later replacement.

The plaques incorporated into this cup are attributed to the workshop of David Altenstetter (ca. 1547-1617), a specialist in the production of panels of translucent champlevé enamel. Altenstetter was born in Colmar and arrived in Augsburg around 1570. During the following decades he collaborated with leading goldsmiths and clockmakers on objects embellished with such plaques. Among the most important of these was the Pomeranian Kunstschrank (cabinet of curiosities) made for Archduke Philipp II between 1610 and 1617 and on which as many as twenty craftsmen were employed. By all accounts his technique was more sophisticated than that of his contemporaries, and on his death the Augsburg art dealer Philipp Hainhofer lamented, "How many

times I warned him that his art, by which the enamel does not spring out from the metal, has been mastered by no one else and that he would take it to the grave" (*Welt im Umbruch*, p. 284).

Altenstetter did not register a goldsmith's mark with the Augsburg guild, but a number of his works are signed with initials and sometimes dated. A cup and cover belonging to the Njutanger parish, Hälsingland, Sweden, signed and dated 1610 (*Welt im Umbruch*, no. 670), is decorated with very similar plaques, and an oblong plaque in the Bayerisches Nationalmuseum, Munich, is signed "D.A. 1601" (Hackenbroch, 1979, fig. 475). An unmarked cup and cover of similar form and with similar decoration to this cup in the Wallace Collection, London (Hayward, 1976, pl. 472), has an enameled finial of spherical form and is probably very like the one that originally surmounted this cup.

Provenance: (?) Palffy Collection, Budapest.
Exhibited: London, Goldsmiths' Hall, 1979, no. 36; Augsburg, *Welt im Umbruch*, 1980. no. 728.
Literature: E. Alfred Jones, *Old Silver of Europe and America*, 1928, p. 217; Helmut Seling, *Augsburger Goldschmiede*, 1980, vol. 3, p. 139.

38

Cup and Cover

Probably German or Swiss, ca. 1600
Silver-gilt and coconut shell
HEIGHT: 10¾ in. (27.5 cm.)
MARKS: Unidentified; marked on foot and lip

On domed foot with a plain band between two of chased masks, foliage, and fruit and with brackets applied to the upper part of the vase-shaped stem; the polished nut with three vertical straps chased with personifications of Virtues and with flared lip chased with fruit and strapwork; the cover formed from a medallion struck on both sides with the arms of the Swiss cantons and the Confederation and surmounted by a figure bearing two shields. The cover is probably not original to the cup; the nut is probably a replacement and the straps, later modifications.

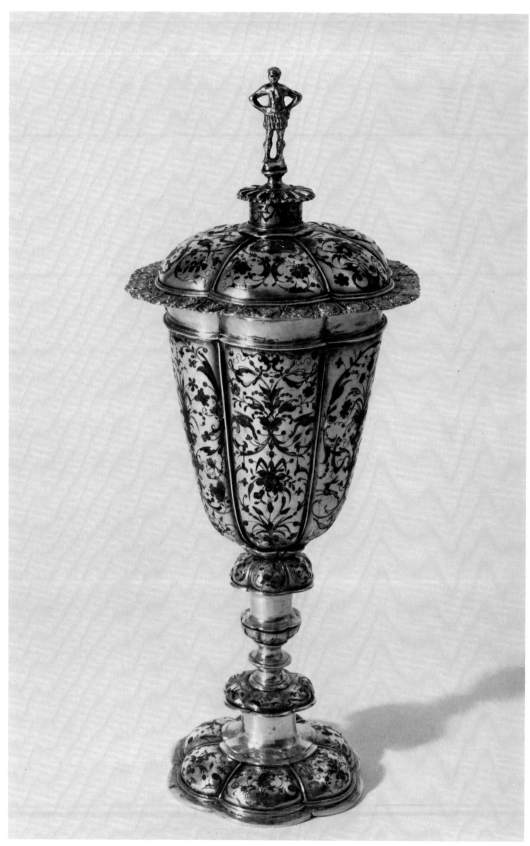

Cat. no. 37, see colorplate p. 116

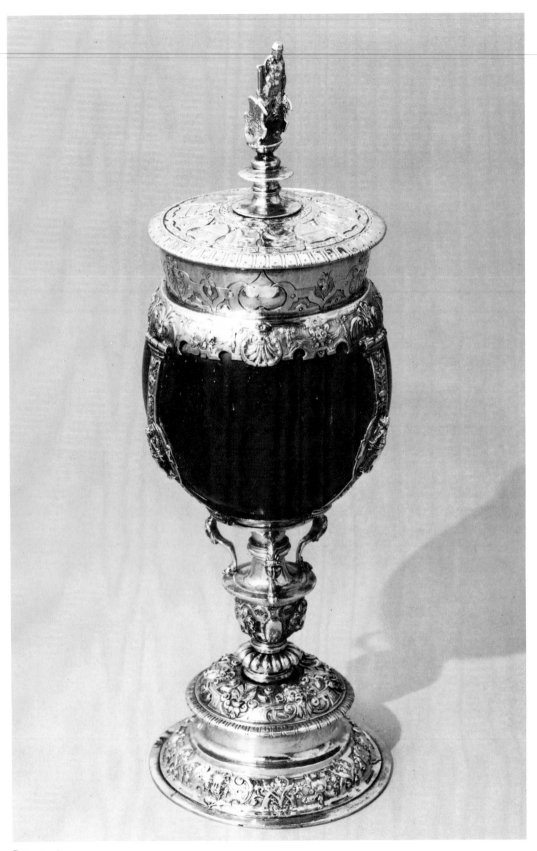

Cat. no. 38

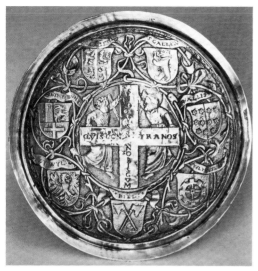

Cat. no. 38

Provenance: Earl of Home, Sale, Christie's, London, June 17, 1919, lot 78.
Exhibited: London, South Kensington Museum, 1862, no. 6313, lent by the Earl of Home; London, Goldsmiths' Hall, 1979, no. 37.
Literature: W. W. Watts, "Continental Silver in the Collection of Baron and Baroness Bruno Schröder," 1927, pp. 4 (ill.), 7; E. Alfred Jones, *Old Silver of Europe and America*, 1928, p. 332.

39

'Puzzle' Jug

German, ca. 1600, the mounts German
or Dutch
Silver, parcel-gilt, and stoneware
HEIGHT: 8 in. (20.4 cm.)
MARKS: None

The stoneware jug with ovoid body and cylindrical neck, incised with flutes and diamond-shaped facets and pierced around the neck with vesicae; the domed silver cover with partly fluted finial and winged female demi-figure thumbpiece, engraved with two coats of arms accollé; with three pipes engraved with scrolling foliage and chevrons projecting from the neck.

The arms are those of Panthaleon accollé with those of van Hoeckelum of Guelders.

The stoneware is typical of a type produced in the potteries of Siegburg, northeast of Bonn,

The cover incorporates a medal designed by Hans Jakob Stampfer of Zurich (1505-1579), commissioned by the Diet of the thirteen cantons and allied states for presentation to King Henry II of France in celebration of the christening of his daughter Claudia in 1547 and presented in 1548. According to Forrer, "The original specimen of this medal weighed 300 crowns in gold. Two others, each of the weight of 50 crowns, were struck for her sponsors. Other specimens cast in silver were issued at a later time as Presentation pieces to Statesmen and Ambassadors of foreign States" (vol. 5, p. 658). Forrer's illustrations of the obverse and reverse of the medal show the center of the design, which is concealed on the present piece by the addition of the finial.

The marks have not been identified, but previous writers have always assumed, on the evidence of the cover, that the cup is Swiss. But the cover would seem not to be original to the cup and has been made to serve as such by the crude addition of the border and the finial to the medal. Consequently, it is of no help in establishing its origin. The vertical straps applied to the nut likewise appear to be later modifications, probably necessitated by the replacement of the nut. Their quality differs from the rest of the cup, and it is unlikely that a mixed group of Virtues, two Theological and one Cardinal, would have been regarded as a satisfactory decorative program.

Cat. no. 39

Cat. no. 39

which specialized in white ware with a thin salt glaze. Although not as prolific as their Rhenish counterparts (see Cat. no. 23), these potteries exported large quantities all over northern Europe and a number exist with contemporary English silver mounts. The best period for the industry was during the second half of the sixteenth century and it never recovered properly after the town was sacked by the Swedes in 1632. Although the shape of this jug is standard, its construction is less usual for Siegburg ware: known as a "puzzle" jug, the handle is hollow and the liquid in the jug may be sucked up through one of the pipes issuing from the neck while closing the small aperture beneath the upper junction in the handle.

Provenance: Unknown.
Exhibited: London, Goldsmiths' Hall, 1979, no. 38.

40

Cup and Cover

North German, ca. 1600
Silver-gilt and cold enamel
HEIGHT: 29⅞ in. (75.7 cm.)
MARKS: Hamburg, maker's mark of Dirich Utermarke (Scheffler, 1965, no. 835); marked on foot and cover, maker's mark once and town mark twice in each case

On spool-shaped foot and with multi-baluster stem, chased with bands of fruit and scrolling foliage and with various registers of applied openwork brackets and one of cherubs; the lower part of the bowl bulbous and similarly chased, with an applied sleeve of chased and cold-enameled portraits above, and with flared lip; the raised cover stepped and similarly decorated, with applied enameled figures of Prudence, Fortitude, and Temperence, and with finial formed as Justice above a baluster plinth.

This cup is recorded as the gift of the Töbling family of Lüneburg to the Ratschatz of the town in 1602. In 1706 it was in turn presented to Georg Ludwig, Elector of Hanover (later George I of England). Dirich Utermarke (1565-1649) was a citizen of Lüneburg who emigrated to Hamburg after becoming a master goldsmith. It is probably because his work was already

known to his patron that this important commission did not go to a local goldsmith. The portraits on the bowl of the cup are very similar to those on another cup of almost identical profile in the Kremlin Museum, Moscow (Markowa, pl. 29). The latter cup has a slightly variant program of chasing and some applied brackets not found on this one, but has applied figures of the three Theological Virtues and employs the same model for the finial, although in that case apparently supporting the arms of the city of Lüneburg. In view of the presence of the remaining Virtues on the Kremlin cup, in addition to the other points of similarity, it would seem that the two cups were originally intended as companions, although probably separated at an early date.

Yvonne Hackenbroch draws attention to the fact that the figure of Justice used for the finial of this cup also occurs as one of "a sequence of virtues placed within niches along the sides of an ebony and gold casket at the Grünes Gewölbe [Dresden]." In view of his own background, Utermarke's early style "may be considered representative of the Lüneburg region at the end of the sixteenth century. Hence it is that we now propose to anchor [a certain] group of north-German jewels [incorporating these figures] in the Hansa town of Lüneburg." But bearing in mind the known trade in castings that went on between goldsmiths of different towns in the sixteenth century (see p. 18 and

Cat. no. 40

Cat. no. 30), it is clear that great care must be taken before using a single comparison as the basis for such a theory. In any event, it must be said that the style of the figures on this cup is not especially close to that of the figures on the other great work associated with Utermarke's name. This is a mirror in the Green Vaults, Dresden (Menzhausen, pl. 64) made by Utermarke in collaboration with his master, Luleff Meyer, for the widowed Electress Sophia of Saxony and delivered in 1592. On this the many figures incorporated into the design are much more anatomically detailed and marked by greater delineation of the drapery than those of the cup. As Hackenbroch points out, the figures of the cup are derived from the work of Albert von Soest, who decorated the Hall of the Great Council at Lüneburg between 1567 and 1584,

and who, according to von der Osten and Vey, "was a great craftsman, but his imagination was limited. Prints by Jost Amman and other German minor masters served him as patterns" (p. 322).

Provenance: Duke of Cumberland Collection; purchased from Crichton Brothers, (?) 1925.
Exhibited: Vienna, *Goldschmiedekunst-Ausstellung*, 1889, no. 528; London, Goldsmiths' Hall, 1979, no. 39.
Literature: M. Rosenberg, *Der Goldschmiede Merkzeichen*, 1922-28, no. 2385; W. Scheffler, *Goldschmiede Niedersachsens*, 1965, p. 416; J. F. Hayward, *Virtuoso Goldsmiths*, 1976, p. 389, pls. 526, 530; Y. Hackenbroch, *Renaissance Jewellery*, 1979, pp. 206-7.

41

Ewer and Basin

North Italian, early seventeenth century
Silver-gilt
HEIGHT OF EWER: 15½ in. (39.4 cm.)
DIAMETER OF BASIN: 23¼ in. (58.9 cm.)
MARKS: None

The vase-shaped ewer on spreading foot, cast and chased with fruit and strapwork, the ovoid body chased with cartouches containing biblical scenes, within elaborate surrounds of strapwork, masks, and sprays of fruit, the waisted neck with a grotesque figure and gadrooned lip, with caryatid figure handle; the large circular basin similarly decorated, repoussé and chased with further scenes within similar surrounds and with stamped beaded and gadrooned border, with a later crest and coronet applied to the center.

The crest and coronet are those of Fitzwilliam, for the Earls Fitzwilliam.

During the Middle Ages the ewer and basin were essential to civilized dining. Prior to the general acceptance of the fork, it was necessary to wash the hands between courses and the ewer and basin were standard items on any substantial inventory of plate. The English Royal Jewel House inventory of 1574, for example, lists only two forks of gold and thirteen of silver; on the other hand, it counts no fewer than thirty ewers with basins and many more unpaired ones (Collins, pp. 298-303, 468-502,

Cat. no. 40

124

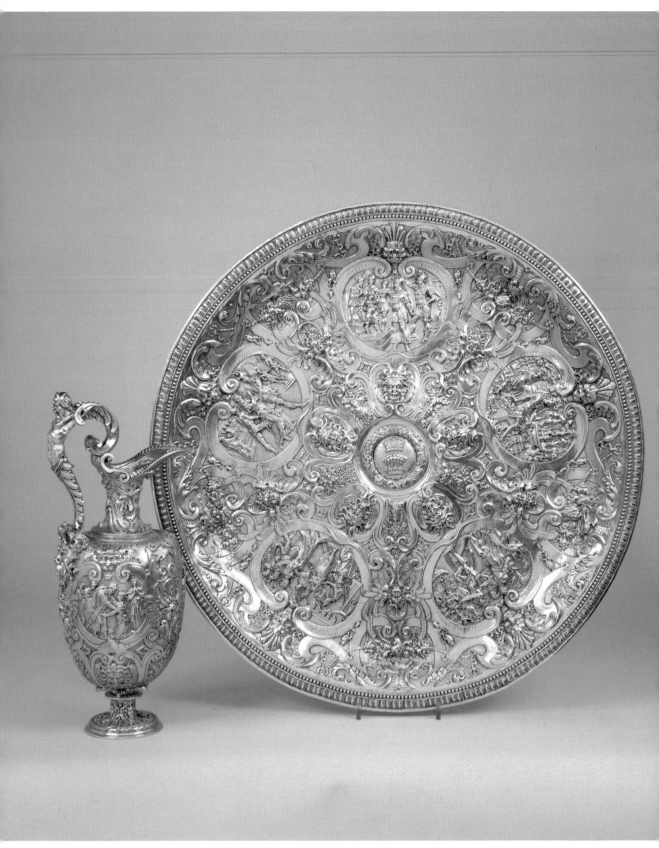

Cat. no. 41

etc.). Similarly, the inventory of Hardwick Hall, compiled in 1601, lists no forks at all, but twelve ewers with basins and again further individual ones (pp. 34-35).

The fork appeared earlier in Italy than elsewhere and by the beginning of the seventeenth century the ewer and basin was already virtually redundant. But the decline of its functional role also enabled the goldsmith to treat it entirely as an object of display, without need to compromise the design by considerations of practicality. In this case it is quite clear that neither piece can actually have been intended for use, since the one is too shallow for convenience, while the other has some minor fractures at the base of the body which seem original and would have leaked.

The eight scenes on the ewer and basin represent the story of Susanna and the Elders, taken from the History of Susanna in the Old Testament Apocrypha. The subject was popular during the sixteenth century and was widely regarded as an allegory of Grace and Chastity. The source of the designs has not been traced, but they are almost certain to have been copied from drawings specially supplied for the commission. Stylistically they are reminiscent of late-sixteenth-century Flemish Mannerism of the kind introduced to Florence by Giovanni da Bologna and are not far removed from the various bronze and wax panels produced by him for his Medici patrons.

In the absence of hallmarks a specific attribution is difficult and in this case tentative, but is based on the form of the ewer and certain decorative details of the basin. The design of the former is quite closely related to drawings by the Florentine artist Francesco Salviati, particularly in the proportions of the body and the treatment of the neck and handle (Ward-Jackson, vol. 1, no. 284). Moreover, the border of the basin corresponds exactly to other designs

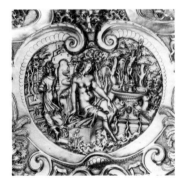

Cat. no. 41

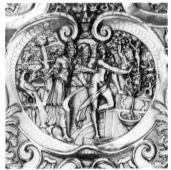

Cat. no. 41

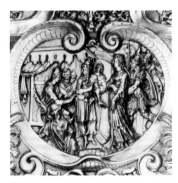

Cat. no. 41

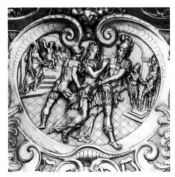

Cat. no. 41

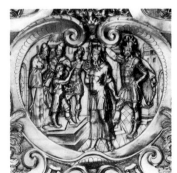

Cat. no. 41

by the same artist. Another ewer and basin in the Victoria and Albert Museum, London (Hayward, 1976, pls. 354, 355), bears Venetian marks and is broadly comparable in form and style to this. Its quality, however, falls far short. Much closer in detail and quality is a further example in the Residenz collection at Munich (Hayward, 1976, pls. 352, 353). This, too, is unmarked, but is generally accepted as Italian.

Provenance: The Countess Fitzwilliam, Sale, Christie's, London, July 7, 1982.

42

Ewer

English, ca. 1610
Silver-gilt
HEIGHT: 13⅝ in. (34.5 cm.)
MARKS: London, 1609-10, maker's mark IM billet below (Jackson, p. 107), probably for John Middleton; marked at lip

The ovoid body repoussé and chased at the shoulder with sea monsters within oval car-

Cat. no. 41

Cat. no. 41

Cat. no. 41

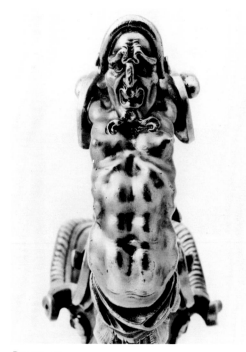

Cat. no. 41

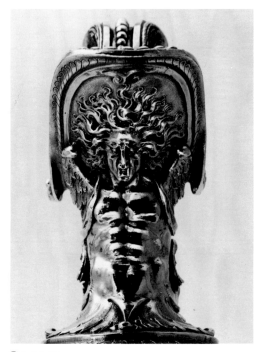

Cat. no. 41

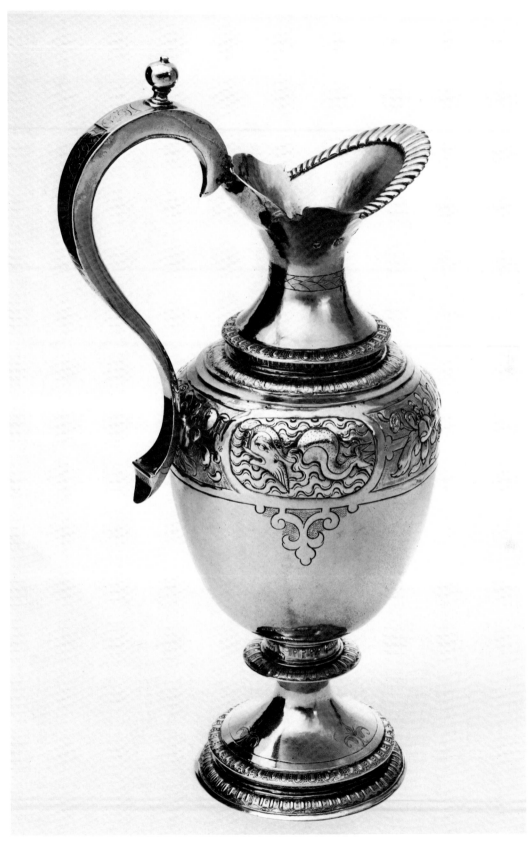

Cat. no. 42

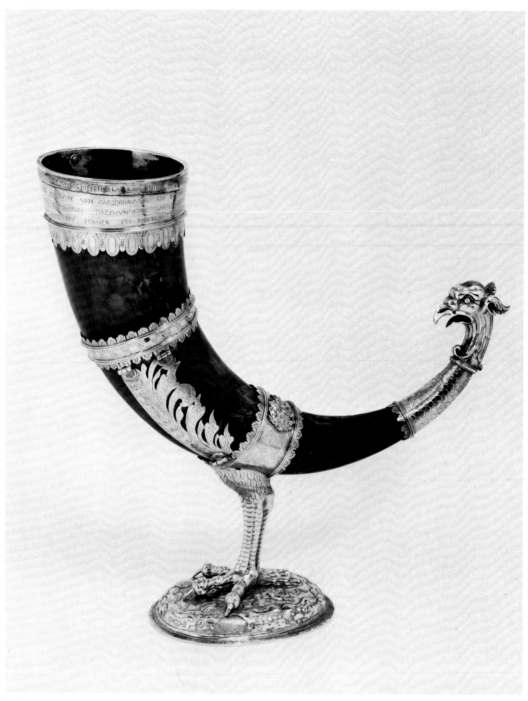

Cat. no. 43

touches and with sprays of fruit between; on waisted spreading foot with bands of stamped ornament around the border; the neck of similar design, engraved at the center with a laurel wreath and with a strip of gadroons applied to the shaped lip; with orb finial surmounting the S-scroll handle.

This ewer would probably have been supplied with a basin *en suite.* An almost identical ewer of 1607 in the Huntington Art Collection, San Marino, California (*British Silver,* no. 80), is accompanied by a basin presumably very like the one originally associated with this. Although they continued to be made for display and ceremonial purposes during the seventeenth and early eighteenth centuries, the practical function of these objects declined early in the seventeenth (see Cat. no. 41). The comparative redundancy of the basin as opposed to the ewer, together with its high bullion value, accounts for the fact that the basin survived less frequently than the ewer.

For the attribution of the maker's mark, see Cat. no. 21.

Provenance: George Webbe Dasent, D.C.L., Sale, Christie's, London, June 2, 1875, lot 131.
Exhibited: London, Goldsmiths' Hall, 1979, no. 70.
Literature: W. W. Watts, "English Silver...in the Collection of Baron and Baroness Bruno Schröder," 1927, pp. 254 (ill.), 255-56.

scription engraved around the lip-mount; a further inscription engraved around the base.

The arms are those of Garssenbüttel of Lüneburg.

The inscription around the foot may be rendered "Hartwich van Garssenbüttel, my hope is in God, made me in the year 1610." That around the lip of the horn relates the family tradition that the heirloom is in fact a griffin's claw, which was captured by Roideffke van Garssenbüttel in 1307 during combat at "Humburg." It adds that how much longer it will remain in the possession of the family "ist nach Gottes Willen."

The naturalism of this object and the comparative absence of formal ornament makes it difficult to date exactly. All the decoration is compatible with the date engraved in the first inscription, but attention should also be drawn to an almost identical example which bears mid-seventeenth-century Augsburg marks and an inscription dated 1650 (Seling, vol. 2, fig. 450).

Provenance: Duke of Cumberland Collection; purchased from Crichton Brothers, 1925.
Exhibited: London, Goldsmiths' Hall, 1979, no. 40.
Literature: M. Rosenberg, *Der Goldschmiede Merkzeichen,* 1922-28, no. 9493; W. W. Watts, "Continental Silver in the Collection of Baron and Baroness Bruno Schröder," 1927, pp. 92, 95 (ill.).

43

Drinking Horn

North German, ca. 1610
Silver-gilt and horn
HEIGHT: 13⅛ in. (33.4 cm.)
LENGTH: 13½ in. (34.4 cm.)
MARKS: Brunswick, maker's mark CK in monogram, also a merchant's mark (Rosenberg, nos. 1307, 9493); the first two marks on the lip, the third on the foot

On raised oval base repoussé and chased with grasshoppers, snails, and reptiles on rockwork ground; the stem formed as a griffin's leg and the horn with three silver-gilt hoops and terminating in a griffin's head; a coat of arms applied twice to the central hoop and an in-

Cat. no. 43

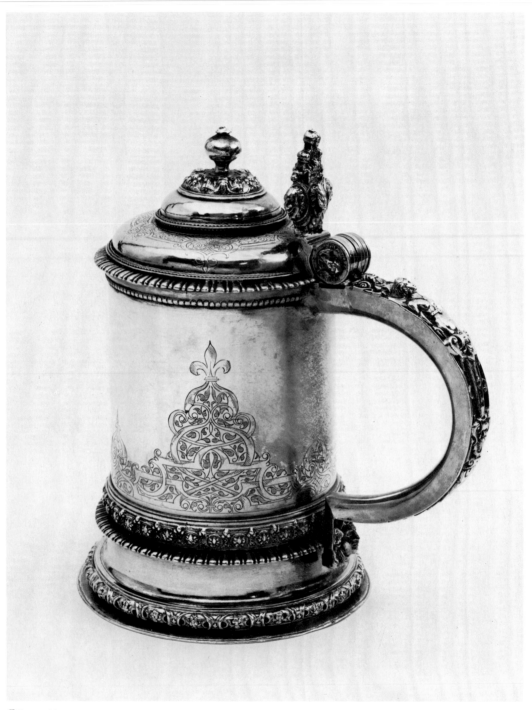

Cat. no. 44

44

Tankard

Probably South German or
Austro-Hungarian, ca. 1600
Silver, parcel-gilt
HEIGHT: 7⅝ in. (19.4 cm.)
MARKS: None

The lower part of the cylindrical body engraved
with panels of strapwork and arabesques, on
high molded foot; the cover domed in stages,
with engraved strapwork and orb finial; the
handle embossed with a terminal figure within
strapwork and the thumbpiece cast as a female
figure above grotesque masks.

While the proportions of the body make it
unlikely that this tankard was produced in
northern Germany, it is extremely difficult to
offer a more specific attribution. The engraved
decoration is typically Late Mannerist, as is the
chasing to the handle, but the moldings and the
pronounced D-form of the handle are difficult
to parallel.

Provenance: Unknown.
Exhibited: London, Goldsmiths' Hall, 1979, no. 41.

45

Double Cup

South German, ca. 1600
Silver-gilt
HEIGHT: 11⅜ in. (29 cm.)
MARKS: Nuremberg, maker's mark of
Martin Rehlein (Rosenberg, no. 3962)

Each cup of goblet form, on ogee foot with a
chased band of gadroons and strapwork and
with similarly decorated baluster stem; the
bowl embossed with masks, scrolling strap-
work, and fruit on matted ground, with a laurel
wreath beneath the lip.

The chasing of these cups shows International
Mannerism in its final, or decadent, phase; al-
though conforming to the style of the contem-
porary Hamburg cup (Cat. no. 40), the quality is
relatively indifferent and the design has been
lifted casually from one of the many standard

pattern books of the period. For a note on double
cups, see Cat. no. 5.

Provenance: Purchased from Crichton Brothers,
1920.
Exhibited: London, Goldsmiths' Hall, 1979, no. 42.
Literature: W. W. Watts, "Continental Silver in the
Collection of Baron and Baroness Bruno Schröder,"
1927, p. 10 (ill.).

46

Cup and Cover

Hungarian, early seventeenth century
Silver-gilt
HEIGHT: 11⅛ in. (28.3 cm.)
MARKS: Pressburg (Bratislava), maker's mark
of Mathias Liebhart (Köszeghy, no. 1737)

The rounded conical bowl chased with scrolls,
cherubs, and fruit on matted ground; on raised
spreading foot, with vase-shaped stem and
raised cover, the foot and cover similarly
chased, and the stem cast and chased with
swags and lions' masks, and with openwork

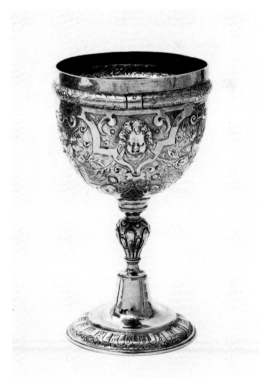

Cat. no. 45

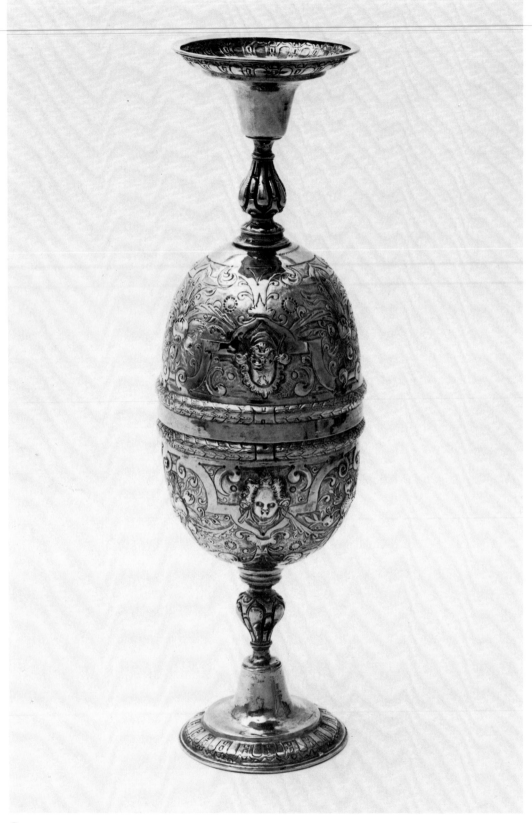

Cat. no. 45

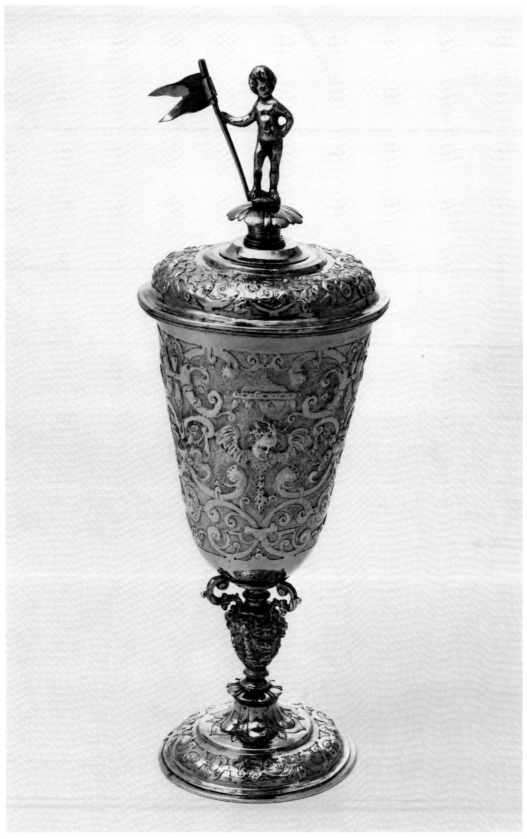

Cat. no. 46

brackets applied above; the finial formed as a standing putto holding a banner. The finial is possibly not original.

See note to Cat. no. 45.

Provenance: Anonymous, Sale, Christie's, London, July 23, 1919, lot 125.
Exhibited: London, Goldsmiths' Hall, 1979, no. 43.
Literature: W. W. Watts, "Continental Silver in the Collection of Baron and Baroness Bruno Schröder," 1927, pp. 9 (ill.), 10.

47

Windmill Cup

Dutch, ca. 1610
Silver, parcel-gilt
HEIGHT (excluding sails): 8½ in. (21.6 cm.)
MARKS: None

With inverted bell-shaped bowl engraved around the lip with strapwork and fruit and repoussé and chased above with gadroons and stylized foliage; the short baluster stem cast with ovals and surmounted by a model windmill, with a figure climbing the steps and another leaning out of the window; engraved with two coats of arms accollé and with a christening inscription dated 1619; a long blowpipe issuing from the base of the windmill. The sails are possibly of later date.

The arms are probably those of Knock of Ostfrise (Netherlands), accollé with an unidentified coat.

This is a type of wager cup chiefly found in Holland. The earliest date from around 1580 and their popularity continued until well into the seventeenth century. The sails may be turned by blowing into the pipe, and the challenge usually consisted of having to drain the cup before the sails stopped turning. It has been suggested (*Dutch Silver*, p. 373) that the dial on the mill "indicated which member of the company would be required to perform this feat."

Provenance: Albert, Lord Londesborough; included in Dell inventory, ca. 1910.
Exhibited: London, Goldsmiths' Hall, 1979, no. 44.
Literature: F. W. Fairholt, *Catalogue of the Collection of . . . Albert, Lord Londesborough,* 1860, p. 13, no. 4, pl. X, 4.

48

Wine Cup

English, ca. 1616
Silver-gilt
HEIGHT: 5½ in. (13.9 cm.)
MARKS: London, 1616-17, maker's mark AB conjoined (Jackson, p. 112), for Anthony Bennett; marked at lip, lion passant beneath the foot

With rounded conical bowl, tall baluster stem, and spreading foot, the foot and bowl chased with a calyx of acanthus foliage and the bowl flat-chased beneath the lip at intervals with stylized foliage; pricked with initials ITE and the underneath of the foot engraved at a later date with further initials SEP.

Wine cups seem to have become popular in England toward the end of the sixteenth century and to have remained in fashion until well into the seventeenth. Thereafter they were gradually replaced by glass drinking vessels, except for ceremonial purposes. Clayton (p. 96) suggests that the form was an Elizabethan innovation, on the grounds that very few survive from the last quarter of the sixteenth century, whereas they become relatively common thereafter. This is supported by the fact that hardly any can be identified in the Hardwick Hall inventory of 1601 or the Royal Jewel House inventory of 1574.

For the attribution of the maker's mark, see Cat. no. 21.

Provenance: Unknown; included in Dell inventory, ca. 1910.
Exhibited: London, Goldsmiths' Hall, 1979, no. 71.

49

Steeple Cup

English, ca. 1620
Silver-gilt
HEIGHT: 20¾ in. (52.7 cm.)
MARKS: London, 1619-20, maker's mark IS, cinquefoil below (Jackson, p. 115); marked on bowl and cover, lion passant under foot

On tall waisted foot, with baluster stem and rounded conical bowl, the foot and bowl chased

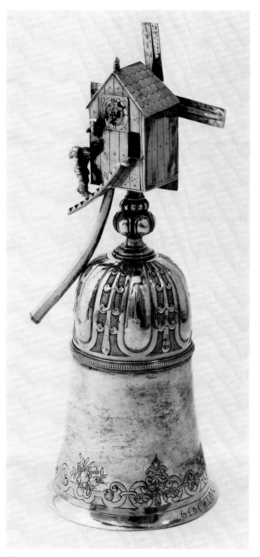

Cat. no. 47

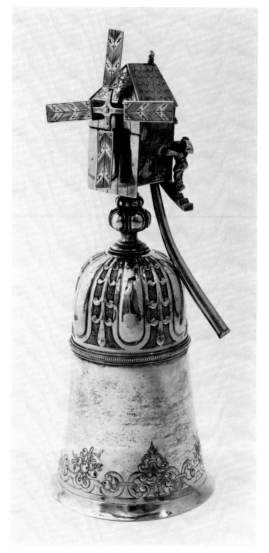

Cat. no. 47

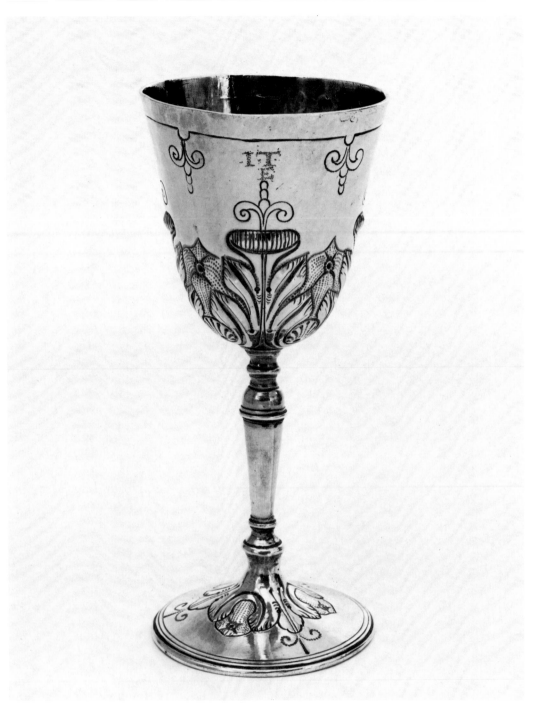

Cat. no. 48

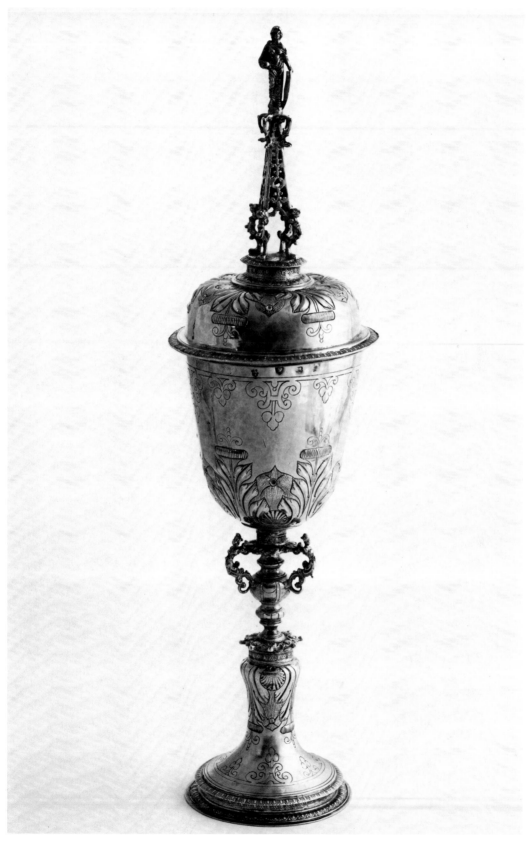

Cat. no. 49

with a calyx of acanthus foliage and flat-chased with a band of foliate strapwork, with applied openwork brackets to the stem; the similarly chased domed cover with finial formed as a pierced steeple above brackets and surmounted by a female figure holding a shield engraved with a coat of arms.

The arms, without tinctures on the chief or impalement, could be for any of several families but are given in Christie's sale catalogue (see Provenance) as those of Sir Thomas Glen, "several times Mayor of Norwich in the reigns of Elizabeth and James I." A note in the catalogue adds that "this splendid piece was acquired at Bensley's sale in Norwich in the year 1849."

The steeple cup, so called because of its characteristic finial, is a peculiarly English form. Recorded as early as 1599, it rapidly became popular and remained a standard piece of display plate until well into the second quarter of the seventeenth century. Norman Penzer records 148 surviving examples with marks ranging from between 1599 to 1646 and on this evidence shows that the popularity of the form peaked in 1611, from which year 14 survive. The tall pyramidal finial was not a motif restricted to goldsmiths, but is frequently found in architectural decoration as well; Gerald Taylor (p. 114) draws attention to the screen in the hall of Wadham College, Oxford (1610-13), and the courtyard of Burghley House, Northamptonshire (1577-85) might also be mentioned.

The final figure is a model frequently used during the period and is found, for example, on a standing cup of 1590, belonging to the corporation of Portsmouth (*Corporation Plate*, no. 5, pl. VII) and on a steeple cup of 1627 in the Victoria and Albert Museum, London (Oman, 1965, pl. 46).

Provenance: (?) Bensley, Sale, Norwich, 1849; George Webbe Dasent, D.C.L., Sale, Christie's, London, June 2, 1875, lot 129.
Exhibited: London, Burlington Fine Arts Club, 1926, Case I, no. 5; London, 25 Park Lane, 1929, no. 79; London, Goldsmiths' Hall, 1979, no. 72.
Literature: W. W. Watts, "English Silver...in the Collection of Baron and Baroness Bruno Schröder," 1927, pp. 255 (ill.), 256; Norman Penzer, "An Index of English Silver Steeple Cups," 1962, no. 120.

Cat. no. 49

50

Peg Tankard

Norwegian, ca. 1620
Silver
HEIGHT: 8⅝ in. (22 cm.)
MARKS: Bergen, maker's mark ML conjoined in a shaped shield; marked under the base

The tall cylindrical body engraved with scrolling strapwork, fruit, and foliage beneath the lip and with an applied rib toward the base; on raised foot and with stepped domed cover, each chased with bands of scrolls and fruit and with a medallion engraved with a merchant's mark and initials NR set into the cover; with engraved scroll handle and cast cherub thumbpiece.

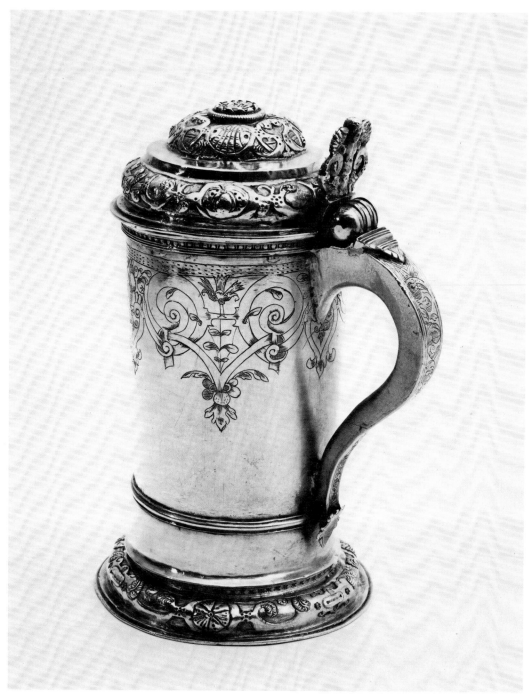

Cat. no. 50

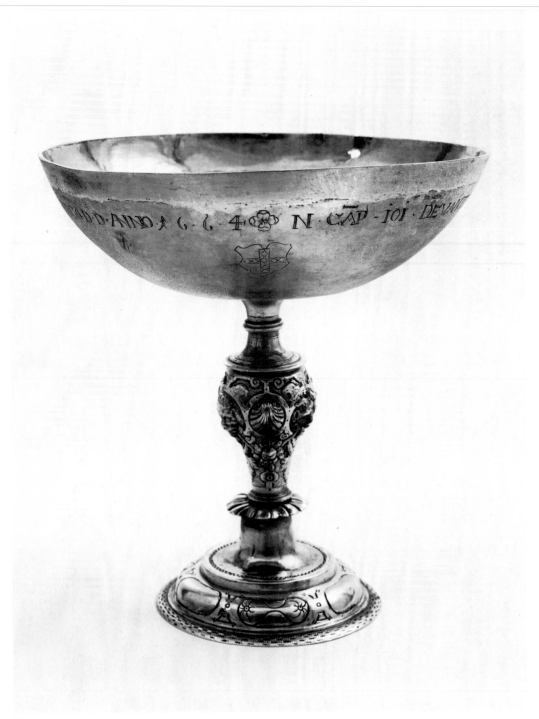

Cat. no. 51

The term "peg-tankard" refers to the stud or studs set at regular intervals down the inside wall of the body. Grose's *Dictionary*, published in 1785, describes their function as follows: "By the rules of good fellowship, every person drinking out of one of these tankards, was to swallow the quantity contained between two pins; if he drank more or less, he was to continue drinking until he finished at a pin: by this means persons unaccustomed to measure their draughts were obliged to drink the whole tankard" (Ash, p. 103). Particularly popular in Scandinavia, such tankards are also found bearing York marks of the second half of the seventeenth century.

Provenance: Unknown; included in Dell inventory, ca. 1910.
Exhibited: London, Goldsmiths' Hall, 1979, no. 46.

51

Cup

Swiss, early seventeenth century
Silver, parcel-gilt
HEIGHT: 6⅜ in. (16.3 cm.)
MARKS: Sion, maker's mark T, a device below (Rosenberg, no. 8964)

The plain shallow bowl with a print engraved with a coat of arms and an inscription applied to the center, and with a Latin inscription dated 1664 engraved around the outside, with a further coat of arms below; on ogee foot flat-chased with a band of ovals containing stylized fruit and with baluster stem, the stem cast and chased on the lower part with shells and masks within strapwork and of plain spool form above.

The arms on the print inside the bowl are unidentified; those engraved on the outside are probably those of Vantery, of Valais, Switzerland.

The inscription around the outside of the bowl is extremely obscure and contracted, but should probably be rendered, "Our Captain Johannes Devanteri [(?) Jean de Vantery] gives and dedicates [this object] to our fort on behalf of those who were faithful in the building of it and in memory of their other services. Anno

1664." The reference is not clear, but given that the cup was made in Sion (capital of Valais), and that it is engraved with the arms of a town in that canton (Vantery), it is probably connected with some event there.

The treatment of the foot and stem both suggest a date rather earlier than the inscription. The latter, while appearing even earlier than the foot, is probably original to it, in view of the construction of the piece as a whole.

Gruber (*Weltliches Silber*, no. 41) suggests that the maker's mark is probably for a member of the Tufitscher family, who came from Brig in the same canton.

Provenance: Unknown; included in Dell inventory, ca. 1910.
Exhibited: London, Goldsmiths' Hall, 1979, no. 47.
Literature: Marc Rosenberg, *Der Goldschmiede Merkzeichen*, 1922-28, no. 8964.

52

Wine Cup

English, ca. 1634
Silver
HEIGHT: 5⅛ in. (13.2 cm.)
MARKS: London, 1634-35, maker's mark IB buckle below (Jackson, p. 119); marked at lip, lion passant beneath the foot

The bowl of plain conical form, on spreading foot and with cast baluster stem with a knop above and below, the bowl pricked with initials IS and date 1634, within a foliate surround, the foot similarly pricked with initials WM and date 1861.

From about 1625 to 1650 wine cups were almost invariably plain and of this form. As the century advanced their proportions tended to become progressively squatter; compare two of 1623 and 1637 in the Victoria and Albert Museum, London (Oman, 1965, pls. 47, 49) and another of 1651 in the Metropolitan Museum (Hackenbroch, 1969, no. 39).

For further on wine cups, see Cat. no. 48.

Provenance: Louis Huth Collection, Sale, Christie's, London, May 26, 1905, lot 41.

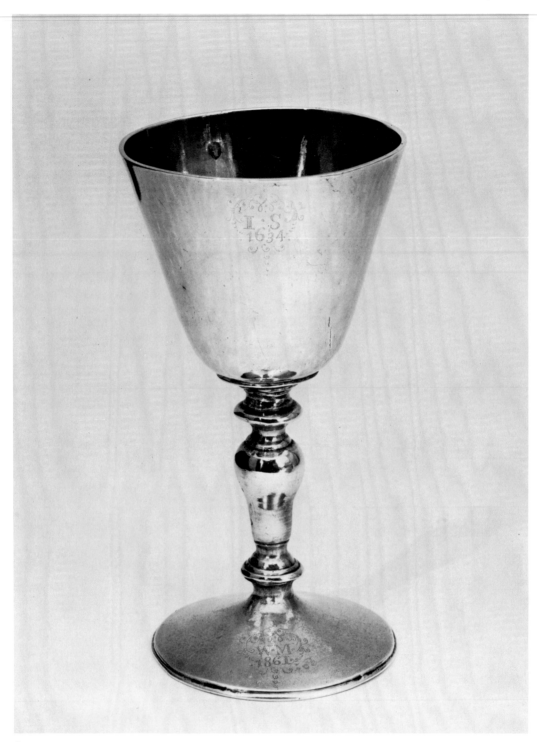

Cat. no. 52

Tankard

North German, ca. 1650
Silver, parcel-gilt
HEIGHT: 7⅜ in. (18.9 cm.)
MARKS: Hamburg, maker's mark a sun in splendor; marked under base

The cylindrical body engraved with a classical scene, the white engraving reserved on gilt ground; with raised foot and cover, each repoussé and chased with scrolls and masks on matted ground, and with finial in the form of a naked seated child; the scroll handle cast with auricular ornament and with fan-shaped fluted thumbpiece. The finial is probably not original.

The subject of the engraved frieze has not been identified but may be taken from the story of Timour, who was said to be a descendant in the female line from Genghis Khan. His story was popularized in England during the sixteenth century by Christopher Marlowe's play *Tamburlaine the Great.*

Provenance: Sir John Duncan Bligh, K.C.B., Sale, Christie's, London, Feb. 16, 1912, lot 190.
Exhibited: London, Goldsmiths' Hall, 1979, no. 48.

Tankard

Hungarian, mid-seventeenth century
Silver-gilt
HEIGHT: 9½ in. (24.2 cm.)
MARKS: Leutschau, maker's mark of David Generisch (Közseghy, no. 1178); marked on foot and cover

The cylindrical body repoussé and chased with auricular masks, scrolls, and bunches of fruit on matted ground, on similarly chased domed foot and with a band of stamped circles and pellets between foot and body; the domed cover similar to the foot, with a raised wreath in the center and with swan finial; the scroll handle with cartouche-shaped thumbpiece.

The slender proportions of this tankard would have seemed rather old-fashioned in the main centers of the craft in Germany and reflect the somewhat conservative character of eastern Europe in the mid-seventeenth century. The decoration is transitional, between the "auricular" style of fluid scrolls popularized in Holland early in the century and the more representational and "scientific" floral style of the third quarter of the century.

Provenance: Purchased from S. J. Phillips, 1980.

Cat. no. 53

Cat. no. 53

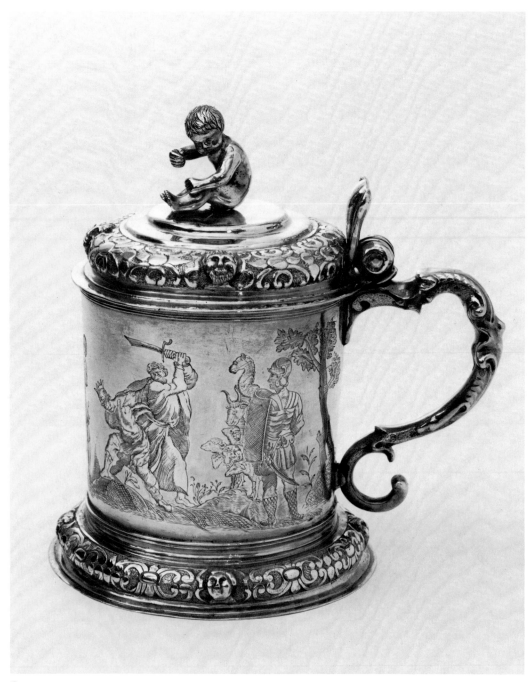

Cat. no. 53

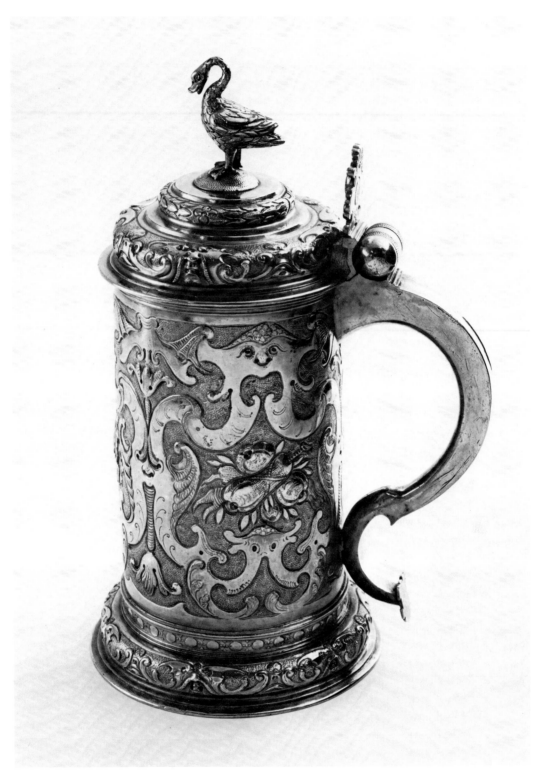

Cat. no. 54

Beaker

Dutch, ca. 1660
Silver
HEIGHT: 9½ in. (24.1 cm.)
MARKS: Dordrecht, 1659, maker's mark II in a
shaped shield; marked under base

The tapering body with flared lip and plain ring
foot with a reeded band above, engraved be-
neath the lip with portraits of rulers of the
House of Orange – William I, Maurice, Freder-
ick, and William II and III – each within auricu-
lar scroll surround; a coat of arms and two fish
engraved beneath.

 The arms are probably those of van Suythem
of Overyseel.

The portraits of Maurice, Frederick, and
William I are all derived from paintings by
Michiel van Mierevelt (1567-1641), who was
official portrait painter to the House of Orange.

Provenance: Stowe House, Sale, Christie's, Sept. 7,
1848 (19th day's sale), lot 606; George Webbe Dasent,
D.C.L., Sale, Christie's, London, June 2, 1875, lot 118.
Exhibited: London, Goldsmiths' Hall, 1979, no. 50.
Literature: E. Alfred Jones, *Old Silver of Europe and
America*, 1928, p. 230.

Tankard

North German, ca. 1660
Silver, parcel-gilt
HEIGHT: 8⅜ in. (21.2 cm.)
MARKS: Kiel (Schleswig-Holstein), maker's
mark a double fleur-de-lis

On three ball feet, the body repoussé and chased
with the stories of Hagar and Ishmael in the
wilderness, Elijah being fed by the ravens and
on the journey to Horeb, each within oval sur-
round and with scrolling foliage between; a
similarly chased disk, with Jezebel exhorting
Ahab to take Naboth's vineyard, applied to
the cover; with cast handle and bifurcated
thumbpiece.

The massive proportions and bold chasing
typify the Baroque style (see p. 24). Pieces of
such size would certainly have been intended
for display rather than use. The bold sculptural
style is characteristic of north Germany during
the second half of the seventeenth century, and
numerous other tankards from Hamburg with
similar handles may be cited, including one in
the Victoria and Albert Museum, London, and
another in the Kunstgewerbemuseum, Berlin
(Hernmarck, figs. 214, 215).

Provenance: Unknown; included in Dell inventory,
ca. 1910.
Exhibited: London, Goldsmiths' Hall, 1979, no. 51.

Cat. no. 55

Cat. no. 56

Cat. no. 55

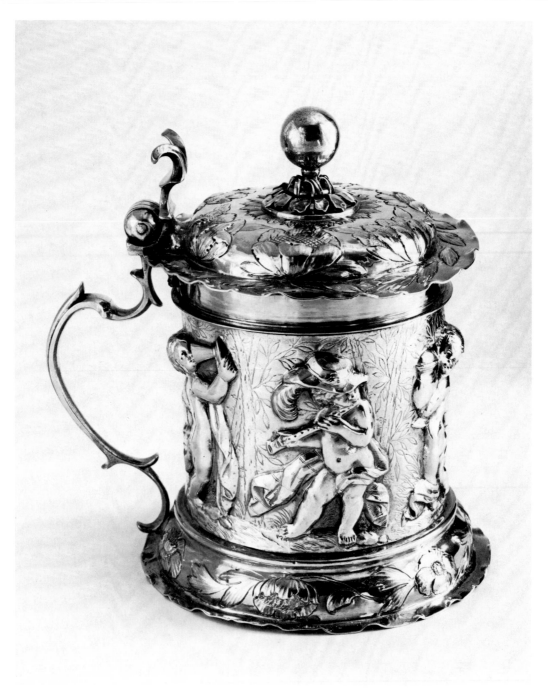

Cat. no. 57

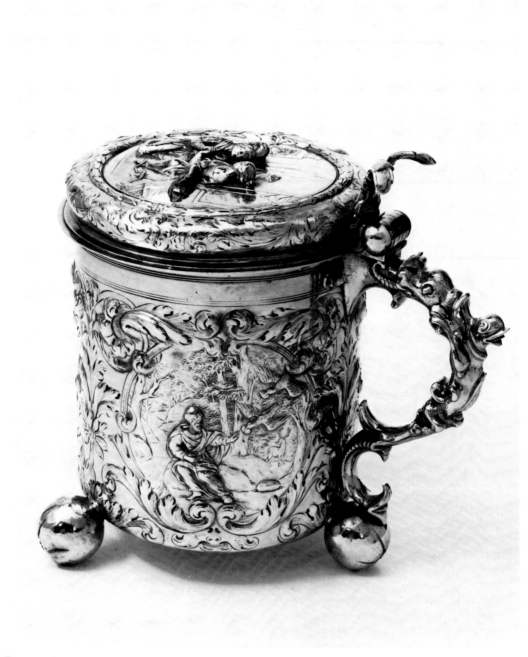

Cat. no. 56

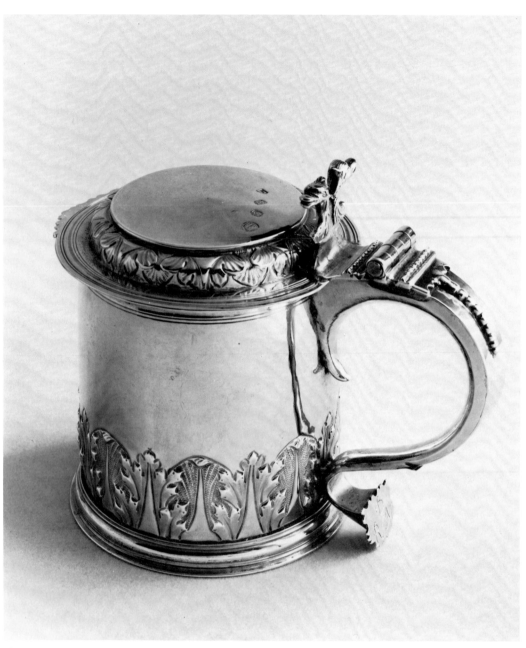

Cat. no. 58

57

Tankard

German, ca. 1670
Silver, parcel-gilt
HEIGHT: 6⅞ in. (17.5 cm.)
MARKS: Augsburg, maker's mark of David
Schwestermüller I (Seling, no. 1442); marked
on foot, lip, and cover

The cylindrical body with an applied sleeve
repoussé and chased with a frieze of bacchana-
lian putti in a landscape, on raised foot chased
with foliage and with waved border; the
slightly domed cover similar to the foot and
with ball finial above a calyx of foliage, with
scroll handle and bifurcated thumbpiece.

None of the three variants of this maker's mark
shown by Seling corresponds exactly to the
mark on this tankard, since the former all show
the two letters conjoined. However, there can
be little doubt about the attribution; Schwes-
termüller appears to have been a specialist
maker of exactly this kind of tankard, with its
characteristic cast scroll handle secured to the
body with nuts rather than solder and the deco-
ration of the barrel chased onto a separate
sleeve rather than onto the body itself. Numer-
ous examples with Schwestermüller's mark
may be cited, including a number in the Krem-
lin museum, Moscow (e.g., Seling, pl. 429).

Provenance: Purchased from Kenneth Davis, 1979.

58

Tankard

English, ca. 1680
Silver
HEIGHT: 6½ in. (16.3 cm.)
MARKS: London, 1679-80, maker's mark GS
in a dotted circle (not recorded by Jackson);
marked on body and cover, maker's mark twice
on handle

Of plain cylindrical form, on reeded rim foot
and repoussé and chased on the lower part of
the body with acanthus foliage, the raised cover
similarly chased and with addorsed birds' heads

thumbpiece; the scroll handle with an applied
beaded rat-tail and engraved on the lower ter-
minal with initials RAM in script; engraved
under the base with an inscription reading,
"The gift of my dear mother Mrs Ann Dunwel
Ano Do 1682."

The Civil War in England led to a vast amount
of plate being melted down in order to mint
silver coinage. It was only after the restoration
of Charles II in 1660 that confidence in long-
term stability returned sufficiently for large-
scale manufacture of plate to be undertaken.
Christie's records show fewer than a hundred
silver tankards from the period 1641-60 but
nearly four times that number for the ensuing
twenty years. This particular type, with its
chased foliage to the lower part of the body,
was one of the more popular models.

Provenance: Unknown; included in Dell inventory,
ca. 1910.

59

Tankard

Swedish, ca. 1685
Silver, parcel-gilt
HEIGHT: 8¾ in. (22.2 cm.)
MARKS: Maker's mark of Jöran Eriksson Straus
of Stockholm (Andrén, no. 248); marked under
base, town mark lacking

The plain cylindrical body on three ball feet
cast and chased with fruit and with similarly
chased triangular panels applied to the body
immediately above; the cushion-shaped cover
with an inset medallion within an engraved
band of scrolling foliage; the scroll handle em-
bossed with further fruit and with thumbpiece
similar to the feet.

The medallion in the cover is dated October 7,
1682, and was designed by Arfvid Karlsteen
(1654-1718) to commemorate the opening of
the Riksdag on that day by King Charles XI.

Provenance: Unknown; included in Dell inventory,
ca. 1910.
Exhibited: London, Goldsmiths' Hall, 1979, no. 52.

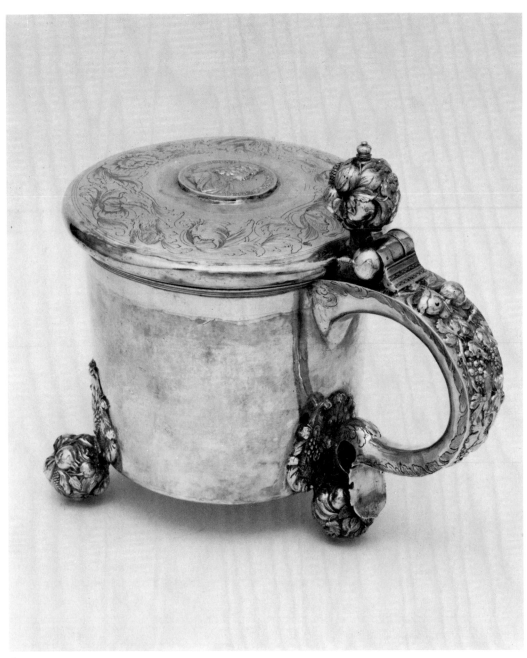

Cat. no. 59

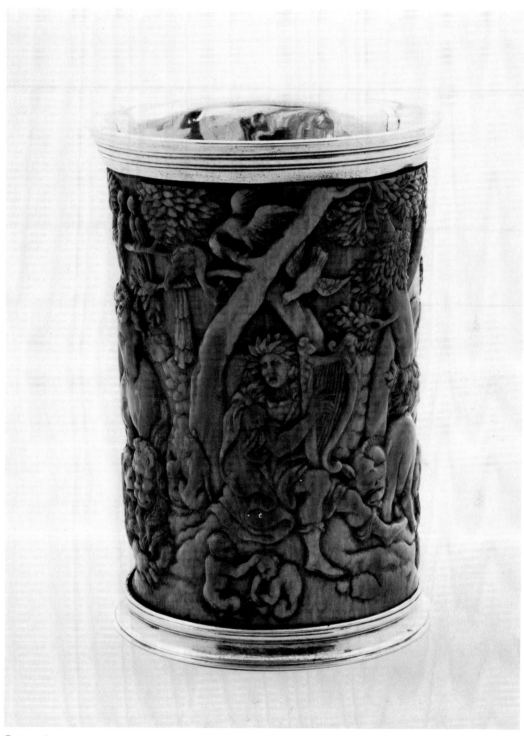

Cat. no. 60

60

Beaker

French, ca. 1700
Silver-gilt and bone
HEIGHT: 5½ in. (14.2 cm.)
MARKS: Strasbourg (town mark only); marked under base

The tapered cylindrical body with silver-gilt lining, carved in relief with Orpheus charming the animals; with molded silver-gilt rim foot and everted lip.

The subject of Orpheus charming the animals with his music was a popular one in classical times and was regarded in the early Church as a pagan pre-figuration of the coming of the Messiah, when "The wolf...shall dwell with the lamb, and the leopard shall lie down with the kid" (Isaiah 11:6).

The source of this design has not been traced. However, its general style is close to that of the sculptor Francesco Fanelli (working 1609/10-ca. 1665) and it is notable that the rather contrived pose of the bear to the right of Orpheus is repeated exactly in a bas-relief panel of the same subject by Fanelli in the Victoria and Albert Museum, London. Fanelli was Italian, first recorded as working in Genoa, and subsequently in England from about 1631. By 1635 he was working directly for Charles I. He left during the early 1640s and is thought to have spent the rest of his working life in France.

Provenance: Purchased from Crichton Brothers, 1924.
Exhibited: London, Goldsmiths' Hall, 1979, no. 53.

61

Model of a Bull

German, ca. 1700
Silver-gilt
HEIGHT: 10¼ in. (26 cm.)
MARKS: Augsburg, maker's mark of Marx Weinold (Seling, no. 1671); marked on base and body, the head unmarked

The rearing body cast in seven sections and with detachable head, chased throughout with hair, the hoofs, and horns ungilded; the oval base chased around the border with gadroons and flat-chased within with scrolling strapwork and foliage on matted ground.

Although the great period for silver models of animals was the late sixteenth century, their popularity never diminished for long in the seventeenth, and toward the end of the century there was a modest revival of the form. Weinold

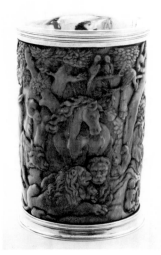

Cat. no. 60 Cat. no. 60 Cat. no. 60

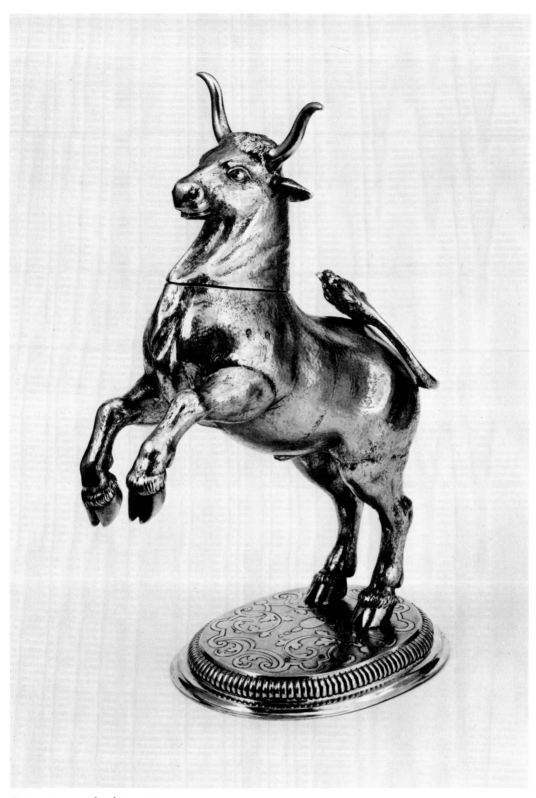

Cat. no. 61, see colorplate p. 56

(formerly misidentified by Rosenberg as Mattheus Wolff) was something of a specialist in this field and a number of other animals by him are recorded, including a rabbit in the Green Vaults, Dresden, and a bear in the Waddesden Bequest at the British Museum (Read, p. 68, no. 139). Seling gives the year of his death as 1700.

Provenance: (?) R.v. Passavant-Gontard, Sale, lot 139; Dr. F. Mannheimer, Sale, Frederik Muller & Cie., Amsterdam, Oct. 14-21, 1952, lot 186; Paul Wallraf, Esq., London; purchased from Kenneth Davis, 1982.

62

Pair of Sconces

English, ca. 1700
Silver
HEIGHT: 11⅞ in. (30 cm.)
MARKS: London, 1700-1701, maker's mark of Joseph Ward (Grimwade, no. 2989); marked on backplates, maker's mark and lion's head erased on wax pans and lion's head only on branches and sockets

Each with large shaped oval backplate and single branch, the backplate repoussé and chased with angels, putti, and foliage surmounted by an eagle and centered with a laurel wreath enclosing a coat of arms; the faceted scroll branch issuing from a grotesque mask and with circular gadrooned wax pan and cylindrical socket chased with foliage.

The arms are apparently those of West.

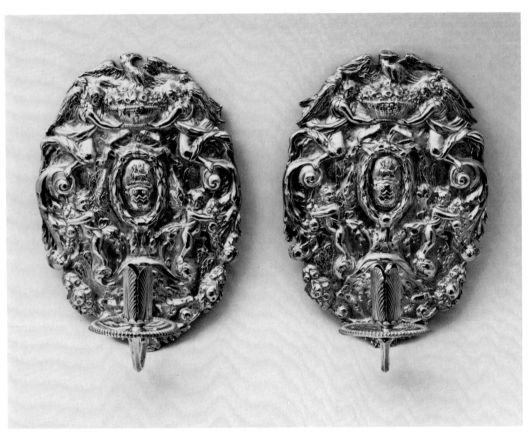

Cat. no. 62

Sconces were popular during the late seventeenth and early eighteenth centuries. They worked on the principle of reflecting the light of the candle against the backplate and diffusing it around the room. The prominently chased design of the backplate was therefore practical as well as decorative, in that it made the light less directional than it would be against a polished surface. Although they appear frequently on inventories of the period in large sets, most have since been destroyed and their decline in popularity is presumably to be associated with the generally larger rooms of the eighteenth century which made hanging chandeliers a more effective and safer form of lighting.

These are considerably larger than the average sconces of the period. An identical pair, by the same maker and of the same year, is in the Untermyer Collection in the Metropolitan Museum, New York (Hackenbroch, 1969, p. 49, no. 93). They differ only in the absence of the chased arms in the center.

Provenance: F. H. Woodroffe.
Exhibited: London, Burlington Fine Arts Club, 1901, Case G, no. 15, lent by Mr. F. H. Woodroffe.
Literature: Y. Hackenbroch, *English and Other Silver in the Irwin Untermyer Collection,* 1969, p. 49, no. 93.

63

Ewer

English, ca. 1700
Silver
HEIGHT: 12¼ in. (31.2 cm.)
MARKS: London, 1700-1701, maker's mark of Pierre Harrache I (Grimwade, no. 936); marked at lip and with lion's head erased under foot

The body of "helmet" form, with cut-card flutes and a plain rib applied to the lower part and with gadrooned rib applied beneath the lip, the shaped lip with molded border and with a cast mask-and-scroll molding applied opposite the caryatid scroll handle; on circular foot with gadrooned border and fluted knop; engraved with a coat of arms within scroll and foliage cartouche.

The arms are those of Lowndes of Winslow, Co. Bucks, impaling Atcherley, for Robert Lowndes (1680-1727) who married Margaret, daughter of Richard Atcherley, Esq.

A simple version of the helmet-shaped ewer was produced by English goldsmiths during the second half of the seventeenth century, but it was not until the arrival of the immigrant Huguenot goldsmiths from France at the end of the century that the fully developed form was introduced to England. In terms of their carefully calculated form, their generous use of metal, the balance of plain and decorated surfaces, or the sculptural quality of the applied ornament, these ewers epitomize the Hugue-

Cat. no. 63

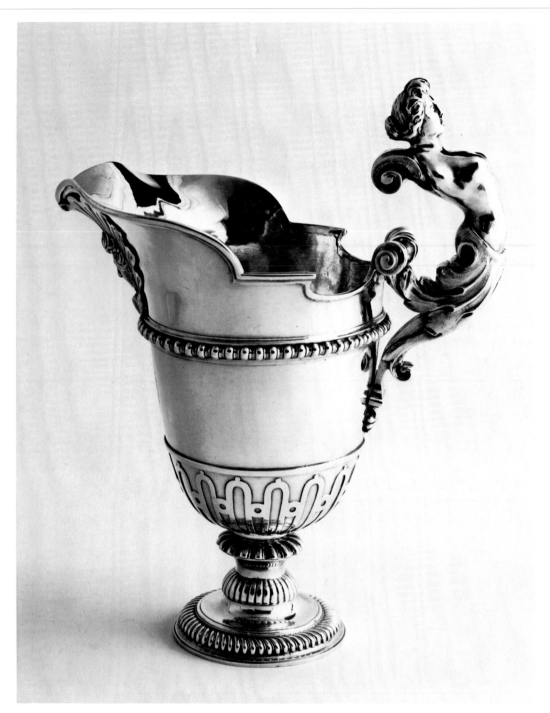

Cat. no. 63

nots' awareness of the plasticity of the material and their contribution to English silver.

The maker's mark on this ewer is the one ascribed by Grimwade to the elder of the two goldsmiths named Pierre Harrache. However, some doubt surrounds attributions to Harrache senior and junior around the turn of the century, due partly to uncertainty as to the exact date of the elder's death and partly to the failure of earlier writers to distinguish between the two marks (Grimwade, p. 533-35). Heal (p. 169) records the date of the elder's death as 1700 and although this ewer bears his mark, it would seem likely that responsibility for it lay more with son than father. Not only was it marked at least halfway through the year of his supposed death (the London assay office date-letter traditionally changes on St. Dunstan's Day, May 19), but the proportions of the design are slightly more attenuated than those of Harrache the Elder and almost identical with those of another ewer of the same year which bears the mark of the Younger and the arms of the Earl of Ancaster (London, Seaford House, pl. 57).

The basin originally associated with this ewer is in a private collection in England. It is not clear when the two were separated, although this was presumably prior to 1888 when the ewer appeared on the market.

Provenance: Anonymous, Sale, Christie's, London, Mar. 22, 1888, lot 132.

64
Écuelle, Cover, and Stand

German, ca. 1710
Silver-gilt
DIAMETER: écuelle, 5¼ in. (13.3 cm.), stand, 8⅞ in. (22.7 cm.)
MARKS: Augsburg, maker's mark of Thomas Dankenmair (Seling, no. 1998); marked on stand, body, and cover

The plain circular body with flat handles pierced with scrolls and foliage; the raised cover embossed with a symmetrical design of scrolls and foliage emanating from a central flower head, within a gadrooned surround and with three applied scroll brackets, reversible to form feet; the circular stand similarly chased around the border to the cover.

The form of covered bowl known as the *écuelle* was especially popular in France during the late seventeenth and early eighteenth centuries but is also frequently found in Germany and Northern Italy. Hernmarck (pp. 78-79) describes their function as follows: "From the latter part of the seventeenth century the *écuelle* became particularly popular as a bowl for serving bouillon in the morning, or beef-tea to invalids.... It should be pointed out that small smooth bowls with two handles and a cover are often found in early toilet sets. Closer examination shows that they are usually of somewhat later date than the rest of the service, and this seems to favour the tradition which asserts that the toilet set would be a wedding present and the bowl a later addition after the birth of the first child; a tradition which also fits in well with the *écuelle's* customary use as a gift to women in childbirth." The German name for these objects, *Wöchnerinnenschüssel,* also reflects this practice.

Provenance: Unknown; included in Dell inventory, ca. 1910.
Exhibited: London, Goldsmiths' Hall, 1979, no. 55.
Literature: E. Alfred Jones, *Old Silver of Europe and America,* 1928, p. 225.

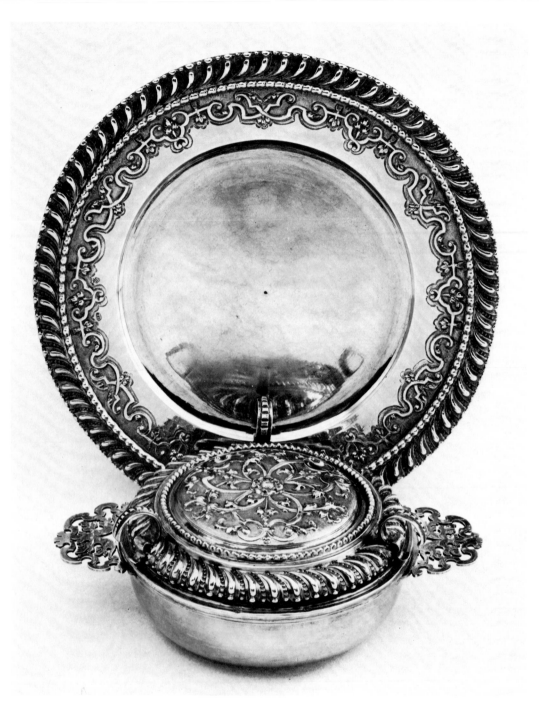

Cat. no. 64

65

Bowl, Cover, and Stand

English, ca. 1702
Silver
DIAMETER: bowl, 4 in. (10.2 cm.), stand, 7⅞ in. (10.2 cm.)
MARKS: Bowl and cover: London, 1702-3, maker's mark of Benjamin Pyne (Grimwade, no. 2245); marked under body and inside cover. Stand: London, 1702-3, maker's mark of Richard Syng (Grimwade, no. 2673); marked under dish, lion's head erased under foot

The circular bowl on gadrooned foot, chased with shallow flutes and with a matted engrailed band beneath the lip, engraved on the inside with a coat of arms within baroque cartouche, with scroll handles; the slightly domed cover with gadrooned border, bands of similarly chased flutes, and an applied beaded rib between, with baluster finial; the stand on central spreading foot, similarly chased to the cover and engraved in the center with the same coat of arms.

The arms are those of Trevanion of Caerhayes, Co. Cornwall, impaling Berkeley of Stratton, for John Trevanion, Esq., who married secondly in 1726 Barbara, daughter of William, 4th Lord Berkeley. He had first married Anne, daughter and co-heiress of Sir Francis Blake of Northumberland, but had no issue from that marriage.

Provenance: Unknown.

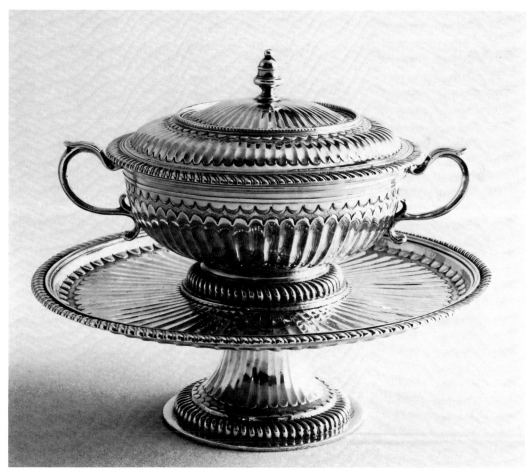

Cat. no. 65

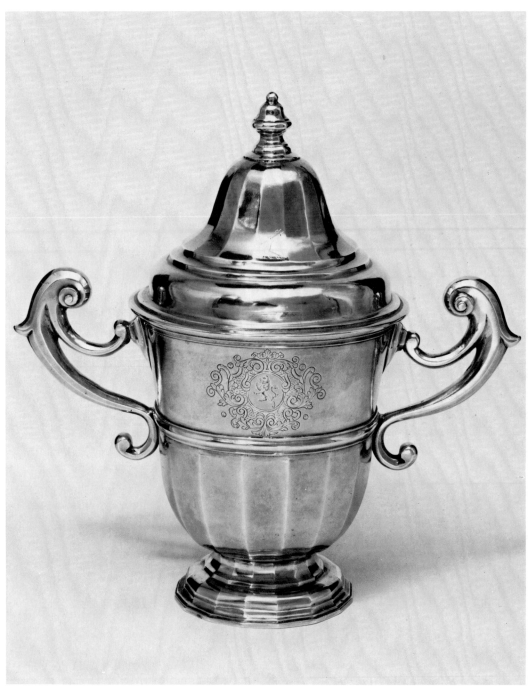

Cat. no. 66

66

Cup and Cover

Irish, ca. 1714
Silver
HEIGHT: 12⅛ in. (31 cm.)
MARKS: Dublin, 1714-15, maker's mark of John
Clifton, Jr. (Jackson, p. 610); marked under the
body and on the rim of the cover

On stepped spreading foot, the foot and lower
part of the body faceted with sixteen sides and
the body with an applied rib above the faceting,
with "harp-shaped" handles; the high domed
cover stepped on the lower part and similarly
faceted above, with ten-sided baluster finial;
engraved on the body with an unidentified coat
of arms within baroque cartouche of scrolls,
foliage, and scalework and on the cover with
a crest.

The two-handled cup and cover has its origins
in the much smaller "ox-eye" cups and candle

cups of the seventeenth century. By the early
eighteenth century a new, more massive form
gained popularity, partly through the influence
of the immigrant Huguenot goldsmiths. These
had a largely ceremonial function and were fre-
quently presented as racing trophies.

Provenance: Unknown.
Exhibited: London, Seaford House, 1929, no. 539.
Literature: E. Alfred Jones, *Old Silver of Europe and
America*, 1928, p. 259.

67

Monteith

Irish, ca. 1717
Silver
DIAMETER: 14⅞ in. (37.9 cm.)
MARKS: Dublin, 1717-18, maker's mark lack-
ing; marked under the body, handles with harp
mark only

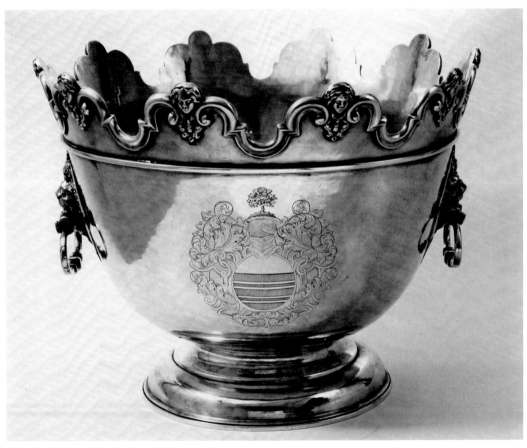

Cat. no. 67

The large plain circular bowl on domed foot, with molded drop-ring handles pendant from lions' masks, the masks cast on shaped panels chased with scalework and applied to the body; a plain rib applied above, and with applied molded border and cherubs' masks to the shaped lip, engraved with a coat of arms within baroque cartouche of scrolls, foliage, and scalework.

The arms are those of Thornhill of Diddington, Co. Huntingdon, or of Thornhill of Thornhill and Stanton, Co. Derby.

The "monteith" was fashionable during the late seventeenth and early eighteenth centuries, the earliest dating from the 1680s. Its purpose and the origin of its name is best described by quoting the diary of Anthony à Wood for December 1683: "This year in the summertime came up a vessel or bason notched at the brim to let drinking vessels hang there by the foot, so that the body or drinking place might hang into the water to cool them. Such a bason was called a Monteigh from a fantasticall Scott called Monsieur Monteigh who at that time or a little before wore the bottome of his cloake or coate so notched" (Clayton, p. 180).

A survey of surviving monteiths shows their popularity suddenly peaking around 1700, with a rapid fall-off thereafter. By the second decade

Cat. no. 68

of the eighteenth century only a few examples from each year occur (see Lee, p. 12).

Provenance: Unknown; included in Dell inventory, ca. 1910.
Exhibited: London, Seaford House, 1929, no. 524.
Literature: E. Alfred Jones, *Old Silver of Europe and America,* 1928, p. 259.

68

Punch Bowl

English, ca. 1717
Silver
DIAMETER: 11½ in. (29.3 cm.)
MARKS: London, 1717-18, maker's mark of Benjamin Pyne (Grimwade, no. 2245); marked under the bowl, the handles unmarked

The plain circular body on molded and stepped spreading foot, of hemispherical form, slightly incurved beneath the lip and with plain molded band applied at the border, the molded drop-ring handles pendant from applied cast and chased lions' masks, engraved beneath the lip with an inscription reading, "The Gift of Richard Musgrave of West Monkton Esqʳ to his

Cat. no. 67

Cat. no. 68

Nephew George Musgrave Juni^r Decem^{br} y^e 26th 1717."

The individuals referred to in the inscription are almost certainly Richard Musgrave of Lyons Inn and West Monkton in Somerset, who died in 1727, and George Musgrave, son of George Musgrave of Nettlescombe, who married Mary Clark, and died in 1724 (Brown, vol. 3, 1889, pp. 39-42). The bowl was presumably a wedding gift.

Provenance: Unknown; included in Dell inventory, ca. 1910.

69

Combined Spoon and Fork

South German, probably Nuremberg, late sixteenth century
Silver-gilt
LENGTH: overall, 7¾ in. (19.7 cm.), fork, 6⅞ in. (17.6 cm.)
MARKS: None

The ovoid bowl pricked with stylized foliage and the two-pronged fork held to the back by an applied cast female demi-figure; the stem hinged at the junction with the bowl, of shaped section and with applied collars and a group of St. George and the dragon; the openwork spherical finial surmounted by the kneeling figure of a princess and unscrewing to reveal a whistle, toothpick, and earpick contained within the stem.

In its sophistication and impracticality, this object is an epitome of Mannerist goldsmiths' work. Ostensibly intended for ordinary use, its complex moldings make it quite inappropriate for eating with, while its decorative program and ingenious combination of functions are best appreciated by examination rather than use. Its fine state of preservation suggests that this is how it must always have been regarded.

The decoration is a curious combination of the contemporary and the historicising: the form and moldings are entirely up-to-date, but the St. George theme is distinctly medieval,

Cat. no. 69

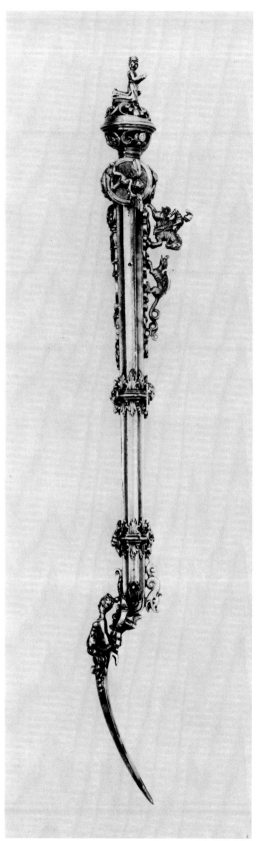

Cat. no. 69

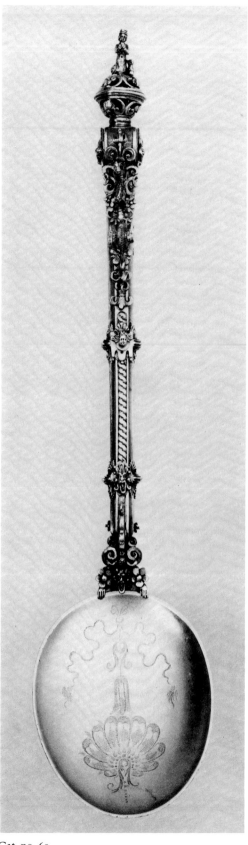

Cat. no. 69

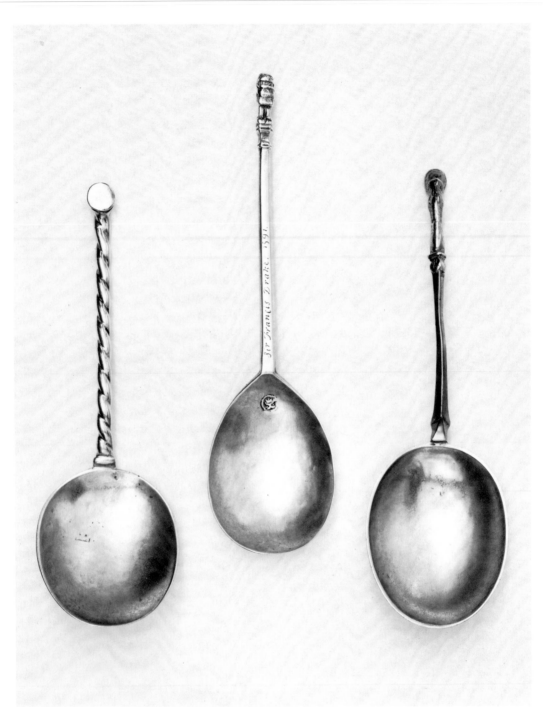

Cat. nos. 70 (center), 71 (right), 72 (left)

and the costume and hair style of the princess – the dragon's intended victim – allude to the fifteenth century.

A number of such pieces survive and have usually been attributed to the Nuremberg goldsmith Friedrich Hillebrand. Perhaps the most notable of these is a gold-and-enamel combined spoon and fork with applied precious stones in the Green Vaults, Dresden (Menzhausen, pl. 62). The Dresden set is slightly larger than this and employs marginally different moldings, but would appear to be from the same workshop. Although it now lacks its finial, records in Dresden show it was originally surmounted by a figure similar to this. None of these, however, appears to be marked. Among marked pieces closest to this in terms of castings and ornamental repertoire is a nautilus cup of similar date by the Nuremberg goldsmith Nikolaus Schmidt, in the collection of Her Majesty the Queen (Hayward, 1976, pl. 473).

Provenance: Alfred de Rothschild, London.
Literature: Charles Davis, *A Description of the Works of Art Forming the Collection of Alfred de Rothschild*, vol. 2, 1884, no. 157; W. W. Watts, "Continental Silver in the Collection of Baron and Baroness Bruno Schröder," 1927, p. 88 (ill.).

70

Spoon

English, ca. 1603
Silver-gilt
LENGTH: 6⅞ in. (16.7 cm.)
MARKS: Exeter, 1603, maker's mark of William Bartlett (Jackson, p. 332); town mark in bowl, maker's mark on stem

With ovoid bowl and tapering octagonal stem; the finial formed as a lion sejant, above a waisted plinth; the back of the bowl pricked with initials T S, and the front of the stem engraved at a later date with an inscription "Sir Francis Drake 1591."

William Bartlett is recorded as working in 1597 and dying in 1646 (*Exeter Silver*, p. 55).

Provenance: Unknown; included in Dell inventory, ca. 1910.

71

Spoon

Dutch, probably Friesland, mid-seventeenth century
Silver-gilt
LENGTH: 6⅜ in. (16.2 cm.)
MARKS: A trefoil (unidentified)

The ovoid bowl with a "rat-tail" applied to the back; the faceted stem terminating in a hoof finial facing to the rear, above a small molding; the back of the bowl engraved with a coat of arms and date 1668, flanked by initials IA LS; two further initials, D L, engraved above.

The arms are probably those of Boutsma of Friesland. However, this identification is tentative, since many families in Friesland bear arms charged with a dimidiated eagle.

Provenance: Unknown; included in Dell inventory, ca. 1910.

72

Spoon

German, mid-seventeenth century
Silver-gilt
LENGTH: 6⅛ in. (15.5 cm.)
MARKS: Wesel, maker's mark of Wilhelm Haussmann (or Husman) (Scheffler, 1973, no. 1382); marked on back of bowl

The bowl of regular oval form and with a "rat-tail" applied to the back; with twisted stem terminating in a plain disk facing to the front; the back of the bowl engraved with a coat of arms and initials I V.

Haussmann is quite fully recorded by Scheffler. He trained as a goldsmith in Aachen and came to Wesel as a refugee. In 1638 he became a master of the guild of goldsmiths and in the following year married Marie Chombert (or Schombert), a native of the town. In addition to two further spoons by this maker, Scheffler also records a cup dated 1643 and a chalice dated 1653.

Provenance: Unknown.

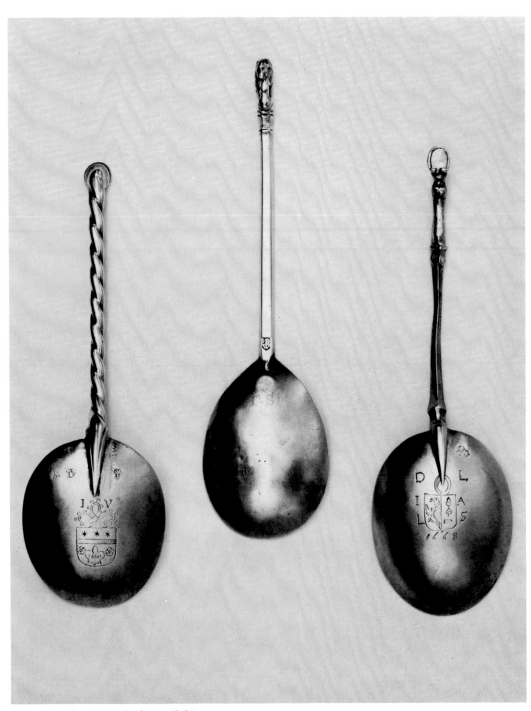

Cat. nos. 70 (center), 71 (right), 72 (left)

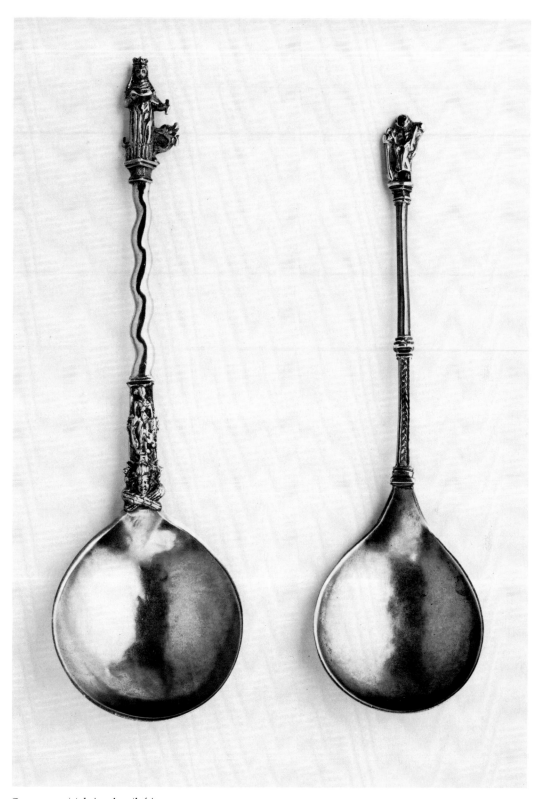

Cat. nos. 73 (right) and 74 (left)

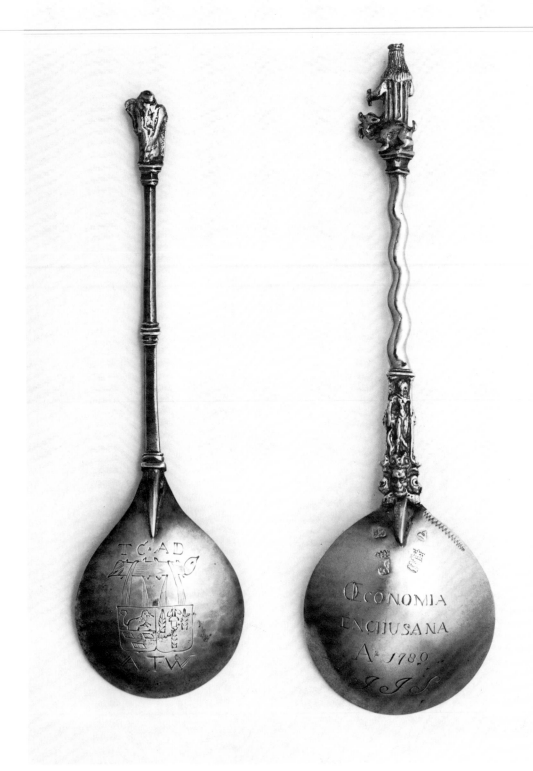

Cat. nos. 73 (left) and 74 (right)

Spoon

Dutch, mid-seventeenth century
Silver-gilt
LENGTH: 6⅞ in. (17.4 cm.)
MARKS: None

The ovoid bowl tapering toward the stem, with
a short applied "rat-tail" to the back; the stem
of square section and engraved with scale pat-
tern on the lower part and of plain circular
section above; the finial formed as figure hold-
ing a staff; the back of the bowl engraved with
two coats of arms accollé and two sets of ini-
tials, TC.AD above and ATW below.

Provenance: Unknown.

Spoon

Dutch, ca. 1710
Silver-gilt
LENGTH: 7½ in. (19.2 cm.)
MARKS: Enkhuizen, 1708, maker's mark
possibly ES

The spoon with ovoid bowl; the lower part of
the stem with cast and chased panel incorporat-
ing an allegorical figure and a mask and with
twisted section above; the finial formed as St.
Catherine of Siena above a lozenge-shaped
plinth; the back of the bowl engraved with
a later inscription reading ŒCONOMIA
ENCHUSANA A 1780 J J S.

Provenance: Unknown; included in Dell inventory,
ca. 1910.

Cat. no. 75

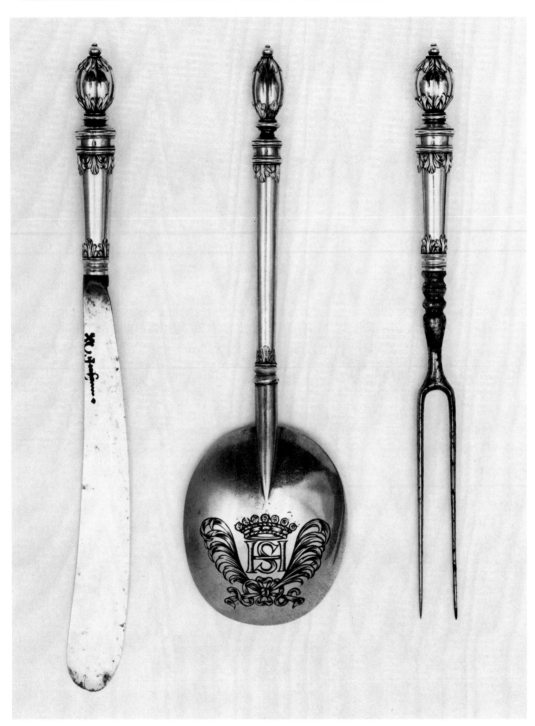

Cat. no. 75

75

Knife, Fork, and Spoon

Probably English, ca. 1680
Gold and enamel, with original leather case
LENGTH: 6¼ in. (16 cm.)
MARKS: The blade with maker's mark FOX, the handles unmarked

The spoon with "rat-tailed" ovoid bowl decorated on the back in niello with monogram HS or SH, with coronet above and crossed fronds below; with tapering tubular handle enameled with polychrome calyxes and with fluted oval finial; the knife and fork with similar handles and with steel scimitar-shaped blade and prongs.

Although the enameled calyxes are strongly reminiscent of German workmanship, three factors taken together seem to support an attribution to an English workshop. First, the nielloed engraving on the back of the bowl of the spoon is very much in the English taste, while the coronet is apparently that of an English viscount. Secondly, the blade, apparently contemporary with the rest, is clearly English. Thirdly, the style in which the leather case is decorated compares closely with that found on some English bookbindings of the period. The coronet on the spoon has been altered from that of an earl. This is probably the correction of an engraver's error.

Provenance: Unknown.
Exhibited: London, Goldsmith's Hall, 1979, no. 73.

Nineteenth-Century Historicism

76

Jug and Cover

English, mid-nineteenth century
Silver-gilt and coconut shell, enriched with pastes
HEIGHT: 9½ in. (24.1 cm.)
MARKS: None

On domed foot repoussé and chased with fruit and foliage, with pierced stem, the polished coconut body with applied vertical straps and broad lip-mount; the domed cover similarly chased to the foot, with figures in late Elizabethan costume, with inverted acorn finial and scroll handle.

The lip is engraved with a coat of arms (a chevron between nine cloves) and incorporating the initials WN. Amid elaborate scrolling foliage on hatched ground are two figures supporting banners bearing the inscriptions FEARE GOD T.N.

and MEMENTO MORI E.N. The coat of arms, however, is spurious. Further inscriptions are on the cover and handle: THE GREATEST TREASVR THAT ONE YEARTH TO MORTAL

Cat. no. 76

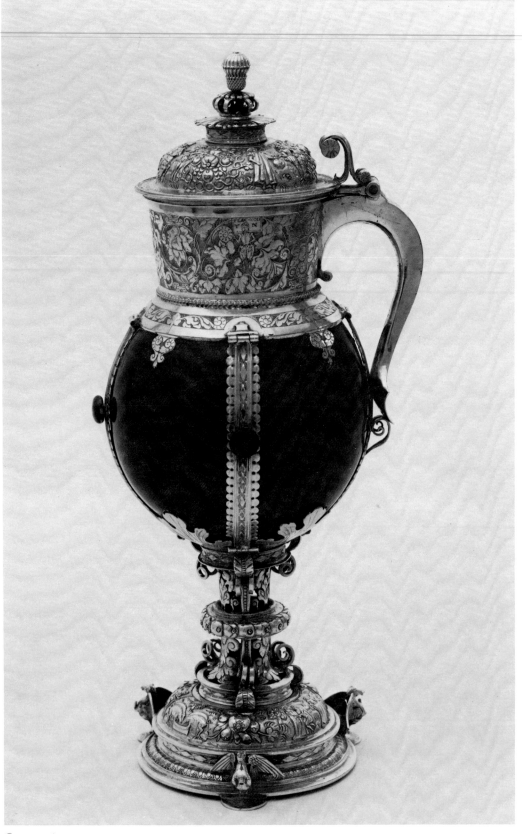

Cat. no. 76

MAN IS LENT IS MODYRAT WELTH TO
NORISH LYFE IF MAN CAN BE CONTENT and
RATHER DEATH THEN FALCE OF FAITH A.N.

An elaborate but self-evidently suspicious
provenance accompanied this piece when ex-
hibited at South Kensington in 1862. The cata-
logue entry read as follows, "This beautiful
piece was probably made in the City of Bristol,
where it was purchased from a silver-smith
some years ago, having previously been from
time immemorial in the possession of an old
family of the city."

Provenance: H. Durlacher, Esq.; J. Dunn-Gardiner,
Esq., Sale, Christie's, London, Apr. 29, 1902, lot 133;
Anonymous, Sale, Christie's, London, Dec. 17, 1919,
lot 101.
Exhibited: London, South Kensington Museum,
1862, no. 5765, lent by H. Durlacher, Esq.
Literature: W. W. Watts, "English Silver...in the Col-
lection of Baron and Baroness Bruno Schröder," 1927,
pp. 246 (ill.), 248-51.

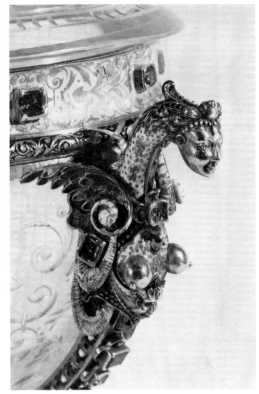

Cat. no. 77

77

Bowl and Cover

German, ca. 1880, probably by Reinhold
Vasters of Aachen
Gold, enamel, and rock crystal
HEIGHT: 9 in. (23 cm.)
WIDTH OVER HANDLES: 7⅞ in. (20 cm.)
MARKS: None

The oval body carved with the stories of
Daphne and Apollo and Cyparissus and the stag
within oval surrounds and with foliage be-
tween; on baluster stem and spreading foot; the

mounts decorated with white and black opaque
enamel, set with emeralds in plain collets; the
handles terminating in enameled and jeweled
harpies and the cover carved with further
foliage, and with openwork baluster finial.

Reinhold Vasters was virtually unknown until
the recent publication of a remarkable series of
drawings discovered by Charles Truman in the
Print Room at the Victoria and Albert Museum,

Cat. no. 77

Cat. no. 77

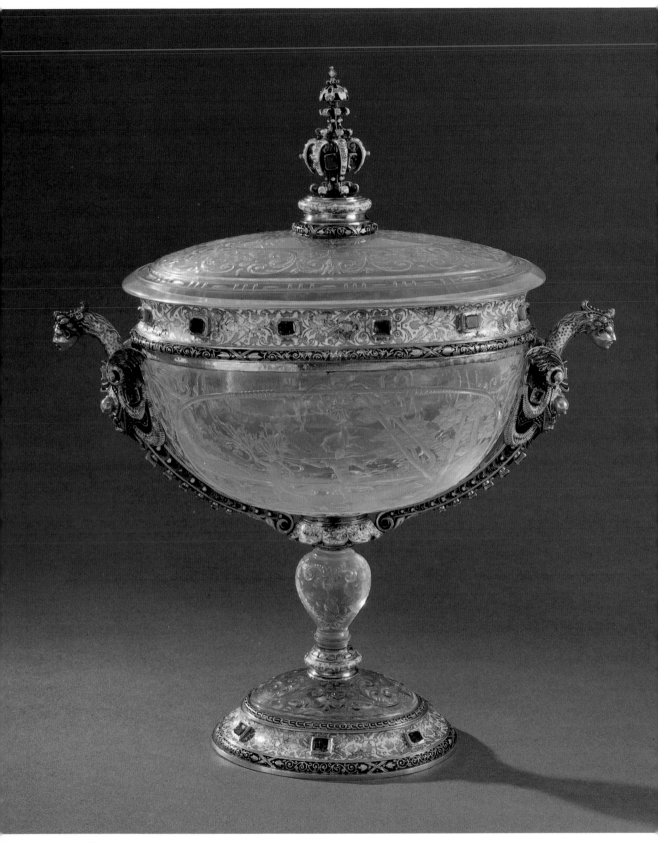

Cat. no. 77

London. These cover a wide range of objects, mostly in the High Renaissance style and were clearly intended as highly finished working drawings (Truman, pp. 154-61). Their discovery led to the unmasking of a number of objects in important private and national collections that had previously been considered fine examples of sixteenth-century workmanship. On this piece, the finial and handles are closely paralleled by Vasters's drawings, though no drawing of the entire cup has yet come to light.

Remarkably little is known of Vasters himself, though Rosenberg (1922-28, no. 42) records his working life as 1853-1890, and it is known that he worked during the 1870s on restoration in the Cathedral Treasury at Aachen. Frédéric Spitzer (see p. 12) had connections with the Cathedral and it is tempting to speculate that he might himself have been responsible for "marketing" some of Vasters's more exotic creations.

The stories carved on the bowl are from Ovid's *Metamorphoses,* books 1 and 10.

Provenance: Unknown.
Exhibited: London, Goldsmiths' Hall, 1979, no. 28.

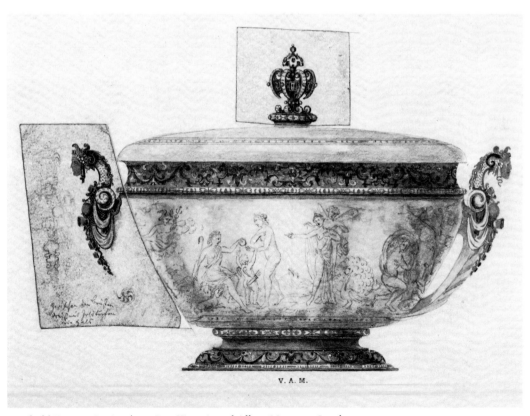

Reinhold Vasters. *Design for a Cup.* Victoria and Albert Museum, London.

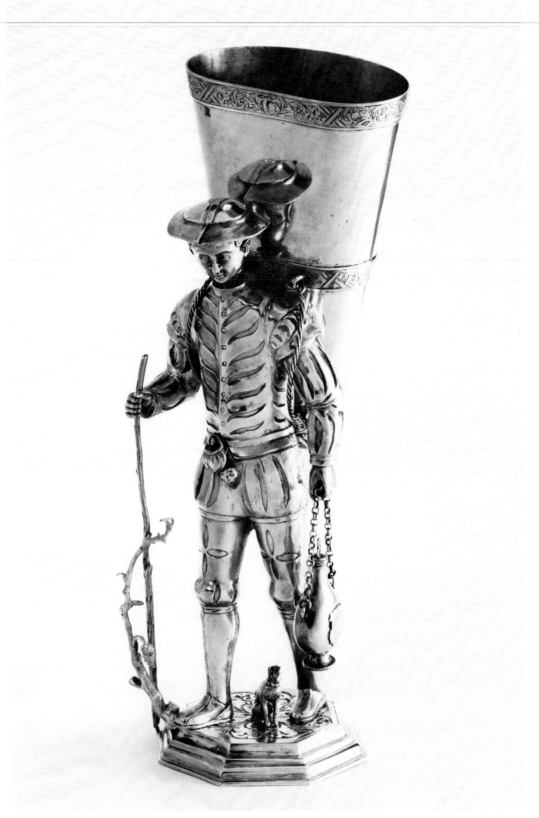

Cat. no. 78

Figure of a Grape Carrier

Probably German, late nineteenth century
Silver-gilt
HEIGHT: overall, 11½ in. (29.2 cm.), figure and
stand, 9¼ in. (23.5 cm.)
MARKS: None

The figure walking, with staff in right hand and
pilgrim bottle in left, wearing slashed doublet
and broad-brimmed hat and carrying a barrel on
his back; on stepped octagonal base engraved
with foliage, and with a small seated dog; the
pilgrim bottle engraved with initials B.W.

Although characteristic of the sixteenth cen-
tury, certain details, such as the mechanically
produced thread of the screws, make it quite
certain that this is a nineteenth-century rep-
lica. It would seem to be an exact reproduction
of a parcel-gilt example formerly in the Alfred
and Lionel de Rothschild Collection (sold at
Christie's, London, July 4, 1946, lot 34, and
Palais Galliera, Paris, Nov. 31, 1965, lot 221)
which, according to the sales catalogues, bears
Frankfurt am Main marks and the maker's
mark BP.

Provenance: Purchased from Crichton Brothers,
1930.

Tazza

Foot and stem probably Dutch, late sixteenth
century; the bowl, late nineteenth century
Silver-gilt and glass
HEIGHT: 4¾ in. (12.2 cm.)
DIAMETER: 5 in. (12.8 cm.)
MARKS: None

The stepped domed foot repoussé and chased
with vases, foliage, and scrolls and within, with
birds, foliage, and strapwork and with three
applied masks; the baluster stem cast with
cherubs' masks and with scroll brackets
applied to the lower and upper parts; the shal-
low glass bowl carved with masks, foliage, and
strapwork.

Typical of many of the "restorations" and
"improvements" carried out during the late
nineteenth century on works of art from the
sixteenth century and earlier, the design of the
glass dish is inspired by genuine objects of the
period. The design of a (?) sixteenth-century
Palissy faïence dish formerly in the Spitzer Col-
lection is in fact almost identical to this (see
Collection Spitzer, vol. 2, 1891, p. 153, no. 30,
colorplate 4).

Provenance: Unknown.

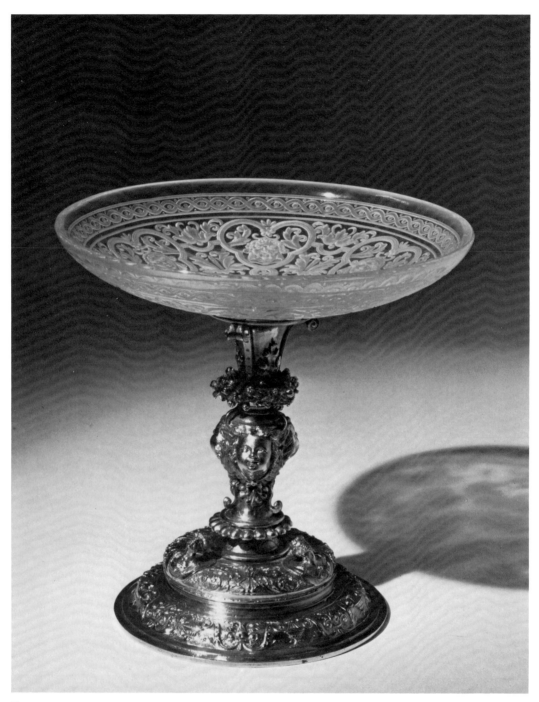

Cat. no. 79

Cat. no. 79

Appendix

A number of works in the Schroder Collection were judged to be too fragile to undergo extensive travel. Some others were excluded on grounds of duplication. In order to serve students, scholars, and other specialists in this field and to present as complete a view as possible of the Schroder Collection, an abbreviated listing is appended here of those pieces in the Collection that are not included in the exhibition.

1 Reliquary

French, probably Limoges, ca. 1200, with later modifications

Silver-gilt, enamel, hardstone, and rock crystal

HEIGHT: 10⅞ in. (27. 5 cm.)

MARKS: None

The square pyramidal foot resting on an arcade and tapering toward the knop, encrusted with filigree, precious stones, and cloisonné enamels and mirrored by a similar section above the knop; the knop with applied friezes of monsters and a band of stones; the square platform above with pendant beads and a small turret at one corner, encrusted with further stones and filigree and set with a carved phial of rock crystal of square section above an arcade, the crystal surmounted by a gilt spray of flowers; and with a lengthy inscription engraved under the foot.

Provenance: Church of Châteauponsac (Haute-Vienne); Goldschmidt-Rothschild Collection, Frankfurt am Main.

Exhibited: Paris, Musée des Arts Décoratifs, 1965, no. 362 (electrotype copy); London, Goldsmiths' Hall, 1979, no. 2.

2 Cup and Cover

Probably Austrian, ca. 1500, with mid-sixteenth-century modifications

Silver-gilt and rock crystal

HEIGHT: 13¼ in. (38.8 cm.)

MARKS: Freiburg im Breisgau, maker's mark B; marked under foot

The ogee crystal foot, vase-shaped stem, and bulbous body carved with spiral facets and the

App. no. 1

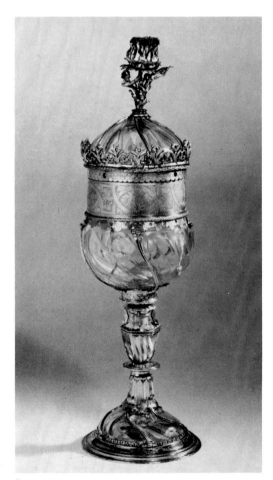

App. no. 2

188

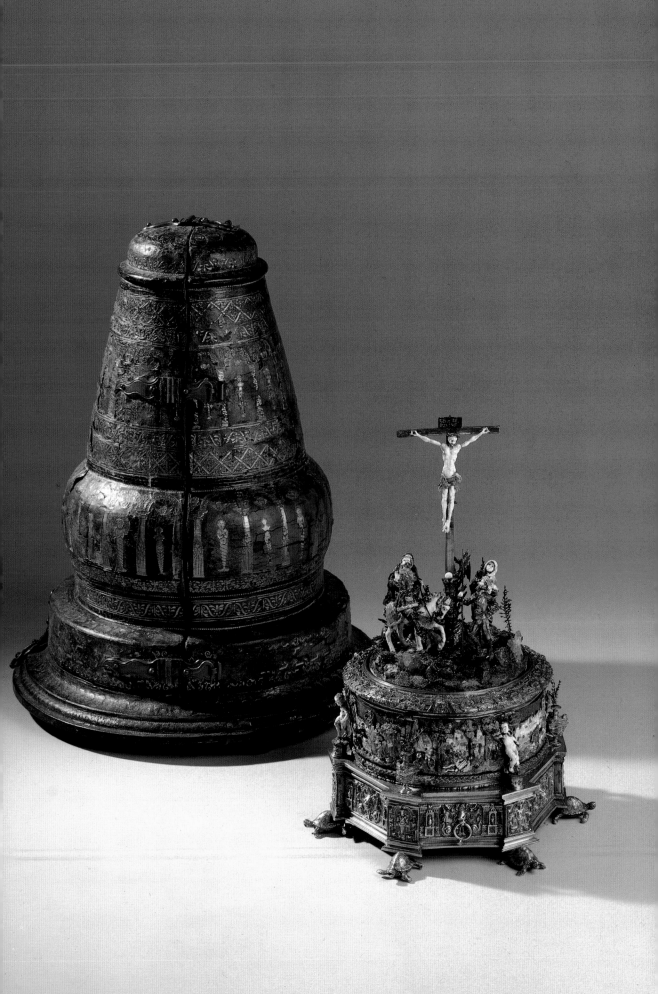

silver-gilt mounts connected by straps following the lines of the facets; with wide lip-mount engraved with a broad band of foliage and strapwork on hatched ground; the domed cover similarly carved, with applied foliate cresting around the border and parcel-gilt thistle finial; an enameled coat of arms applied beneath the cover. The engraved band around the lip is possibly nineteenth century.

The arms are probably those of Görtz, counts of Austria, possibly for Leonhard von Gör(t)z, who married a Mantuan princess around 1470.

Exhibited: London, Goldsmiths' Hall, 1979, no. 7.

3 Salt Cellar

German, dated 1550, attributed to the workshop of Wenzel Jamnitzer
Silver-gilt and enamel, with original leather case
HEIGHT: 9¼ in. (23.4 cm.)
MARKS: Nuremberg, maker's mark probably of Christoff Ritter[le] I (cf. Rosenberg, nos. 3880B and 3881, ascribed to Christoff Ritter[le] II)

The hexagonal base supported by tortoises, with panels of lions' masks and strapwork within architectural frames applied to the sides and with enameled putti and vases of flowers above the angles; the circular drum enameled in relief with six biblical scenes (the drunkenness of Noah, Abraham and the three angels, Lot and his daughters, the Baptism of Christ, Christ and the woman of Samaria, and the Good Samaritan), with shallow receptacle for the salt; the cover formed as a polychrome enameled group of the Crucifixion, with the Virgin, St. John, the centurion on horseback, and a soldier with halberd around the foot of the cross; three drawers forming an inkstand contained within the base; with original tooled and gilded leather case.

Provenance: (?) Rathaus, Nuremberg (see Rosenberg, no. 3880B); Sir George Lindsay Holford, Sale, Christie's, London, July 14, 1927, lot 137.
Exhibited: London, Goldsmiths' Hall, 1979, no. 12.
Literature: M. Rosenberg, *Jamnitzer*, 1920, pl. 14 (drawing); R. Benson, ed., *The Holford Collection*, vol. 2, 1927, no. 197 (ill.); W. W. Watts, "Continental Silver in the Collection of Baron and Baroness Bruno Schröder," 1927, pp. 86-88 (ill.); C. Hernmarck, *Art of the European Silversmith*, 1977, p. 282.

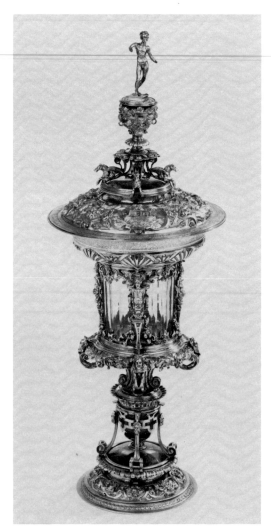

App. no. 4

4 Cup and Cover

Flemish, probably Antwerp, ca. 1560
Silver-gilt, rock crystal, and agate
HEIGHT: 19 in. (48.2 cm.)
MARKS: None

The spreading foot chased with allegorical subjects and with a crystal disk at the center; the stem formed from an onyx urn within cagework, with scrolling brackets above, and the faceted cylindrical crystal bowl with applied vertical demi-figure straps and flared lip-mount engraved with arabesques and chased with shells; the raised cover chased with scenes emblematic of the Four Elements, with a crystal disk at the center, and surmounted by a naked figure above a vase-shaped

plinth supported by winged demi-horses. The finial is a restoration.

Provenance: Duke of Cumberland Collection; purchased from Crichton Brothers, 1924.
Exhibited: London, Goldsmiths' Hall, 1979, no. 13.
Literature: W. W. Watts, "Continental Silver in the Collection of Baron and Baroness Bruno Schröder," 1927, p. 90 (ill.); E. Alfred Jones, *Old Silver of Europe and America,* 1928, pp. 184, 208, pl. 54, 3; J. F. Hayward, *Virtuoso Goldsmiths,* 1976, p. 286, pls. 600, 603, 604.

5 Cup and Cover

English, ca. 1555, the crystal probably carved in Freiburg im Breisgau, Germany
Silver-gilt and rock crystal
HEIGHT: 11⅛ in. (28.4 cm.)
MARKS: London, 1554-55, maker's mark a bird in a shaped shield (Jackson, p. 100); marked on lip and cover

On octagonal ogee foot, with vase-shaped stem and shallow circular bowl carved with triangular facets and with a bulbous ring below chased with strapwork and fruit, and with three verti-cal straps springing from openwork brackets and terminating in masks and fruit; with flared lip engraved with arabesques; the raised cover embossed with gadroons within strapwork and with vase-shaped crystal finial.

Provenance: Green Vaults, Dresden; given to the House of Wettin, 1924; purchased from Crichton Brothers, 1926.
Exhibited: London, 25 Park Lane, 1929, no. 78; London, Royal Academy of Arts, 1934, no. 1425; London, Goldsmiths' Hall, 1979, no. 57.
Literature: Jean Louis Sponsel, *Das Grüne Gewolbe zu Dresden,* vol. 1, 1925, pl. 8; W. W. Watts, "English Silver...in the Collection of Baron and Baroness Bruno Schröder," 1927, p. 247 (ill.); E. Alfred Jones, *Old Silver of Europe and America,* 1928, p. 108, pl. 33,1.

6 Communion Cup and Cover

English, ca. 1570
Silver
HEIGHT: 7¾ in. (19.8 cm.)
MARKS: London, 1570-71, maker's mark a pair of bellows (Jackson, p. 101); marked on body and cover

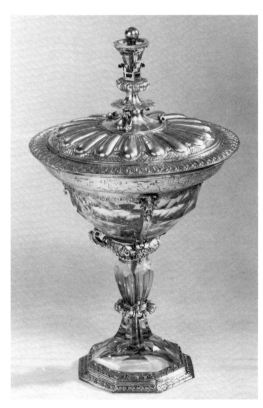

App. no. 5

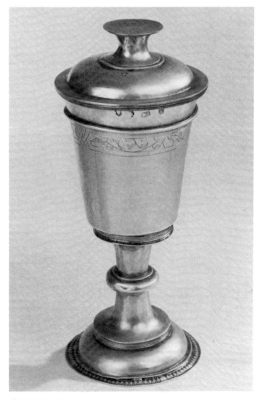

App. no. 6

The conical bowl engraved with a band of
strapwork and arabesques and with an applied
rib beneath the everted lip; on raised spreading
foot and spool-shaped stem with plain knop;
the raised cover reversible to form the paten
and with flat-topped spool-shaped finial.

Provenance: Unknown; included in Dell inventory,
ca. 1910.
Exhibited: London, Goldsmiths' Hall, 1979, no. 59.

7 Celestial Globe

German, 1575
Steel, copper-gilt, and silver
HEIGHT: 21⅝ in. (55 cm.)
MARKS: None; the globe by Hermann Diepel of
Giessen, the frame by Wolff Mayern of Nurem-
berg, the movement by Eberhardt Baldewein

The silvered globe formed from two hemi-
spheres, engraved and etched with the constel-
lations; the supporting frame with plain base
ring and four paw-feet above rising to scroll
brackets terminating in lions' masks; four ter-
minal figures representing the Four Ages of
Man and the Four Seasons above, springing
from a circular disk and supporting the equator-
ial ring, with date pointer and engraved annual
calendar; the meridian ring of blued steel inlaid
with gold and silver; with iron movement con-
tained within the globe.

Provenance: William IV, Landgrave of Hesse-Kassel
(1567-92); Marburg University, 1694-1922; Graf
Adelman Collection.
Exhibited: London, Asprey's, 1973, no. 22; London,
Goldsmiths' Hall, 1979, no. 25; Washington, D.C.,
National Museum of History and Technology, 1980,
no. 115.
Literature: Karl Adelhard von Drach, *Die zu Marburg
im Mathematisch-Physikalischen Institut befind-
liche Globusuhr Wilhelms IV von Hessen*, Marburg,
1894; J. H. Leopold and K. Pechstein, *Der kleine
Himmelsglobus 1594 von Jost Bürgi*, Lucerne, 1977,
pp. 20 ff.; Ludolf von Mackensen, *Die erste Stern-
warte Europas mit ihren Instrumenten und Uhren:
400 Jahre Jost Bürgi in Kassel*, Munich, 1979, pp. 15 ff.

App. no. 8

8 Jug

German, last quarter of sixteenth century, the
mounts English
Silver and stoneware
HEIGHT: 9½ in. (24.2 cm.)
MARKS: Exeter, maker's mark of John Edes
(Jackson, p. 331)

The pear-shaped jug with cylindrical neck
and mottled brown glaze; the neck- and foot-
mounts and the domed cover embossed with
strapwork and fruit on matted ground; with
baluster finial and winged mermaid thumb-
piece; the handle-mount engraved with
initials TIC.

Exhibited: London, Goldsmiths' Hall, 1979, no. 62.

App. no. 7

9 Ewer

English, ca. 1597, the crystal probably Roman, fourth century A.D.
Silver-gilt and rock crystal
HEIGHT: 10⅜ in. (26.4 cm.)
MARKS: London, 1597-98, maker's mark an anchor (not recorded by Jackson); marked on foot, lip, and cover

Of attenuated form, on domed foot embossed with fruit and foliage and with short fluted stem; with four vertical straps in the form of terminal figures within strapwork to the body; the everted lip-mount chased with gadroons within strapwork, with raised cover similarly chased to the foot and with seated Bacchus finial; with snake-scroll handle and female demi-figure thumbpiece.

Provenance: Purchased from Crichton Brothers, 1925.
Exhibited: London, Burlington Fine Arts Club, 1926, Case F, no. 4, pl. XXVII; London, Royal Academy of

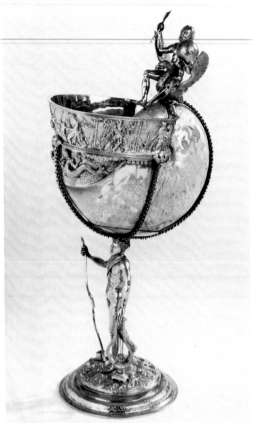

App. no. 10

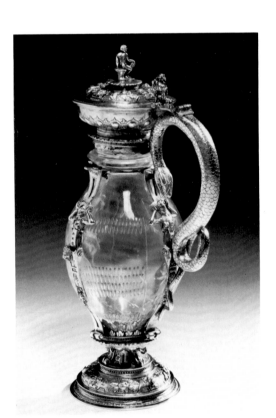

App. no. 9

Arts, 1934, no. 1431; London, Goldsmiths' Hall, 1979, no. 64.
Literature: W. W. Watts, "English Silver... in the Collection of Baron and Baroness Bruno Schröder," 1927, p. 252 (ill.); E. Alfred Jones, *Old Silver of Europe and America*, 1928, p. 108, pl. 33,2.

10 Cup

German, ca. 1600, the shell Chinese
Silver-gilt and engraved nautilus shell
HEIGHT: 12¾ in. (32.3 cm.)
MARKS: Nuremberg, maker's mark of Friedrich Hillebrand[t] (Rosenberg, 1922-28, no. 4017)

The polished shell engraved with a Chinese processional scene; on stepped circular base with a cast band of putti and grotesque masks and set with an amethyst in a plain collet

mount; the stem in the form of Apollo, and the lip-mount with a frieze of planets and astrological signs, with mermaids applied to a lunette below and with vertical straps applied to the body; the cup surmounted by Jupiter astride an eagle. Jupiter's spear is a replacement; Apollo's lyre is probably a replacement.

Provenance: Unknown.
Exhibited: London, Goldsmiths' Hall, 1979, no. 34.
Literature: W. W. Watts, "Continental Silver in the Collection of Baron and Baroness Bruno Schröder," 1927, pp. 91 (ill.), 92; E. Alfred Jones, *Old Silver of Europe and America*, 1928, p. 201; C. Hernmarck, *Art of the European Silversmith*, 1977, p. 112.

On three ball-feet and in three sections, each of tapering waisted form; the lower two sections flat-chased with strapwork, foliage, shells, and vacant escutcheons on matted ground, and with plain shallow receptacle for the salt; the domed cover flat-chased with an acanthus calyx and with pierced spherical finial.

Provenance: George Webbe Dasent, D.C.L., Sale, Christie's, London, June 2, 1875, lot 107.
Exhibited: London, Burlington Fine Arts Club, 1926, Case I, no. 19; London, Goldsmiths' Hall, 1979, no. 67.

11 Bell Salt

English, ca. 1600
Silver-gilt
HEIGHT: 8⅞ in. (22.4 cm.)
MARKS: London, 1600-1601, maker's mark TS in monogram (Jackson, p. 109)

12 Bowl

English, ca. 1610, the porcelain Chinese, Wan-Li period (1573-1620)
Silver-gilt and porcelain
DIAMETER: 6¼ in. (15.9 cm.)
MARKS: None

The circular blue-and-white bowl painted with flowers and leaves; the mounts consisting of a spreading foot and lip and four vertical straps, stamped with repeating ovals, buds, and rose heads; with two scroll handles cast and chased with bearded demi-figures above plaiting.

Provenance: Unknown; included in Dell inventory, ca. 1910.
Exhibited: London, Burlington Fine Arts Club, 1926, Case I, no. 2, pl. XXX; London, Goldsmiths' Hall, 1979, no. 69.

13 Windmill Cup

Dutch, ca. 1640
Silver
HEIGHT (excluding sails): 8 in. (20.4 cm.)
MARKS: Amsterdam, 1638, maker's mark probably for Gerrit Valck (Citroen, no. 996)

With inverted bell-shaped bowl embossed with sprays of fruit, foliage, and scrolls on matted ground; the windmill supported by three scroll branches above a cylindrical plinth stamped with fruit and foliage; a figure descending the steps from the mill and another in the doorway

App. no. 11

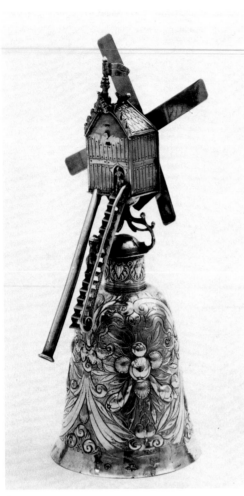

App. no. 13

above; with a small flag and foliate gables to the pitched roof; a long blowpipe issuing from the base of the windmill.

Provenance: Unknown; included in Dell inventory, ca. 1910.
Exhibited: London, Goldsmiths' Hall, 1979, no. 45.

14 Figure of a Bagpipe Player (Guild Cup)

German, mid-seventeenth century
Carved and painted wood with silver mounts
HEIGHT: 11 in. (27.9 cm.)
MARKS: Probably Heilbronn, maker's mark a rampant animal

The bearded figure, on circular silver-mounted base, walking and playing bagpipes, dressed in contemporary costume and painted in red, green, brown, with beige flesh colors, silver hat, apron, sword, and an oval barrel on his back; the various mounts engraved with inscriptions and dated 1654 and 1669; numerous medallions pendant from the barrel, with further inscriptions and dates ranging between 1679 and 1789.

Provenance: Purchased from Crichton Brothers, 1923.
Exhibited: London, Goldsmiths' Hall, 1979, no. 49.

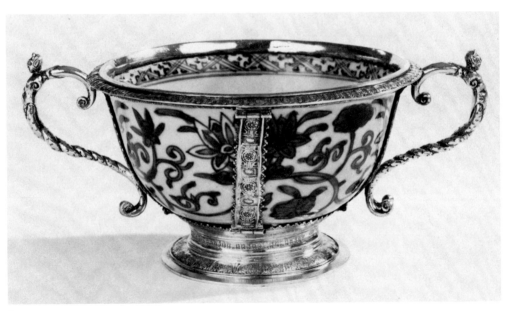

App. no. 12

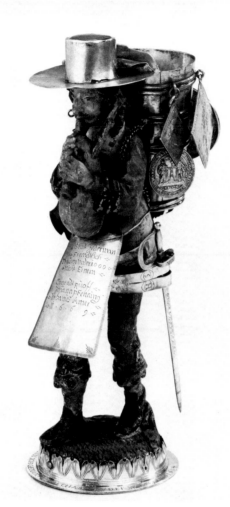

App. no. 14

the Rape of Europa and with a band of scrolling foliage above; with gadrooned silver-gilt mounts, curved spout terminating in a swan's head, and raised crystal cover carved with acanthus foliage; the thumbpiece spherical and faceted.

Provenance: Sigmaringen Museum; sold by the Prince Hohenzollern Estate in Sigmaringen, 1928.
Exhibited: London, Goldsmiths' Hall, 1979, no. 54.
Literature: M. Rosenberg, *Der Goldschmiede Merkzeichen*, 1922-28, no. 4041; U. Thieme and F. Becker, *Lexikon*, vol. 31, 1937, p. 379.

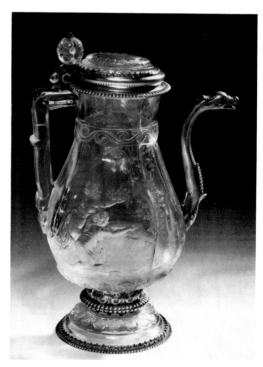

App. no. 15

15 Ewer

German, Berlin, ca. 1700, the rock crystal probably Sicilian, twelfth/thirteenth century
HEIGHT: 8¾ in. (22.3 cm.)
MARKS: Maker's mark only, ZH probably for Zacharias Haase of Berlin; marked on foot; the engraved crystal signed "G. Spiller," for Gottfried Spiller

The pear-shaped ewer on spreading foot and with angular handle, engraved in intaglio with

Marks

Cat. no. 3 Cat. no. 5 Cat. no. 6 Cat. no. 8

Cat. no. 9 Cat. no. 10

Cat. no. 12 Cat. no. 13

Cat. no. 15 Cat. no. 18

Cat. no. 19 Cat. no. 21

Cat. no. 22 Cat. no. 23

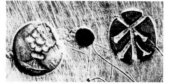

Cat. no. 24

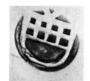

Cat. no. 25

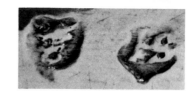

Cat. no. 26

Cat. no. 27

Cat. no. 29

Cat. no. 30

Cat. no. 31

Cat. no. 32

Cat. no. 33

Cat. no. 34

Cat. no. 36

Cat. no. 37

Cat. no. 38

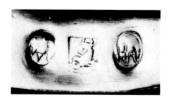

Cat. no. 40

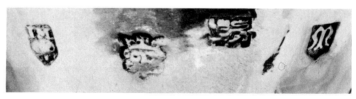

Cat. no. 42

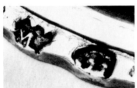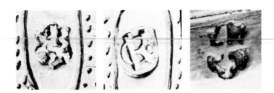

Cat. no. 43 Cat. no. 45

Cat. no. 46 Cat. no. 48

Cat. no. 49

Cat. no. 50 Cat. no. 51

Cat. no. 52 Cat. no. 53

Cat. no. 54 Cat. no. 55 Cat. no. 56

Cat. no. 57

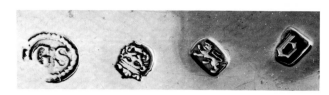

Cat. no. 58

Cat. no. 59

Cat. no. 60

Cat. no. 61

Cat. no. 62

Cat. no. 63

Cat. no. 64

Cat. no. 65

Cat. no. 65

Cat. no. 66

Cat. no. 67

203

Bibliography

Andrén
ANDRÉN, ERIK; HELLNER, BRYNOLF; HERNMARCK, CARL; and HOLMQUIST, KERSTI. *Svenskt Silversmide 1520-1850.* Stockholm, 1963

Art in Seventeenth Century Holland
LONDON, NATIONAL GALLERY. *Art in Seventeenth Century Holland.* Catalogue of a loan exhibition. 1976

Ash
ASH, DOUGLAS. *How to Identify English Silver Drinking Vessels 600-1830.* London, 1964

Beer
BEER, RÜDIGER ROBERT. *Unicorn, Myth and Reality.* Trans. by Charles M. Stern. London and New York, 1977

Benson
BENSON, R., ed. *The Holford Collection, Dorchester House.* 2 vols. Oxford, 1927

British Silver
WARK, ROBERT R. *British Silver in the Huntington Collection.* Henry E. Huntington Library Publication. San Marino, Calif., 1978

Brown
BROWN, FREDERICK. *Abstract of Somersetshire Wills, etc.* 6 vols. London, 1887-90

Carrington
CARRINGTON, J. B., and HUGHES, G. R. *The Plate of the Worshipful Company of Goldsmiths.* Oxford, 1926

Citroen
CITROEN, K. A. *Amsterdam Silversmiths and Their Marks.* Amsterdam, 1975

Clayton
CLAYTON, MICHAEL. *The Collector's Dictionary of the Silver and Gold of Great Britain and North America.* London and New York, 1971

Collection Spitzer
La Collection Spitzer. 6 vols. Paris, 1890-92

Collins
COLLINS, A. JEFFERIES. *Jewels and Plate of Queen Elizabeth I, The Inventory of 1574.* London, 1955

Cook Collection
[COOK, WYNDHAM FRANCIS]. *Catalogue of the Art Collection.* 2 vols. London, 1904-08

Corporation Plate
LONDON, GOLDSMITHS' HALL. *Corporation Plate of England and Wales.* Introduction by Charles Oman. Catalogue by J. F. Hayward. Exhibition catalogue. 1952

Davis
DAVIS, CHARLES, comp. *A Description of the Works of Art Forming the Collection of Alfred de Rothschild.* 2 vols. London, 1884

Delmár
DELMÁR, EMIL. "Zwei Goldschmiedewerke von Ludwig Krug," *Zeitschrift für Kunstwissenschaft,* vol. 4, nos. 1/2 (1950), pp. 49-67

Drach
DRACH, KARL ADELHARD VON. *Die zu Marburg im Mathematisch-Physikalischen Institut befindliche Globusuhr Wilhelms IV von Hessen als Kunstwerk und astronomisches Instrument.* Marburg, 1894

Dutch Silver
AMSTERDAM, RIJKSMUSEUM. *Dutch Silver 1580-1830.* Exhibition catalogue. 1979. (Exhibition circulated to the Toledo Museum of Art and the Museum of Fine Arts, Boston, 1980.)

Eucharistic Vessels
CAMBRIDGE, MASS., HARVARD UNIVERSITY, BUSCH-REISINGER MUSEUM. *Eucharistic Vessels of the Middle Ages.* Exhibition catalogue. 1975

Exeter Silver
EXETER, ROYAL ALBERT MEMORIAL MUSEUM AND LIBRARY. *Catalogue of Exeter Silver.* Museum Publications, no. 86

Fairholt
FAIRHOLT, FREDERICK W. *An Illustrated Descriptive Catalogue of the Collection of Antique Silver Formed by Albert, Lord Londesborough.* London, 1860

Forrer
FORRER, LEONARD, comp. *Biographical Dictionary of Medallists....* 8 vols. New York, 1904-30

Frederiks
FREDERIKS, J. W. *Dutch Silver.* 4 vols. The Hague, 1952-61

Gans
GANS, M. H., and DUYVENÉ DE WIT-KLINKHAMER, T. M. *Dutch Silver.* Trans. by Oliver van Oss. London, 1961

Graves
SUETONIUS. *The Twelve Caesars.* Trans. by Robert Graves. Rev. ed. Penguin Classics. Harmondsworth, Eng., 1979

Grimwade
GRIMWADE, ARTHUR G. *London Goldsmiths, 1697-1837, Their Marks and Lives.* London, 1976

Grose
GROSE, FRANCIS. *Classical Dictionary of the Vulgar Tongue.* London, 1785

Hackenbroch, 1950
HACKENBROCH, YVONNE. "The Emperor Tazzas," *Bulletin, The Metropolitan Museum of Art* (Mar. 1950), pp. 189-97

_____, 1969
_____. *English and Other Silver in the Irwin Untermyer Collection.* Rev. ed., New York, 1969

_____, 1979
_____. *Renaissance Jewellery.* London, 1979

Hardwick Hall Inventory
BOYNTON, LINDSAY, ed. *The Hardwick Hall Inventories of 1601.* The Furniture History Society. London, 1971

Hayward, 1970
HAYWARD, J. F. "The Aldobrandini Tazzas," *Burlington Magazine,* vol. 112, no. 811 (Oct. 1970), pp. 669-74

_____, 1976
_____. *Virtuoso Goldsmiths and the Triumph of Mannerism 1540-1620.* London, 1976

Heal
HEAL, AMBROSE. *The London Goldsmiths, 1200-1800.* Cambridge, 1935

Hearst Sale
Catalogue of the Highly Important Collection of Old English and Foreign Silver. The Property of William Randolph Hearst, Esq. Sale, Christie's, London, Dec. 14, 1938

Hernmarck
HERNMARCK, CARL. *The Art of the European Silversmith 1430-1830.* 2 vols. London, 1977

Husband
NEW YORK, THE METROPOLITAN MUSEUM OF ART, THE CLOISTERS. *The Wild Man: Medieval Myth and Symbolism.* By Timothy Husband, with the assistance of Gloria Gilmore-House. Exhibition catalogue. 1980

Jackson, 1911
JACKSON, CHARLES JAMES. *An Illustrated History of English Plate, Ecclesiastical and Secular.* 2 vols. London, 1911

_____, 1921
_____. *English Goldsmiths and Their Marks.* 2nd ed., rev. and enl. London, 1921

Jones, 1910
JONES, E. ALFRED. *The Old Plate of the Cambridge Colleges.* Cambridge, Eng., 1910

_____, 1928
_____. *Old Silver of Europe and America, From Early Times to the Nineteenth Century.* London and Philadelphia, 1928

Kohlhaussen
KOHLHAUSSEN, HEINRICH. *Nürnberger Goldschmiedekunst des Mittelalters und der Dürerzeit 1240 bis 1540.* Berlin, 1968

Köszeghy
KÖSZEGHY, ELEMÉR. *Magyarországi Ötvösjegyek/ Merkzeichen der Goldschmiede Ungarns, Vom Mittelalter bis 1867.* Budapest, 1936

Lasko
LASKO, PETER. *Ars Sacra: 800-1200.* Pelican History of Art. Baltimore, 1972

Lee
LEE, GEORGINA E. *British Silver Monteith Bowls.* Byfleet, Eng., 1978

Leopold
LEOPOLD, J. H., and PECHSTEIN, K. *Der kleine Himmelsglobus 1594 von Jost Bürgi.* Lucerne, 1977

Lightbown
LIGHTBOWN, R. W. *Secular Goldsmiths' Work in Medieval France: A History.* London, 1978

London, Asprey's
LONDON, ASPREY'S, *Bond Street. The Clockwork of the Heavens.* Exhibition catalogue. 1973

London, Brod Gallery
LONDON, BROD GALLERY. *Jan Brueghel the Elder: A Loan Exhibition of Paintings.* Catalogue. 1979

London, Burlington Fine Arts Club, 1901
LONDON, BURLINGTON FINE ARTS CLUB. *Exhibition of a Collection of Silversmiths' Work of European Origin.* Introduction by J. Starkie Gardner. Catalogue. 1901

_____, 1926
_____. *Catalogue of an Exhibition of Late Elizabethan Art, in Conjunction with the Tercentenary of Francis Bacon.* 1926

London, Goldsmiths' Hall, 1979
LONDON, GOLDSMITHS' HALL. *The Schroder Collection, Virtuoso Goldsmiths' Work from the Age of Humanism.* Preface by Graham Hughes. Introduction and catalogue by Timothy Schroder. Exhibition catalogue. 1979

_____, 1983
_____. *The Goldsmith and the Grape.* Compiled by Claude Blair. Exhibition catalogue. 1983

London, Royal Academy of Arts, 1929
LONDON, ROYAL ACADEMY OF ARTS. *Commemorative Catalogue of the Exhibition of Dutch Art Held in the Galleries of the Royal Academy, Burlington House, London, January-March 1929.* London, 1930

_____, 1934
_____. *Exhibition of British Art, c. 1000-1860.* Catalogue. 1934

London, Seaford House
LONDON, SEAFORD HOUSE. *Queen Charlotte's Loan Exhibition of Old Silver, English, Irish and Scottish, All Prior to 1739.* Catalogue. 1929

London, South Kensington Museum
LONDON, SOUTH KENSINGTON MUSEUM. *Catalogue of the Special Exhibition of Works of Art of the Medieval, Renaissance, and More Recent Periods, on Loan at the South Kensington Museum.* 1862; rev. ed., 1863

London, 25 Park Lane
LONDON, 25 PARK LANE. *Catalogue of a Loan Exhibition of Old English Plate* (for the Benefit of the Royal Northern Hospital). 1929

Luthmer, 1883
LUTHMER, FERDINAND. *Der Schatz des freiherrn Karl von Rothschild. Meisterwerke alter Goldschmiedekunst aus dem 14.–18. Jahrhundert.* 2 vols. Frankfurt, 1883-85

_____, 1888
_____. *Gold und Silber.* Leipzig, 1888

Mackensen
MACKENSEN, LUDOLF VON. *Die erse Sternwarte Europas mit ihren Instrumenten und Uhren: 400 Jahre Jost Bürgi in Kassel.* Munich, 1979

Markowa
MARKOWA, G. A. *Deutsche Silberkunst des XVI.–XVIII. Jahrhunderts in der Sammlung der Rüstkammer des Moskauer Kreml.* Moscow, 1975

McFadden
MCFADDEN, DAVID R. "An Aldobrandini Tazza: A Preliminary Study," *Bulletin, The Minneapolis Institute of Arts,* vol. 63 (1976-77), pp. 42-55

Menzhausen
MENZHAUSEN, JOACHIM. *The Green Vaults.* Trans. by Marianne Herzfeld, revised by D. Talbot Rice. Leipzig, 1968

O'Dell-Franke
O'DELL-FRANKE, ILSE. *Kupferstiche und Radierung aus der Werkstatt des Virgil Solis.* Wiesbaden, 1977

Oman, 1965
LONDON, VICTORIA AND ALBERT MUSEUM. *English Silversmiths' Works, Civil and Domestic.* By Charles Oman. London, 1965

_____, Apollo, 1965
OMAN, CHARLES. "Some Sienese Chalices," *Apollo* (April 1965), pp. 279-81

_____, 1968
LONDON, VICTORIA AND ALBERT MUSEUM. *The Golden Age of Hispanic Silver 1400-1665.* By Charles Oman. London, 1968

_____, 1978
OMAN, CHARLES. *English Engraved Silver 1150 to 1900.* London, 1978

Osborne
OSBORNE, HAROLD, ed. *The Oxford Companion to the Decorative Arts.* Oxford, 1975

Paris, Musée des Arts Décoratifs
PARIS, MUSÉE DES ARTS DÉCORATIFS. *Les Trésors des Eglises de France.* Introduction by Jean Taralon. Exhibition catalogue. 1965

Penzer
PENZER, NORMAN N. "An Index of English Silver Steeple Cups," *Proceedings of the Society of Silver Collectors.* London, 1962

Read
READ, CHARLES HERCULES. *The Waddesdon Bequest. Catalogue of Works of Art Bequeathed by Baron F. Rotchschild [to the British Museum].* London, 1898

Read and Tonnochy
READ, H., and TONNOCHY, A. B. *Catalogue of the Silver Plate, Medieval and Later, Bequeathed to the British Museum by Sir Augustus Wollaston Franks, K.C.B.* London, 1928

Rohault de Fleury
ROHAULT DE FLEURY, C. *La Messe.* 8 vols. Paris, 1883-89

Rosenberg, 1920
ROSENBERG, MARC. *Jamnitzer. Alle erhaltenen Goldschmiedearbeiten, Verlorene Werke, Handzeichnungen.* Frankfurt, 1920

_____, 1922-28
_____. *Der Goldschmiede Merkzeichen.* 3rd. ed., enl. and ill. 4 vols. Frankfurt, 1922-28

Scheffler, 1965
SCHEFFLER, WOLFGANG. *Goldschmiede Niedersachsens.* 2 vols. Berlin, 1965

_____, 1973
_____. *Goldschmiede Rheinland-Westfalens.* 2 vols. Berlin, 1973

Scheicher
SCHEICHER, ELISABETH. *Die Kunst- und Wunderkammern der Habsburger.* Vienna, 1979

Schroder
SCHRODER, T. "Sixteenth-Century English Silver: Some Problems of Attribution," *Proceedings of the Silver Society,* 1983

Seling
SELING, HELMUT. *Die Kunst der Augsburger Goldschmiede 1529-1868.* 3 vols. Munich, 1980

Sponsel
SPONSEL, JEAN LOUIS. *Das Grüne Gewolbe zu Dresden.* 4 vols. Leipzig, 1925-32

Suevia Sacra
AUGSBURG, RATHAUS. *Suevia Sacra: Frühe Kunst im Schwaben.* Exhibition catalogue. 1973

Tait
TAIT, HUGH. *The Golden Age of Venetian Glass.* British Museum Publications. London, 1979

Taylor
TAYLOR, GERALD. *Silver.* Pelican Books. Harmondsworth, Eng., 1956

Thieme-Becker
THIEME, U., and BECKER, F. *Allgemeines Lexikon der bildenden Künstler....* 37 vols. Leipzig, 1907-50

Touching Gold and Silver
LONDON, GOLDSMITHS' HALL. *Touching Gold and Silver.* Exhibition catalogue. 1978

Truman
TRUMAN, CHARLES. "Reinhold Vasters – 'The Last of the Goldsmiths'?," *Connoisseur,* vol. 200, no. 805 (March 1979), pp. 154-61

Vienna, *Goldschmiedekunst Ausstellung*
VIENNA. *Goldschmiedekunst Ausstellung.* Exhibition catalogue. 1889

Virtuoso Craftsman
MASSACHUSETTS, WORCESTER ART MUSEUM. *The Virtuoso Craftsman. Northern European Design in the Sixteenth Century.* Catalogue by John David Farmer. Loan exhibition. 1969

Von der Osten
VON DER OSTEN, GERT, and VEY, HORST. *Painting and Sculpture in Germany and The Netherlands 1500-1600.* Pelican History of Art. Baltimore, 1969

Ward-Jackson
WARD-JACKSON, PETER W. *Italian Drawings. vol. 1, 14th–16th Century.* Victoria and Albert Museum Catalogues. London, 1979

Washington, D.C., National Museum of History and Technology
WASHINGTON, D.C., NATIONAL MUSEUM OF HISTORY AND TECHNOLOGY, SMITHSONIAN INSTITUTION. *The Clockwork Universe: German Clocks and Automata, 1550-1560.* Ed. by Klaus Maurice and Otto Mayr. Trans. by H. Bartlett Wells. Exhibition catalogue. 1980

Watts
WATTS, W. W. "English Silver, Chiefly of the Tudor Period, in the Collection of Baron and Baroness Bruno Schröder," *Old Furniture,* vol. 1, no. 4 (Sept. 1927), pp. 245-56; idem, "Continental Silver in the Collection of Baron and Baroness Bruno Schröder," ibid., vol. 2, no. 5 (Oct. 1927), pp. 3-14; no. 6 (Nov. 1927), pp. 86-95

Welt im Umbruch
AUGSBURG, RATHAUS, ZEUGHAUS. *Welt im Umbruch. Augsburg zwischen Renaissance und Barock.* 2 vols. Exhibition catalogue. 1980

Weltliches Silber
ZURICH, SCHWEIZERISCHES LANDESMUSEUM. *Weltliches Silber. Katalog der Sammlung des Schweizerischen Landesmuseum, Zürich.* Zurich, 1977

Wirth
WIRTH, KARL-AUGUST. "Von Silbernen und Silbermontierten Eulengefässen," *Anzeiger des Germanischen Nationalmuseum,* 1968, pp. 42-83

Photo Credits

All photographs by Eileen Tweedy, London, except: cover, colorplates pp. 116, 117, and 126 and Appendix nos. 1-15 by P. J. Gates, Ltd., London; colorplate p. 126 by Michael Fear, London.

208